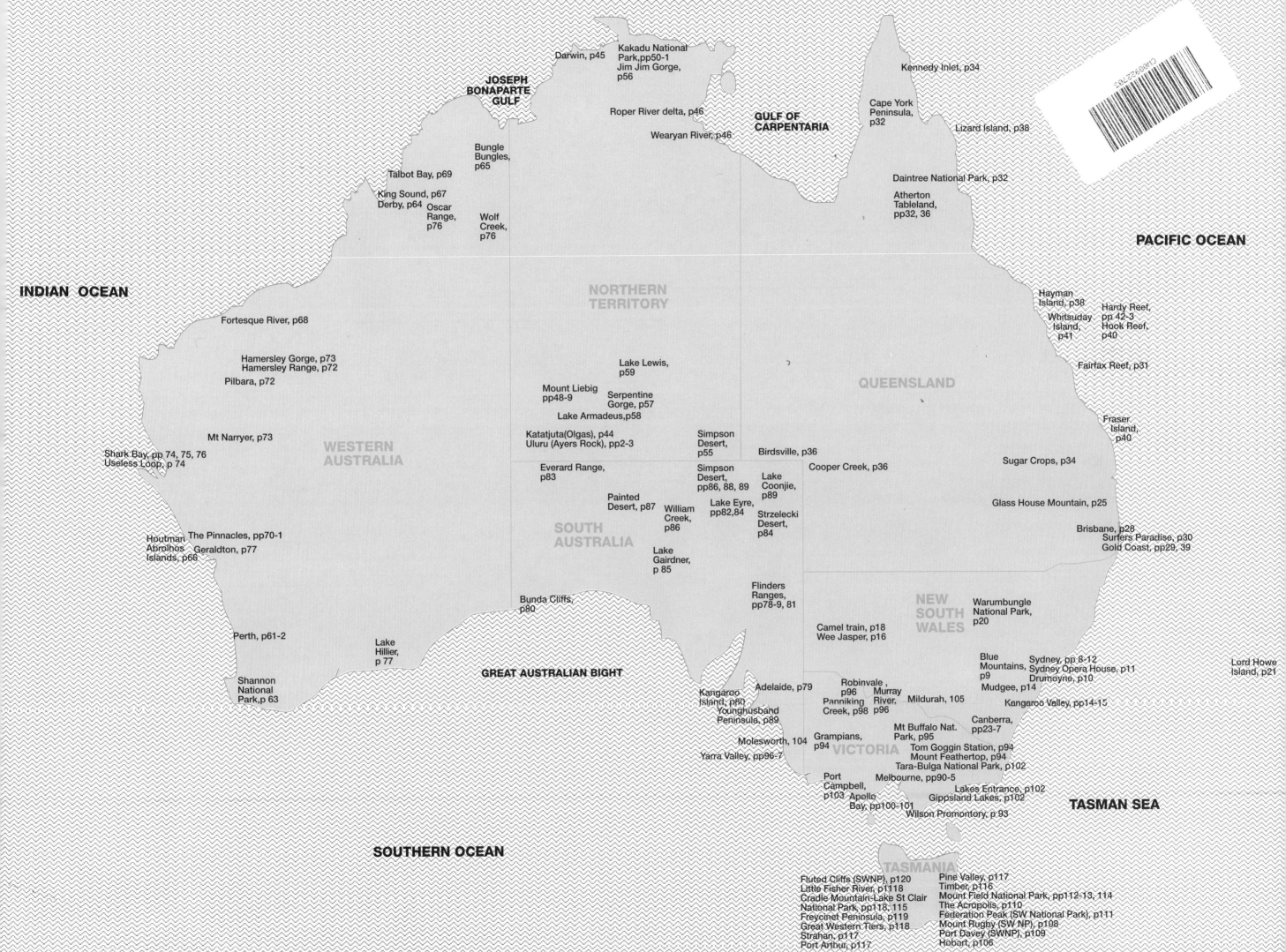

ARAFURA SEA

PACIFIC OCEAN

INDIAN OCEAN

GULF OF CARPENTARIA

JOSEPH BONAPARTE GULF

GREAT AUSTRALIAN BIGHT

SOUTHERN OCEAN

TASMAN SEA

NORTHERN TERRITORY

WESTERN AUSTRALIA

SOUTH AUSTRALIA

QUEENSLAND

NEW SOUTH WALES

VICTORIA

TASMANIA

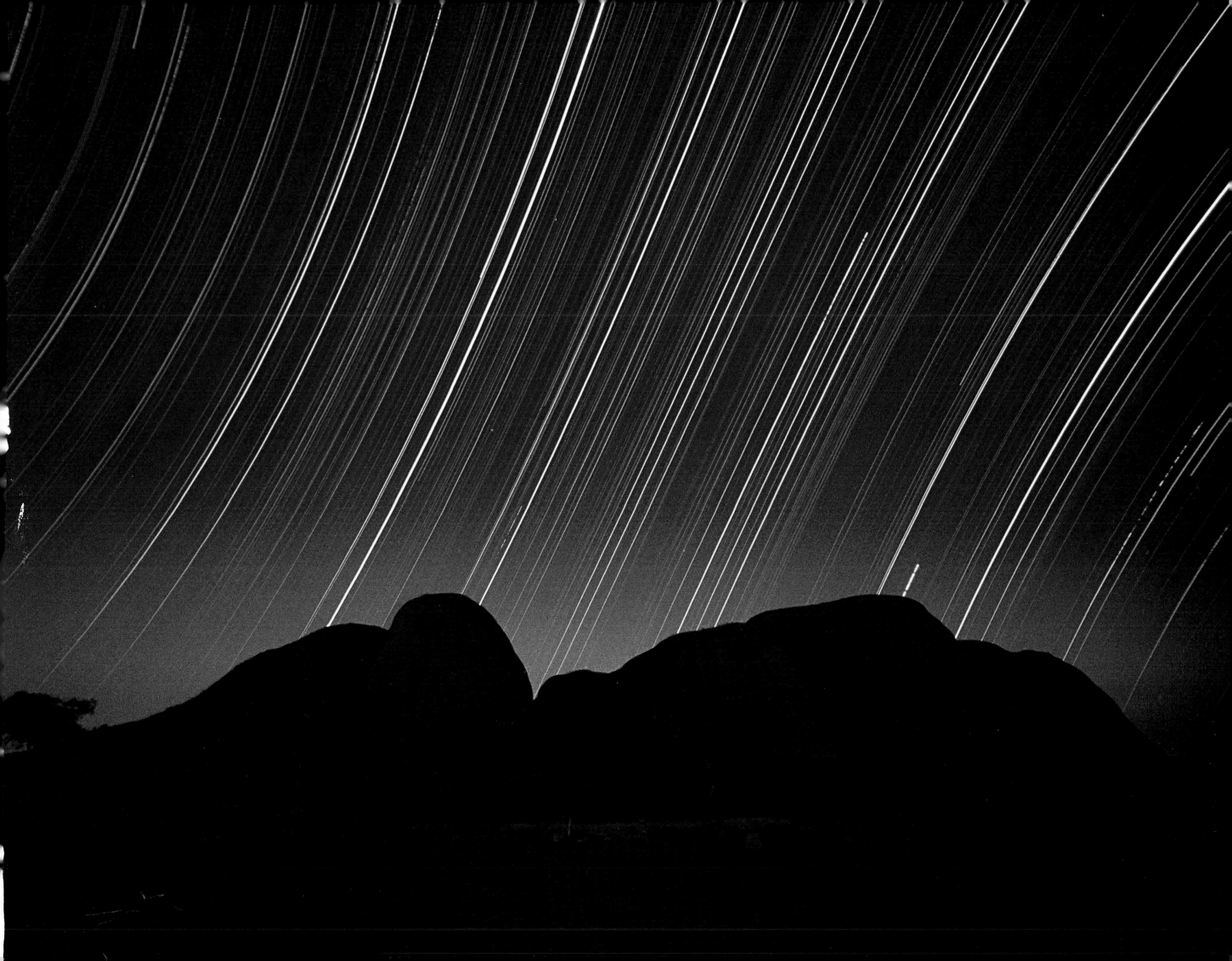

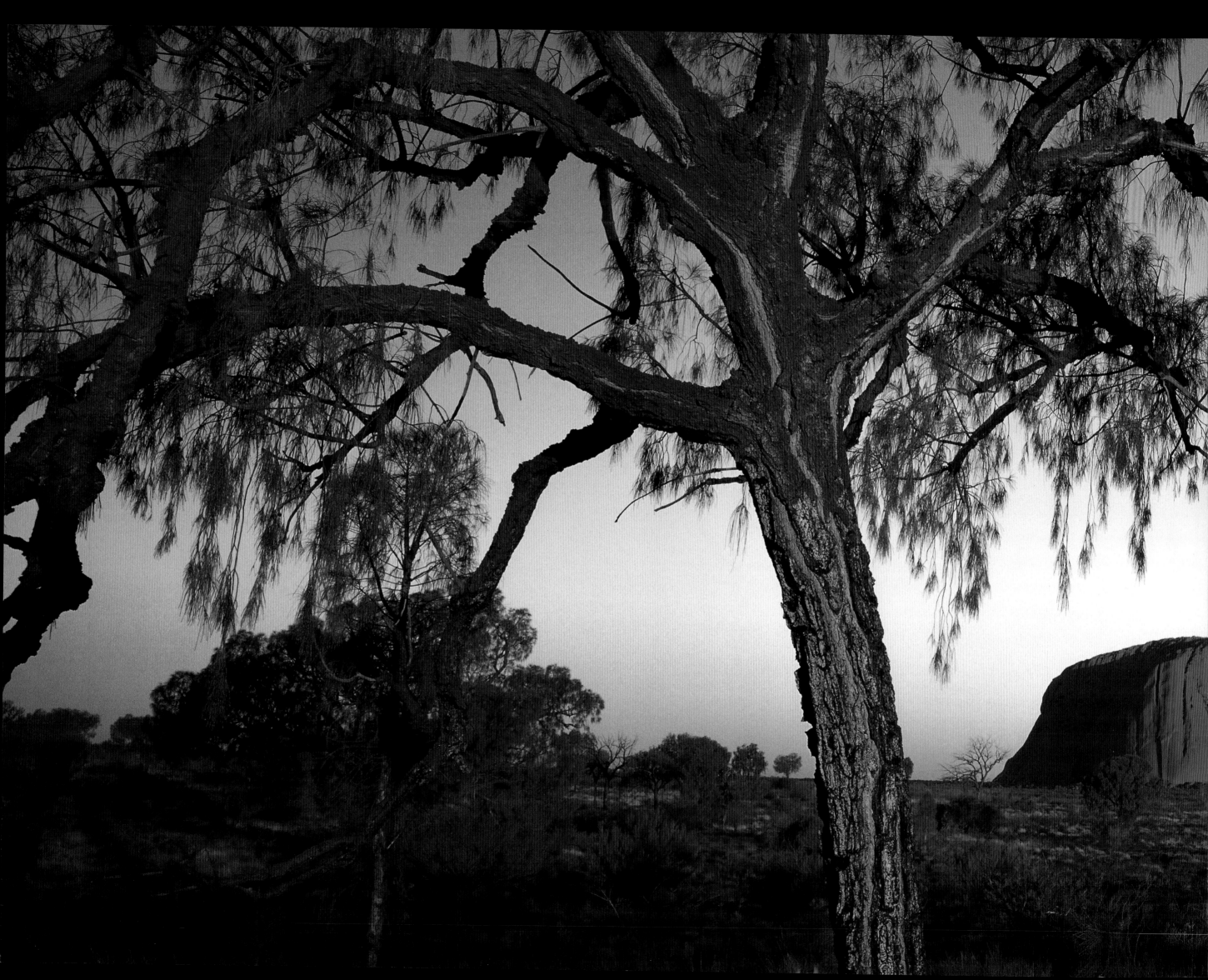

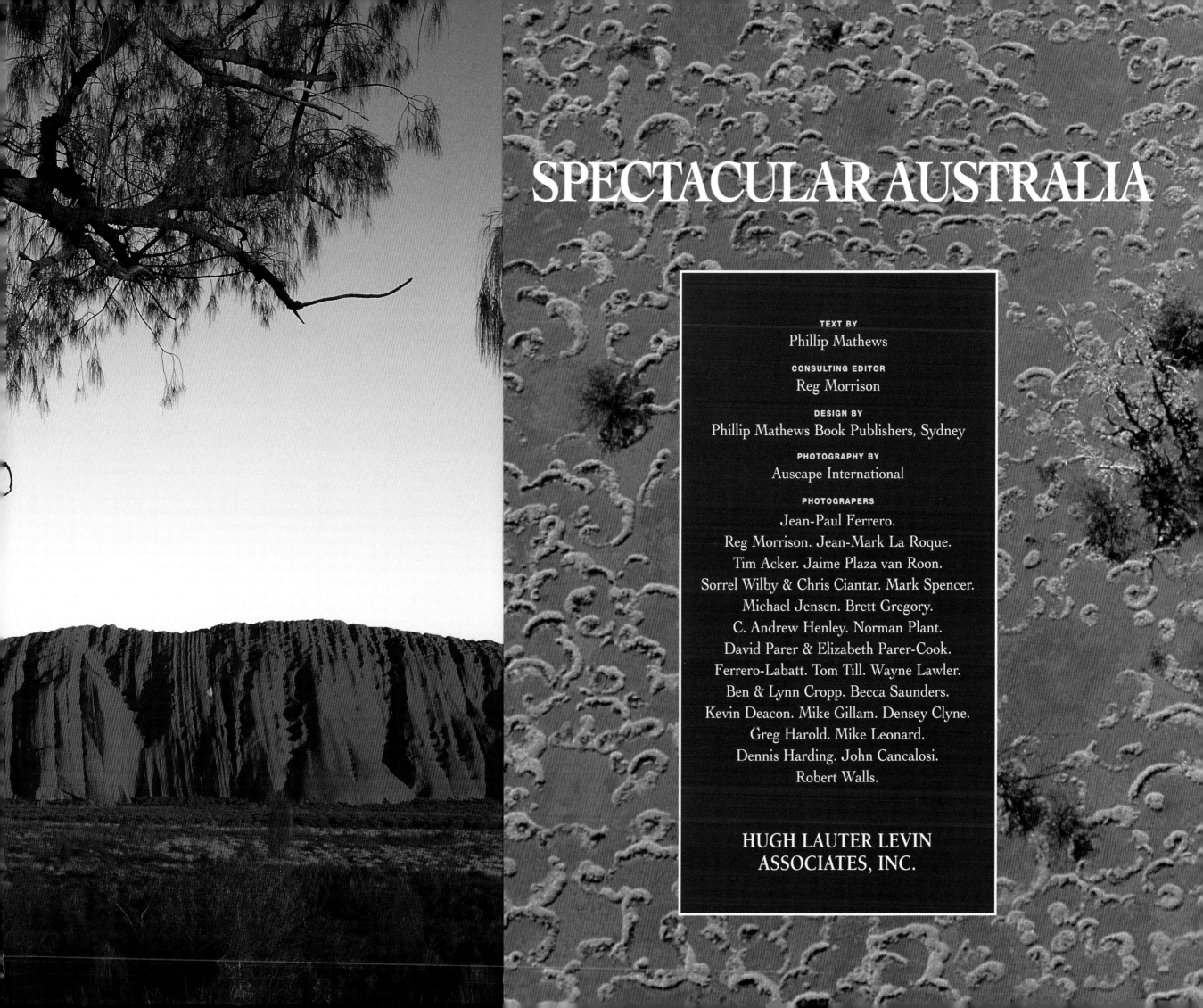

SPECTACULAR AUSTRALIA

TEXT BY
Phillip Mathews

CONSULTING EDITOR
Reg Morrison

DESIGN BY
Phillip Mathews Book Publishers, Sydney

PHOTOGRAPHY BY
Auscape International

PHOTOGRAPERS
Jean-Paul Ferrero.
Reg Morrison. Jean-Mark La Roque.
Tim Acker. Jaime Plaza van Roon.
Sorrel Wilby & Chris Ciantar. Mark Spencer.
Michael Jensen. Brett Gregory.
C. Andrew Henley. Norman Plant.
David Parer & Elizabeth Parer-Cook.
Ferrero-Labatt. Tom Till. Wayne Lawler.
Ben & Lynn Cropp. Becca Saunders.
Kevin Deacon. Mike Gillam. Densey Clyne.
Greg Harold. Mike Leonard.
Dennis Harding. John Cancalosi.
Robert Walls.

**HUGH LAUTER LEVIN
ASSOCIATES, INC.**

CONTENTS

Spectacular Australia was researched, compiled, edited and designed by Phillip Mathews Book Publishers, of Sydney, Australia, for the publisher, Hugh Lauter Levin Associates Inc.

Distributed by Publishers Group West

© 2000 Hugh Lauter Levin Associates, Inc.

© Text : Phillip Mathews

© Photographs : Auscape International, Sydney

© Design : Phillip Mathews Book Publishers Pty Ltd

ISBN 0-88363-846-0

Printed in Hong Kong, bound in China

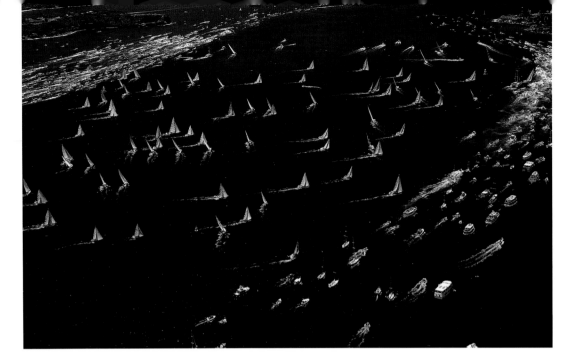

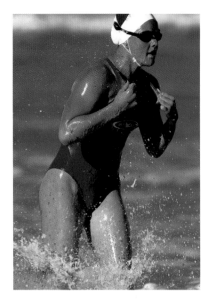

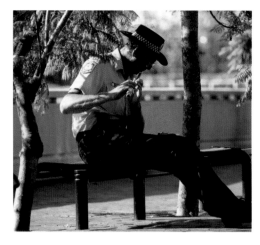

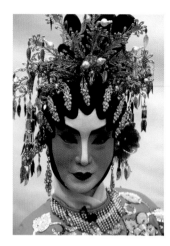

■ ABOVE : Police bandsman,Queensland.
■ LEFT : Surf carnival competitor, Gold Coast.
■ FAR LEFT : The start of the Sydney-Hobart race.

■ Chinese Opera, Sydney

Australia

erra Australis Incognita. For centuries a great unknown southland was presumed to exist to counterbalance the mass of the then known world, largely in the northern hemisphere. If it did not, so thinkers reasoned, the earth would surely wobble on its axis. Though its size and precise whereabouts remained unknown, romantics evoked a southern paradise. In the end, European discovery was by chance.

The Spanish nearly found it in 1606 when Luis de Torres sailed through the straits that are named for him. A decade later, the Dutch spotted the west coast while plotting a quicker route across the Indian Ocean to the spices of the East Indies (Indonesia). The first Englishmen to sight it took their discovery to the grave, when the *Tryall* foundered on west coast reefs in 1622. By 1642, the bold Dutchman Abel Tasman had ventured as far as the south coast of Tasmania and, in 1688–9, English buccaneer explorer William Dampier landed in the northwest of the continent long enough to form a sour impression.

The breadth of the continent remained a mystery until 1770, when the bluff-bowed *Endeavour* of 93 feet closed on the east coast of Australia. Her master, the brilliant British navigator Captain James Cook, had been conducting a scientific expedition in the south Pacific, but among his orders was an instruction to find *Terra Icognita* and claim it, or any useful part, for the Crown.

Cook landed at Botany Bay with the influential botanist Joseph Banks, who made the first serious record of the flora, fauna and native people of Australia, which was to have unimagined consequences. Cook then headed north, charting the coast

as he went, and claiming eastern Australia for Britain, naming it New South Wales.

The Aborigines first arrived from southern Asia between 50,000 and 84,000 years ago, long before rising sea levels isolated them by flooding land bridges in the northern archipelagos. Their history is lost in time, though we know that Australia had a more inviting climate and bigger game before the last ice age, some 20,000 years ago, which desiccated the continent to its recognisable state.

By the time the British arrived there were at least 300,000 Aborigines scattered across the continent in loosely knit groups, speaking 300 languages and many more dialects. Nomadic hunter-gatherers of primitive technology, they used fire cleverly, not just to flush out game, but to regenerate bushlands. Permanent dwellings were extremely rare and perfunctory, and they used no beasts of burden. Herds or crops were unknown. The only animal they kept was the Dingo, or wild dog, believed to have arrived in the last 5,000 years.

There were neither chiefs nor temples. Their culture was in the hands and minds of tribal elders, and a mystical belief system known as the Dreaming, which bound them and all creatures to the land. The only records, however, were living memory and rock paintings. Like moving shadows in their vast landscape, they prevailed in even the harshest regions with astonishing bushcraft, particularly the desert dwellers.

Only Cook among those earliest seafarers envied their freedom from materialism. Yet their nomadic ways and the absence of a leadership with which to

treaty—unlike the structured Maori nation in New Zealand—led to the absurd assumption at law that the continent was *Terra Nullius* (uninhabited), which was to render the Aborigines landless in their own landscape for more than 200 years.

When the American colonies won their independence, British convicts could no longer be transported there as indentured labour. Soon prison hulks, commissioned to relieve overflowing British jails, were groaning at the gunwales, fed inexorably by a legal system with some 100 crimes punishable by death, including property crimes. Britain needed a penal colony and the influential Banks lobbied for Botany Bay. A strategic presence on the southern continent seemed propitious too, Dutch and French intentions ever a concern.

The First Fleet was assembled by Captain Arthur Phillip, a man of admirable leadership, who was to be the colony's first governor. The 11 vessels included two warships, six convict transports and three store ships. The full complement of some 1,400 men, women and children, included about 800 convicts, of whom 192 were women, the balance being sailors, marines and their families.

After a gruelling 15,000 nautical mile voyage of 250 days, Phillip had reason for satisfaction. When the fleet limped into Botany Bay on January 18 and 20, 1788, no ship had been lost and the 48 deaths *en route* were modest by prevailing standards. But bitter disappointment followed. Botany Bay was hopelessly barren: sandy soil, lifeless grassland, and mangrove flats, and the only spring a trickle.

Cook had noted a promising entrance flanked by forbidding cliffs some 11 sea miles north, which he

had named Port Jackson but not approached. Thus it fell to the desperate Phillip, reconnoitering in a cutter, to discover not only the best natural harbour on the continent within days of his bitter landfall, but "the finest in the world in which a thousand sail of the line may ride in the most perfect security". Better known today as Sydney Harbour, few could quibble with Phillip's first impression. In Sydney Cove he found a deep water landing, a reliable spring, and hope.

Phillip's resentful felons and their reluctant military jailers were utterly ill-equipped to pioneer any land, let alone one so brutally alien to them. Hardwood eucalypts blunted saws and broke axes. Meagre soils were unyielding to scattered grain, and livestock disappeared into the bush or were speared. They found no obvious bush food to supplement their diet (80 per cent of Australia's 28,000 plant species have never been found elsewhere). Kookaburras "laughed" rather than sang, kangaroos hopped rather than galloped. Sharks lurked in the harbour, and snakes ashore. Those who strayed into the bush risked a lingering death from thirst or sudden death by spearing. The colony began to starve.

Though frail, Phillip had the steel for his task. He dispatched a ship for stores, placed the colony on subsistence rations, and sent out bands to fish and hunt. He reduced the mouths to feed by sending his biggest ship to establish a secondary colony at Norfolk Island, 900 nautical miles northeast.

In time, the relief ship returned (having circled the globe), Norfolk Island became self-sufficient, and when fertile flats were found upriver at Parramatta, he granted small acreages to convicts who had served their time. These "Emancipated" farmers worked

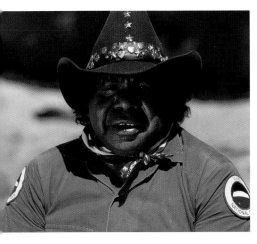

■ Aboriginal Ranger, Central Australia

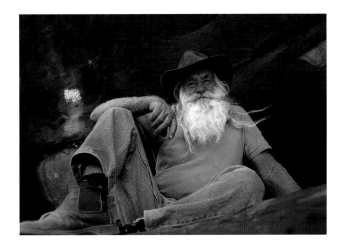

■ Camel driver, South Australia

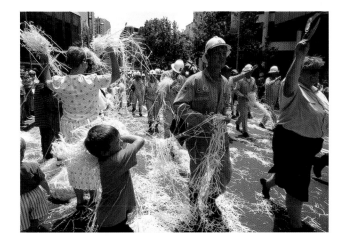

■ Sydney salutes its volunteer bush fire fighters
■ RIGHT : The Sydney-to-Surf annual marathon

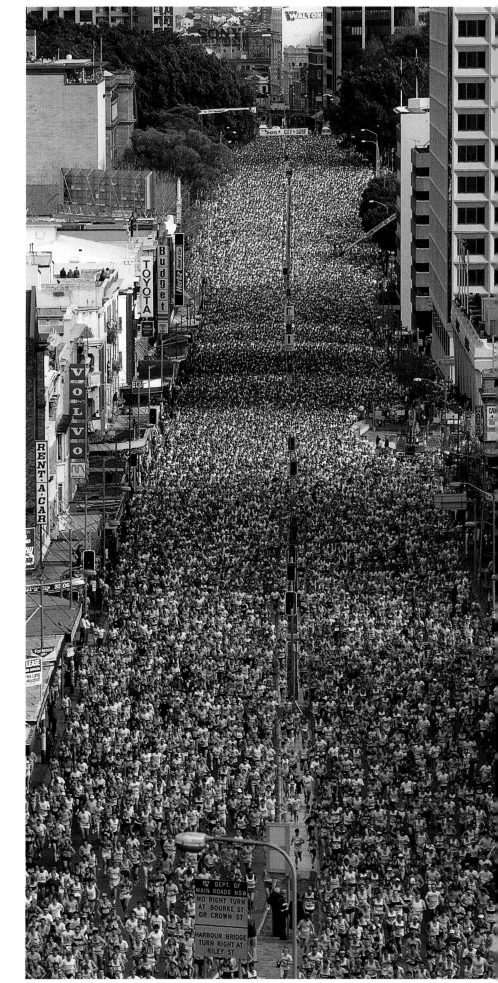

with new-found will. Gradually the prospect of starvation receded.

Phillip also extended his hand to the Aborigines, as was his brief from the British Government, punishing convicts with Aboriginal blood on their hands. But the two cultures shared nothing but competition for land and game. Skirmishes and killings by both sides escalated a conflict that was ultimately settled by disease. Corpses began to appear in numbers around the harbour. The Aborigines of the region, with no resistance to European diseases, were doomed.

Paradoxically, the European settlement gradually grew more robust. When Phillip's tour of duty ended in 1792, the first free immigrants were on their way. The most distant migration in history had began...

Australia today is a wealthy independent nation astride an island continent about the size of the U.S., minus Alaska. Its population of almost 20 million is growing at about one per cent, though not in the interior. Indeed, Australia is one of the most urban of nations, with more than 85 per cent living in coastal cities, the vast majority in Sydney, Melbourne and Brisbane, in the eastern States. Australia has always felt uneasy about its vast emptiness, with neighbouring Asia so densely populated. Yet the comparison is flawed. This is a parched, flat land of thin soils, one third of which is desert and more is semi-desert. Only the antarctic is drier. The only substantial mainland river system, the Murray-Darling, which flows through the eastern region, is already strained. It supports a third of Australia's agriculture production, including half its sheep and crops and a quarter of the beef and dairy herds. Vast pastoral areas

of the hinterland depend entirely on artesian (underground) water. A sustainable population and potable water are problematic national issues yet to be resolved.

Nevertheless, Australians became so skilled at farming light, arid soils, on a necessarily vast scale—more than 460 million hectares or 1,138 million acres at present—that they created one of the world's significant food bowls. The nation's fortunes "rode on the sheep's back" for generations, but it also profits from its now highly-diversified crops and herds.

The rural sector employs only 420,000 people, yet the gross value of agricultural production, despite periodic droughts, exceeds $25,000 million, primarily for export.

The clamourous Gold Rush of the 1850s exposed the most spectacular of the continent's mineral riches, but substantial reserves of iron ore, zinc, copper, bauxite (alumina), and uranium, among many others, followed. Minerals are the biggest contributor to nonrural exports, which exceed $57,000 million. Vast reserves of natural gas, coal, and more limited oilfields help reinforce the strong economy.

The success of Australia's primary industries had an unforeseen cost. More than half of Australia's native forests have been cleared since first settlement, a major cause of salination and erosion. Forests now cover only five per cent of the continent, though a wiser Australia is struggling to redress this with huge replanting programmes, if some believe this falls short of the task.

Australia's native animal species include an estimated 2,240 marsupials, of which 48 species are kangaroo-like animals, 540 birds, 530 reptiles, the bats

and dingoes, and the most bizarre of them all, two monotremes—the duck-billed platypus and the spiny echidna— the only animals on earth to lay eggs *and* suckle their young.

Few Australian animals pose any threat to man, though the first settlers fears were not entirely irrational. The fierce snake, the taipan and the tiger snake are amongst the most venomous anywhere, and sharks *still* loom large in the Australian nightmare. Of 350 species in Australian waters, the tiger shark and the white pointer are the most feared. Yet less than 200 of some 500 attacks since first settlement have been fatal. Australians are more likely to be killed by lightning or a bee sting. Saltwater crocodiles of the northern regions are certainly dangerous, as are the near invisible box jellyfish. Yet introduced animals are a much more tangible threat. The rabbit, cane toad and carp all reached plague proportions largely *because* there were no native predators to stop them. Feral pigs, cats and foxes have also wreaked havoc amongst vulnerable native wildlife.

Australians enjoy relative comfort. Generally kind weather and an outdoors lifestyle has helped, as has security and political stability. Their egalitarian outlook has blurred class distinctions and the tolerance implicit in the Australian "fair go" has forged a remarkably homogenous though immigrant nation, in which 20 per cent of today's population were born overseas. A century of nationhood, declared in 1901, has eased the tether of their European origins. Australians are now self-assured in their geographic isolation, more conscious of their region and more imbedded in their unique landscape. ■

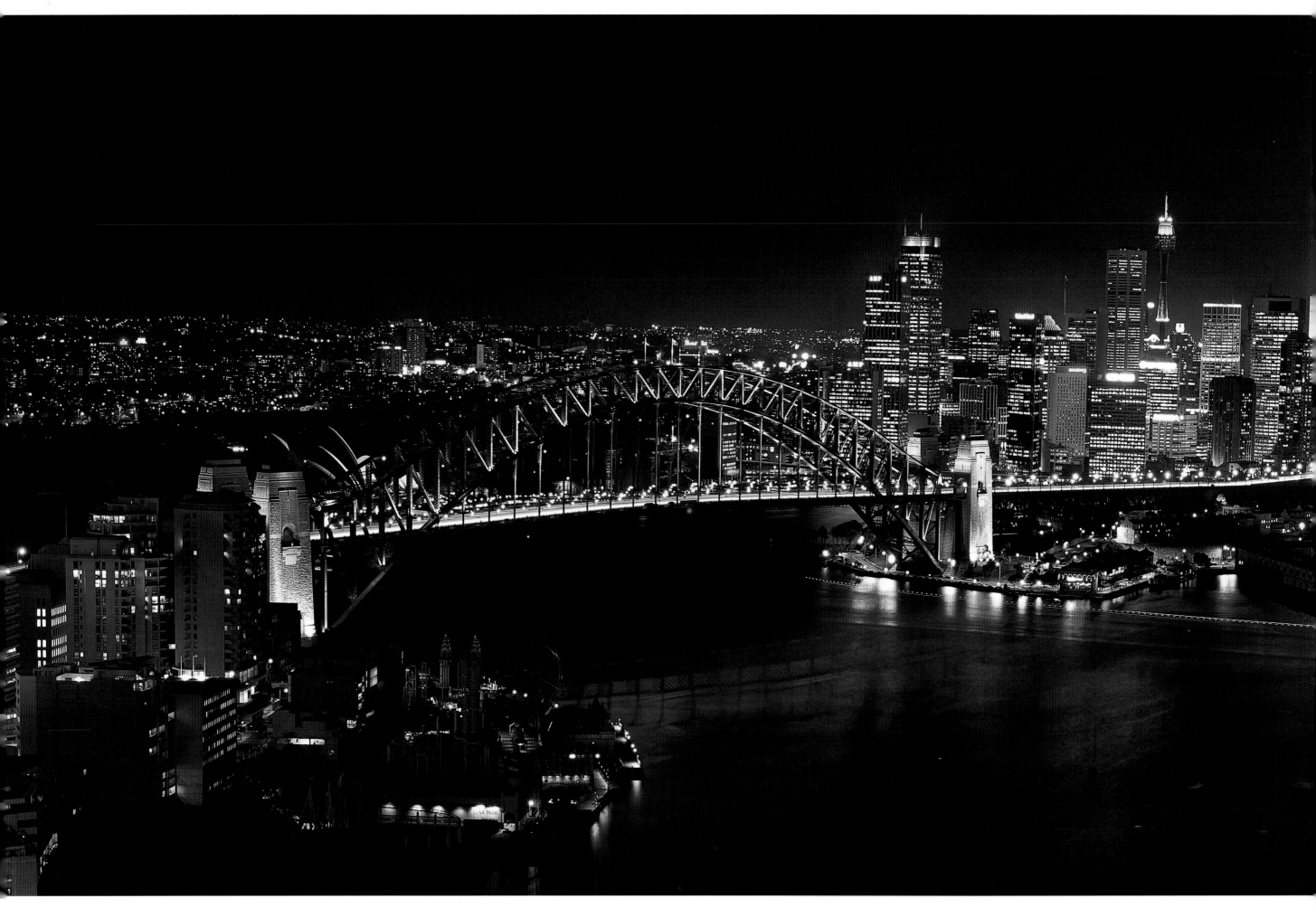

New South Wales

From its subtropical north to the more temperate south, the variety of scenery in New South Wales verges on the sublime. Certainly the mix is richer than any other State: from snowfields to semi-deserts, boisterous surf beaches to rolling rural landscapes, industrial cities to one-horse sidings. To the west lie the unforgiving, dusty red flats of the far Western Plains; to the east, some 700 kilometres (435 miles) offshore, is a shimmering dot that hints of paradise, lush Lord Howe Island.

Sydney, the State capital, is Australia's biggest, most vibrant, and arguably its most beautiful city. Agglomerated around a superb harbour, its foreshores stretch 250 kilometres (155 miles) in a string of delightful bays, coves and promontories. Large stretches of the foreshores are protected national parks, others are residential, built to the waters edge. Remarkably little of the harbour is industrial. From there, the city spreads, often recklessly, along its score of sparkling surf beaches, of which Bondi and Manly are the most prized, then westward to the Blue Mountains. The Central Business District, however, flanked by Circular Quay, the historic Rocks area, and the parks of the Domain and Botanical Gardens, reaches skyward.

The city has also grown in social complexity, sophistication, wealth and stature over 200 years. Largely Anglo-Celtic, Sydney is nevertheless remarkably multiracial. This has enriched a local culture that is as easygoing as a bustling city with a slightly larrikin edge allows. Kind weather, an outdoors lifestyle, and the recreational space to enjoy it helps. As does civic pride: "The Coat-hanger" (Sydney Harbour Bridge) and the incomparable Sydney Opera House are national icons. Add the imposing arenas for the 2000 Olympics, and the city has almost an embarrassment of civic riches, not to mention self-assurance!

Rival States often challenge NSW's pre-eminence in the Australian firmament, but more in jibe than substance. NSW once encompassed more than half the continent before being whittled to 800,000 square kilometres (300,000 square miles) as other colonies, then States and Territories, became established. Yet it remained the most populous, powerful and diverse. Most of NSW's population, including 3.5 million Sydneysiders, still cling to the lowland coastal belt that faces the vast Pacific; sail due east from Sydney and the first landfall is Chile, 11,000 kilometres (6,800 miles) away.

The older settlements were inclined to British nomenclature, but mellifluous Aboriginal place names now proliferate, particularly inland, such as Wagga Wagga, Wee Waa, Coonabarabran, and Wallerawang.

Behind the State's coastal strip stand the ramparts of the Great Dividing Range. Though pioneers found its steep eastern escarpment a formidable barrier, this is no mountain range. The Great Divide is an unbroken series of plateaux, some 50 to 160 kilometres (30–100 miles) wide, running almost the length of eastern Australia, from Cape York in Queensland, through New South Wales, and across the Victorian border. Its tablelands rarely exceed 1,000 metres (2,700 feet), and are often half that. Notable exceptions are the Snowy Mountains in the southwest of the State, the pinnacle of which is 2,228-metre (7,300-foot) Mount Kosciusko, the continent's highest peak. The Australian Alps, which include the "Snowies", are less than half the height of the European Alps, yet they boast bigger snowfields than Switzerland, if rather less challenging!

The western slopes of the Great Divide's tablelands flatten on to the parched Western Plains, which receive less than 200mm (8 inches) of rainfall annually. This is hard pastoral country, redeemed by pockets of rich mineral deposits, particularly lead, zinc, silver and copper in the far west. Mining built the western border city of Broken Hill, and the huge Australian company that bears its name, BHP.

The southern tail of the Great Divide tends westward at the Victorian border, where it cradles Australia's most crucial river system. There, the "Mighty" Murray River, which rises in the Australian Alps, is fed by the Darling, Murrumbidgee, Lachlan, Macquarie and Namoi inland rivers. The rich alluvial soils they have deposited in the broad basin known as the Riverina, underpin the most prolific agricultural region on the continent, producing high-yield grain crops and fine Merino sheep. And within the Riverina lies the Murrumbidgee Irrigation Area, where more than 100,000 irrigated hectares (250,000 acres) produce rice, fruit, cotton and wine.

NSW has harnessed vast tracts throughout the State for agriculture, with more each year, despite the environmental risks of excessive clearing. On the credit side, national parks have been gazetted in increasing numbers, with laudable historic precedent: in 1879, the Royal National Park, south of Sydney, was only the second in the world to be set aside, after Yellowstone in the U.S.

The Molongolo Valley, which nestles in a natural amphitheatre some 200 kilometres (175 miles) southwest of Sydney, is the site of the national capital, Canberra. Though geographically within NSW, Canberra stands in an autonomous enclave designated the Australian Capital Territory. [The territory was isolated largely to assuage fears within the federation that any host State might gain undue influence in national affairs.] Self-consciously picturesque, Canberra is clearly purpose-built, but imaginatively planned by American architect Walter Burley Griffin. Established in the last century, it has become a showplace for town planning. Bold, somewhat monumental architecture creates a theme of national aplomb: the National Library, High Court of Australia, and the Australian War Memorial, among many. The city is set around an elegantly landscaped ornamental lake, but the focal point is the new Parliament house, sunken into Capital Hill, the only modern Australian building that might be compared with Sydney's Opera House. ■

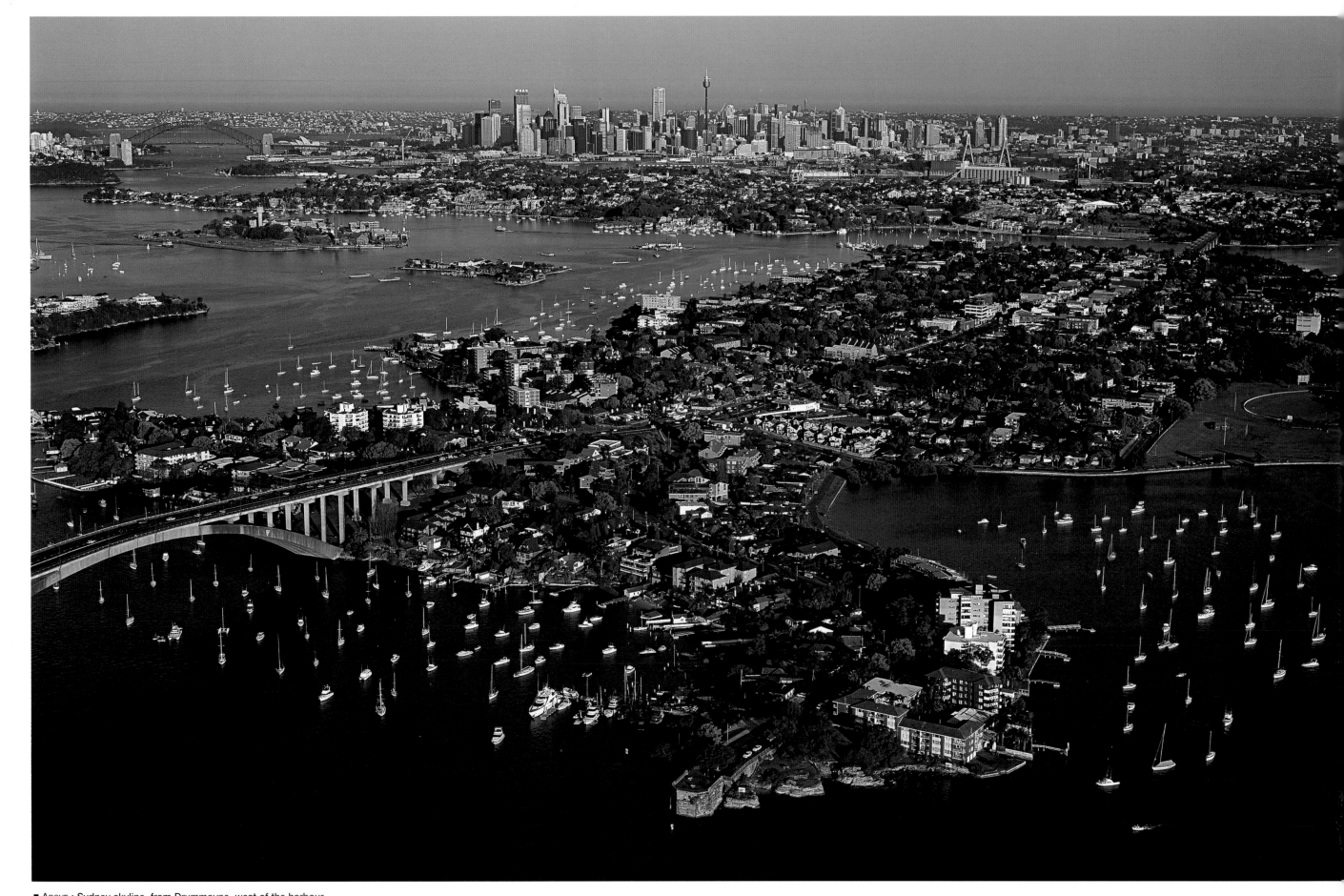

■ Above : **Sydney skyline, from Drummoyne, west of the harbour**
Sydney's splendid natural harbour covers nearly 50 square kilometres
(20 square miles). Its foreshores — an irregular chain of coves, bays
and promontories—extends some 250 kilometres (156 miles).

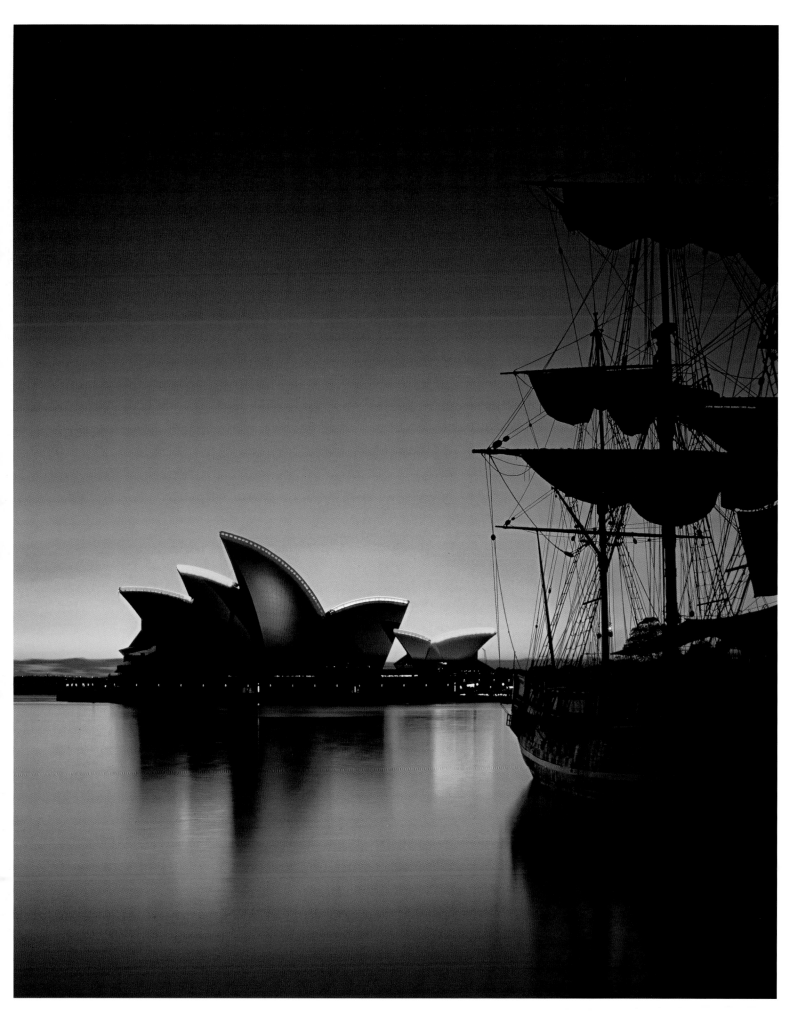

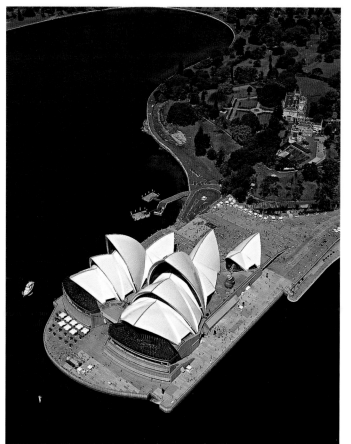

■ ABOVE : The start of the City-to-Surf
Tens of thousands of Sydneysiders compete in
the annual 13 kilometre (8 mile) City-to-Surf fun
run. If the front runners are fiercely competitive,
most aspire only to a "personal best" time.
Others jog or just walk, often in zany costumes.

■ LEFT & FAR LEFT: The Sydney Opera House
An architectural wonder of the world and
Australia's most treasured building, the Sydney
Opera House soars above Bennelong Point,
the complex curves of its splendid, cream-tiled
roofs like surreal sails stretched taut by a fair
wind. Danish architect Joern Utzon's great gift,
which tragically he never completed, is the
aesthetic crown of the great natural harbour
that characterises Australia's biggest city. The
Opera House took 16 years to complete
(1973), pushing modern architecture and
engineering to new levels with brilliant original
thinking. Its costs blew out from an estimated
$7 million to $102 million, shaking governments
before a quintessentially Australian financial
solution was found—the Sydney Opera House
Lottery! Sociologists have long berated
Australians for being the most profligate
gamblers on earth, which has its dark side.
At least, or so it is argued, this was a lottery
of richer civic purpose.

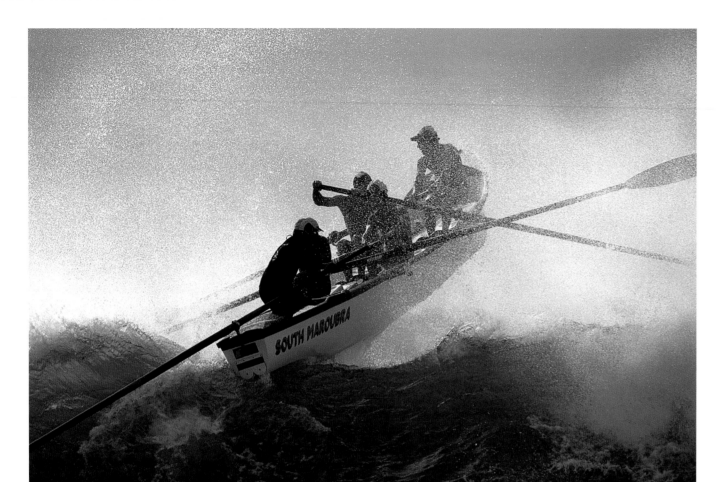

■ LEFT : Surfboat crew, off Mollymook, New South Wales
Inflatable dinghies with powerful outboards have superseded the uniquely Australian surfboat as a rescue craft, but the traditional boats are still raced at the interclub surf lifesaving carnivals, the purpose of which is to hone the fitness, skills and drills of life-savers. No carnival event is more spectacular—or hazardous—than the surfboat race, especially when a big surf is running.

■ BELOW : A giant cuttlefish, Jervis Bay, New South Wales
The clear waters of Jervis Bay, a natural harbour midway between Sydney and Canberra, is a popular destination for divers. Of nearly 30 species of cuttlefish that exist in Australian waters, the biggest grow to more than a metre (3 feet) long.

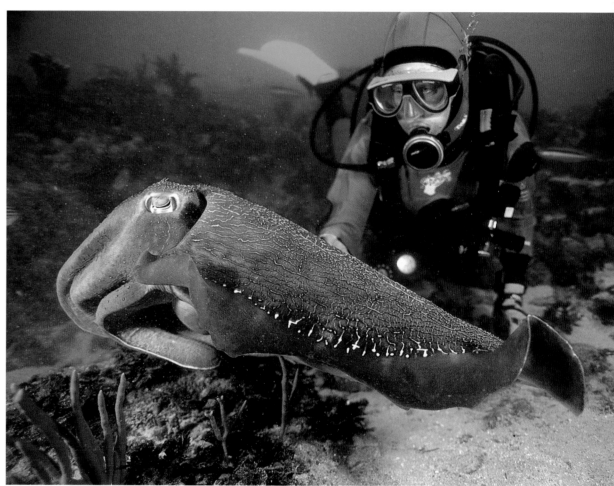

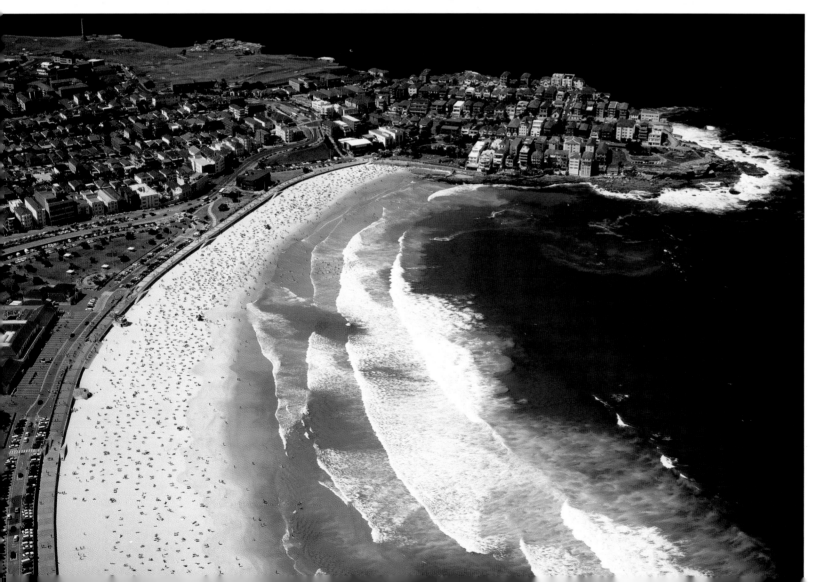

■ LEFT : Summer, Bondi beach, Sydney
The broad sweep of Bondi beach, which attracts droves of Sydneysiders to sunbake or surf, is the best known of more than 20 sandy surf beaches along Sydney's metropolitan seaboard. It is also where Australia's surf lifesaving movement began, when the Bondi Surf Bathers Lifesaving Club was formed there in 1906. This voluntary movement, the first in the world, has since saved countless lives on Australia's surf beach-es. The most dramatic was at Bondi in 1938, when more than 200 bathers were swept suddenly to sea after a sand bank was washed from beneath them by a series of huge waves. All but five of the victims were saved in the biggest mass rescue in the surf lifesaving movement's heroic history.

■ OPPOSITE : Sydney-Hobart race leader clears the Heads
U.S. yacht *Sayonara* leads the fleet out of Sydney Harbour, escorted by spectator boats, the first hurdle in this major inter-national ocean race to Tasmania. Founded in 1956, the start of "The Hobart" each Boxing Day is a gala Sydney event.

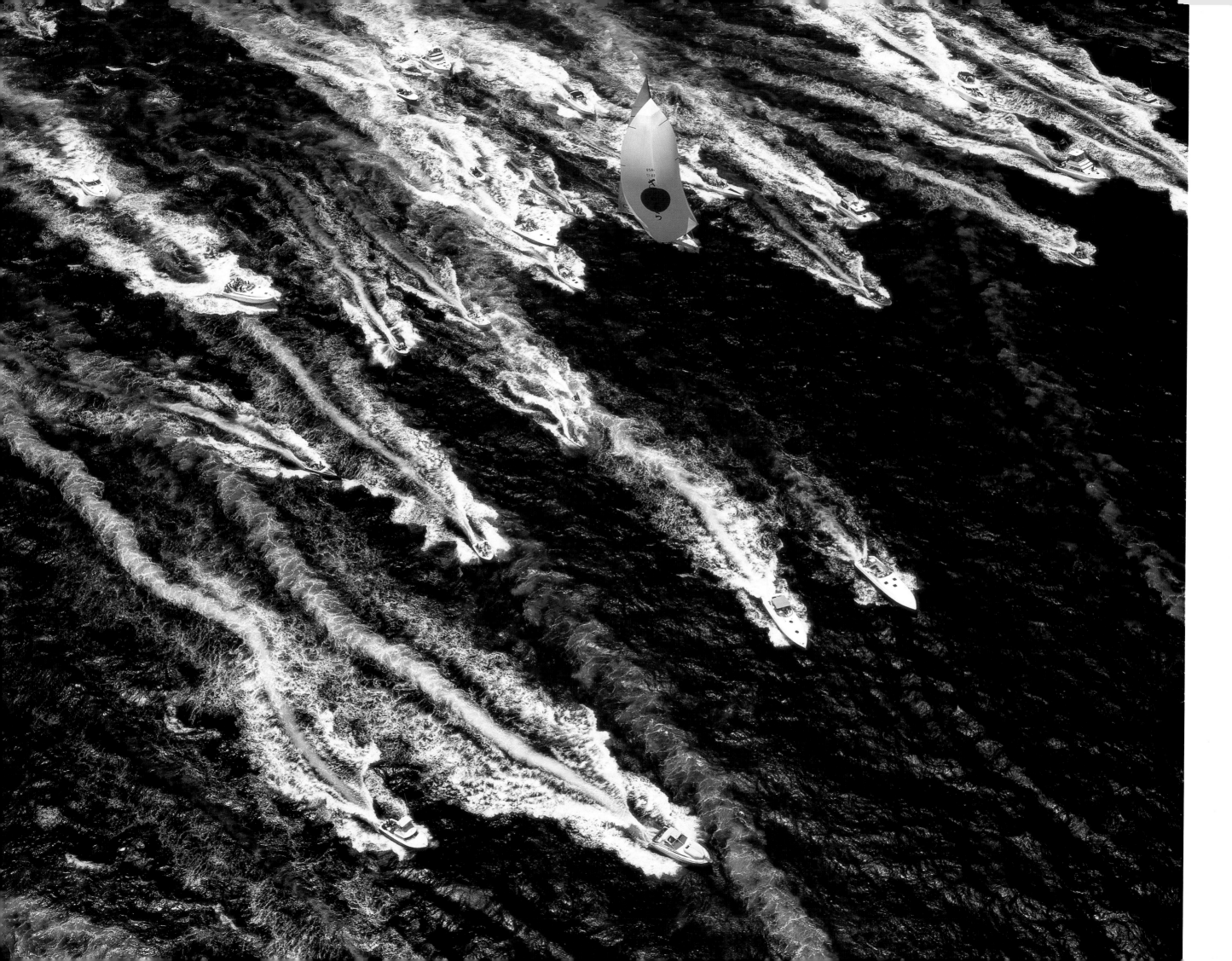

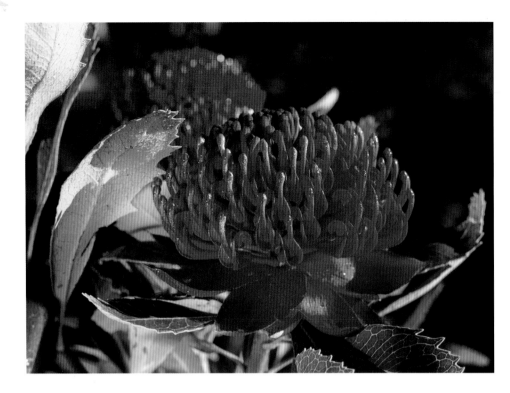

■ ABOVE : Waratah, *Telopea speciosissima*

Perhaps the most spectacular of all Australia's wildflowers, the New South Wales Waratah flaunts its ancient genetic heritage like a banner. Its peculiar structure not only links it to South Africa's protea family, but clearly displays its ancient dependence on relatively large, honey-eating birds for pollination.

■ RIGHT : Dairy Farm, Kangaroo Valley

A dairy farm nestled in the lush folds of Kangaroo Valley some 144 kilometres (90 miles) south of Sydney. The rural character of this region is changing rapidly, however, as increasing numbers of well-to-do city dwellers—"Pitt Street farmers"—buy up small, economically unsustainable blocks of farmland in an attempt to escape the stresses of city life with a hobby farm.

■ BELOW : Vineyard, Mudgee

Mudgee is a rural region, on the Cudgegong River, 255 kilometres (160 miles) northwest of Sydney. Noted for its fine Merino (wool) studs, it is also a small but successful wine region. The main wine region of New South Wales is east of Mudgee, in the Hunter River Valley.

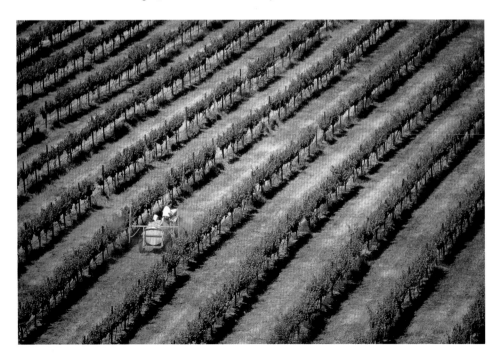

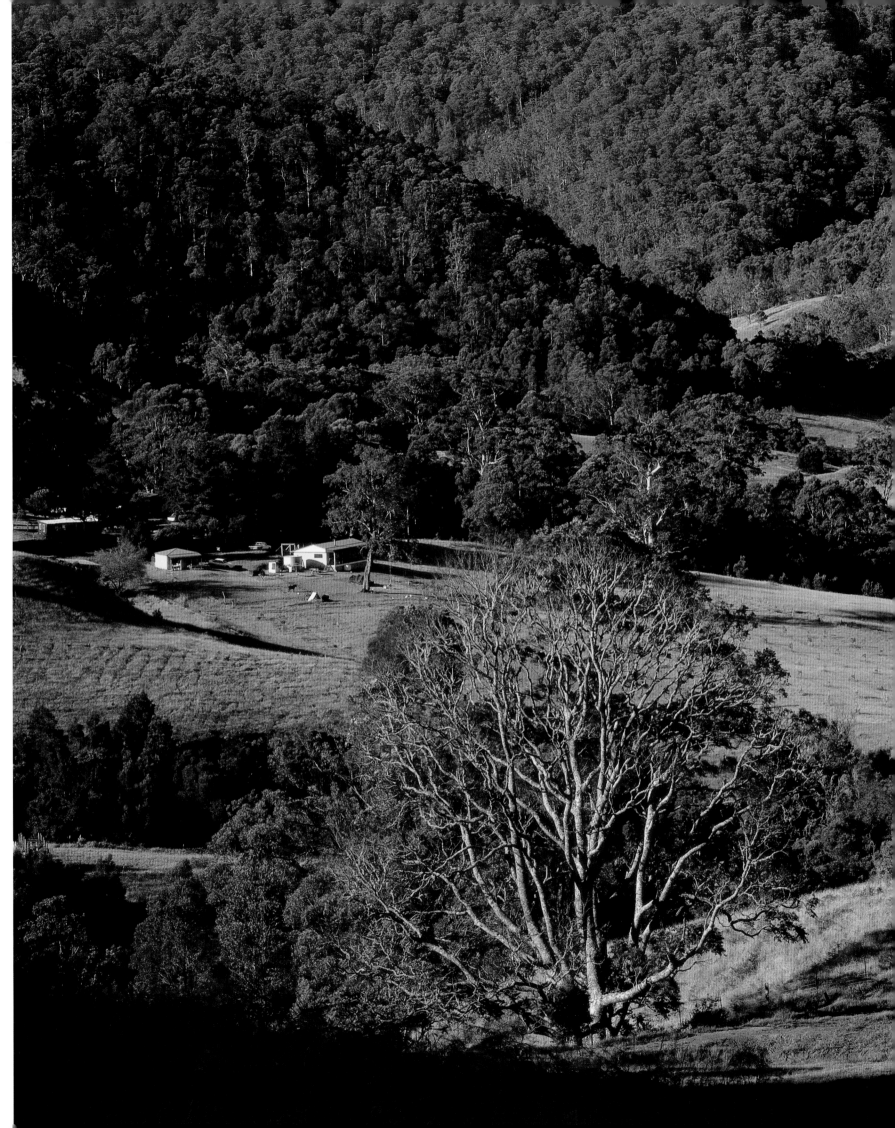

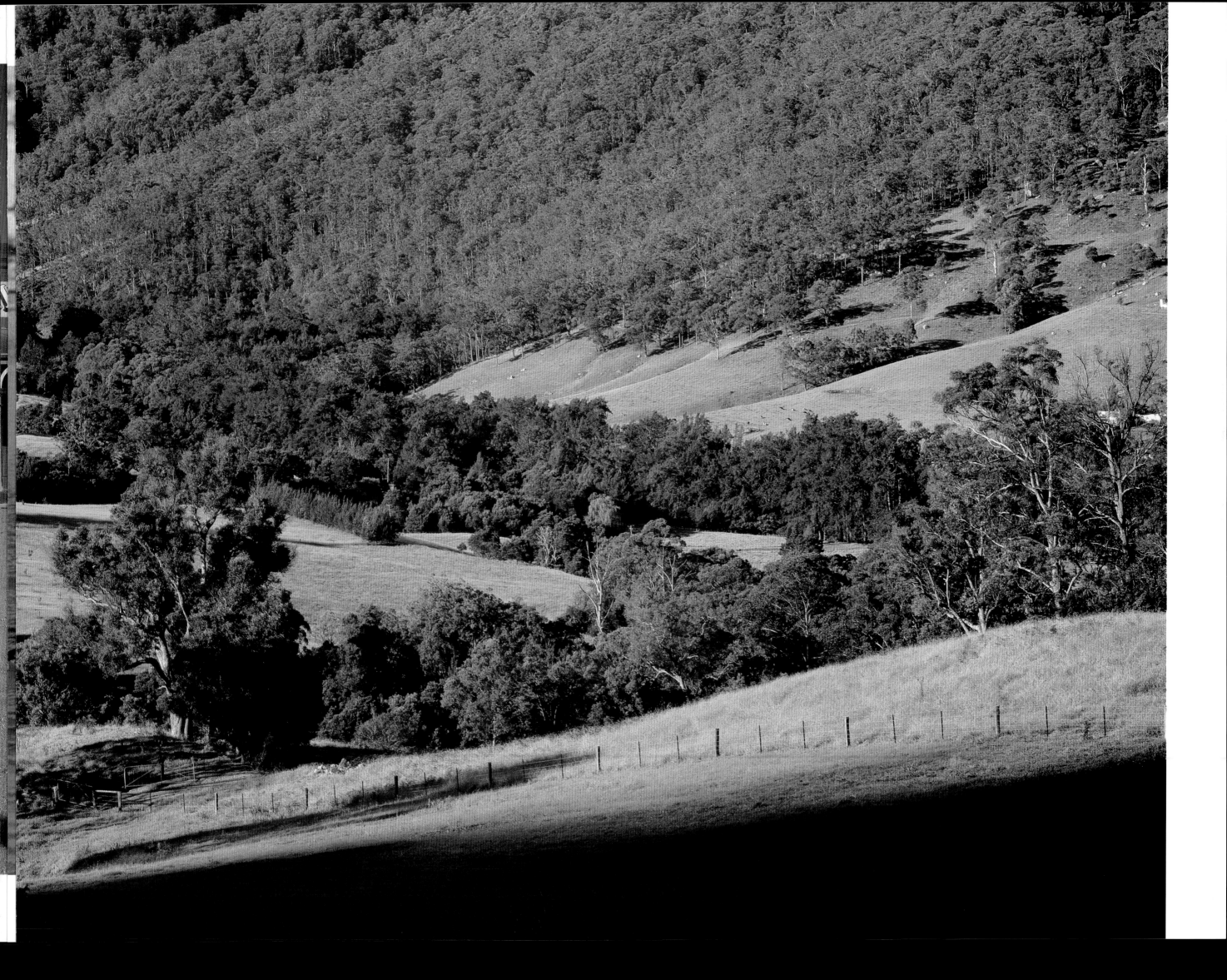

■ RIGHT : A Red Bloodwood, *Corymbia gummifera,* regrows after a bushfire

A feature of many Australian plants is their ability to withstand repeated burning. Specialised growth centres around the trunks and around the bases of many trees may burst into new life whenever the insulating layer of bark is sufficiently scorched. The crimson shoot erupting from this badly burnt Red Bloodwood typifies the process so common among eucalypts.

■ FAR RIGHT : A Strangler Fig, *Ficus watkinsiana,* strangling a Brush Box, *Lophostemon confertus*

Inverting the usual botanical rules, the Strangler Fig typically begins its life in the forest canopy, expend-ing most of its energy in downward growth as its roots race for the ground in search of moisture and nutrients. These adventitious roots gradually envelop and strangle the host tree, which dies and rots inside its fig-root prison. The doomed tree in this picture is a splendid Brush Box.

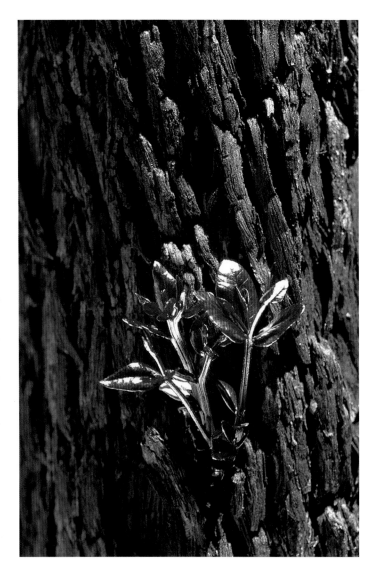

■ RIGHT : Grass trees, *Xanthorrhoea glauca,* Warrumbungle National Park

Known as grass trees because of their foliage, members of the xanthorrhoea family are confined to the Australian continental raft, with all but five of the 75 species growing only on the mainland. They rep-resent an early offshoot of the order that also pro-duced the lily family. Their tolerance of aridity and poor soils enables them to grow best in semi-arid heathland and open forest.

■ OPPOSITE : Mount Lidgbird and Mount Gower, Lord Howe Island

Lying off Australia's east coast, about 700 kilome-tres (435 miles) northeast of Sydney, is a distant part of New South Wales. The crescent-shaped island, volcanic in origin, has a permanent popula-tion of just over 200, dependent largely on tourism. The island is dominated by the twin volcanic peaks of Mount Lidgbird and Mount Gower. A major tourist attraction is a large fish-filled lagoon on its western side which is enclosed by the most southerly of the known coral reefs. The island's most valuable asset, however, is its luxuriant vegetation, one third of which is endemic, including the four species of palm which have been exported around the world as "Kentia" palms.

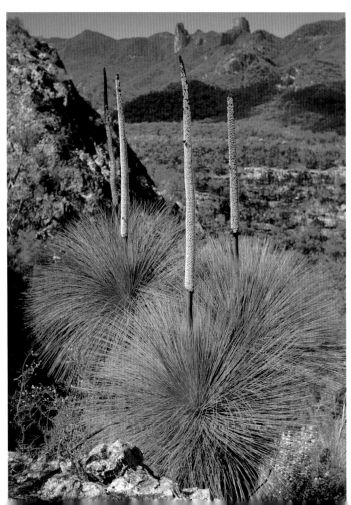

■ RIGHT : Red Kangaroos, *Macropus rufus*

Young male Red Kangaroos frequently spar with each other in preparation for the serious business of some day challenging a mature male for access to breeding females. The largest of the kangaroos, the Reds are highly mobile and semi-nomadic, ranging over most of the inland plains. Perversely, "Big Reds" are not always red, a minority having grey-blue coats like the female of this group. They tend to feed at night, although they may begin in the late afternoon and finish after sunrise. A mature male may weigh over 63 kilograms (140 pounds) and measure 2.4 metres (8 feet) from nose to tail.

■ OPPOSITE : Dingoes, *Canis familiaris*, attack a Lace Monitor, *Varanus varius*

Having surprised a Lace Monitor in an ephemera desert pool in western New South Wales, these two young dingoes were uncertain how to pursue the attack to its natural conclusion. They finally tired of the game and withdrew. The dingo, or Warrigal, which does not bark, is a wild native dog, believed to have arrived in Australia more than 4,000 years ago. They will breed with domestic dogs so readily that it has reached the point at which few pure dingoes remain in southern and eastern Australia.

■ BELOW : Yarding sheep, Wee Jasper, New South Wales

Competition for food between sheep and kangaroos sets the latter at odds with Australian farmers. Kangaroos can decimate pasture and their mobility enables them to range widely. They also control their breeding pattern, reducing it in times of drought, and reproducing in numbers during periods of plenty. Woolgrowers tended to regard them as any other rural vermin, killing them indiscriminately. But times have changed. City people—and Australians are predominantly city people—dominate the political overview, and sympathy for the plight of the national symbol has led to stricter culling regulations in many parts of Australia. Perceptions of the kangaroo meat industry, initially for pet food though increasingly for table game, added emotional fuel to this ongoing debate.

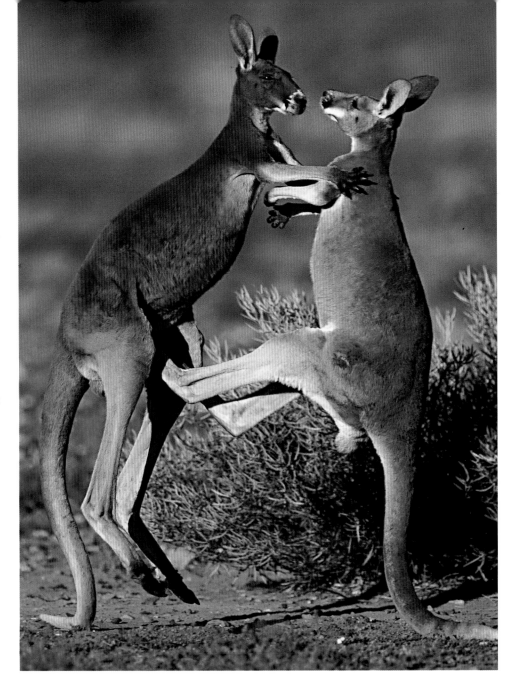

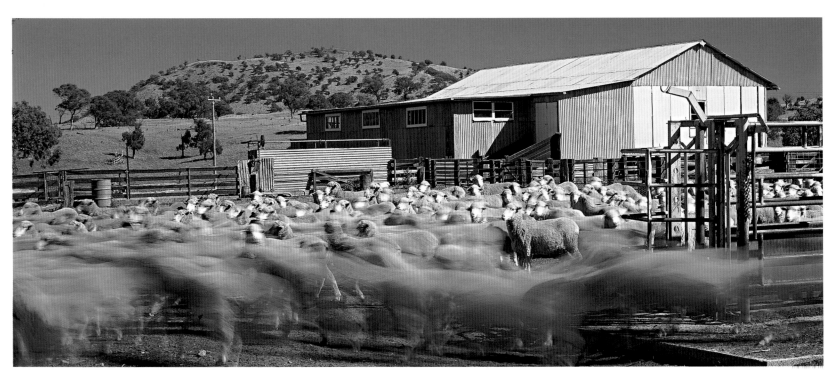

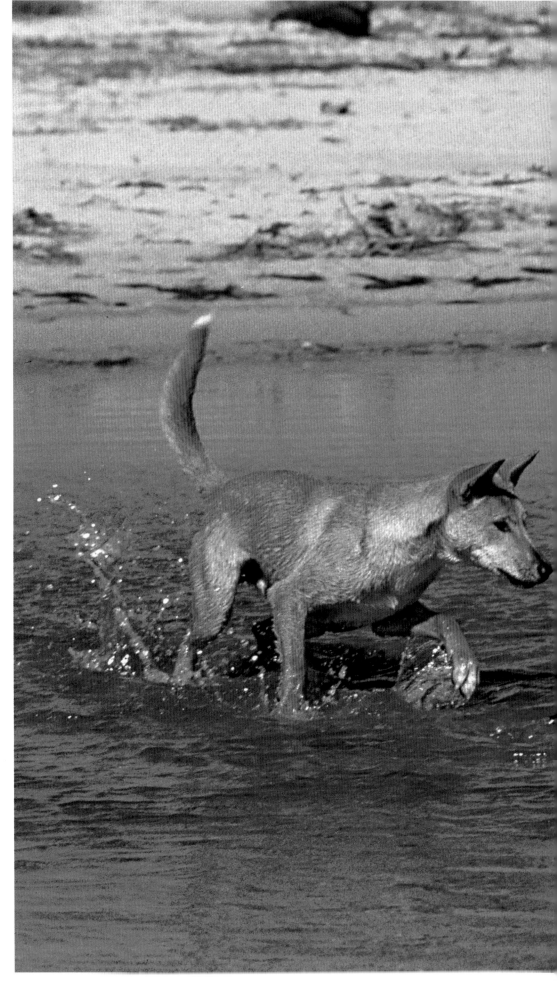

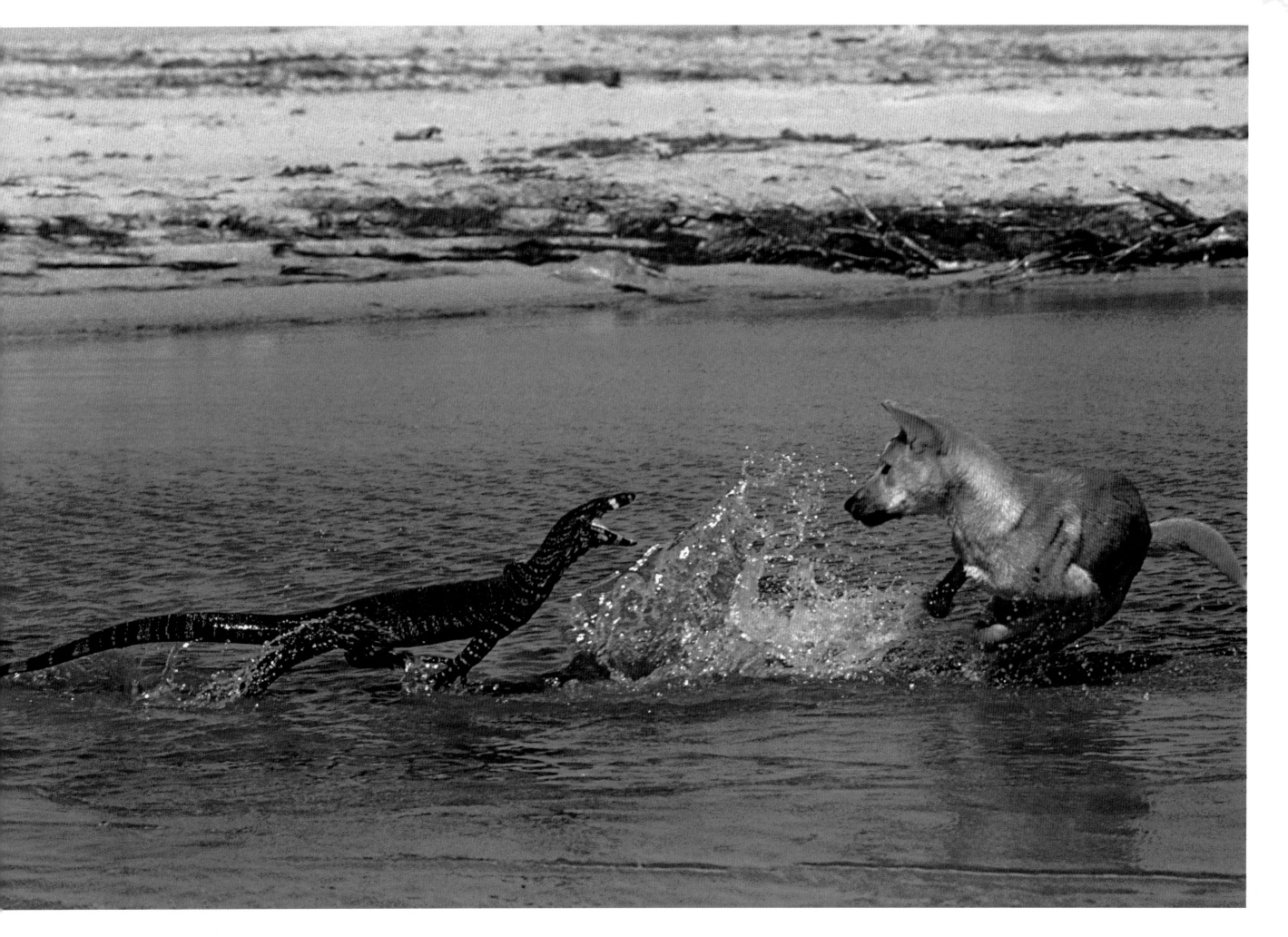

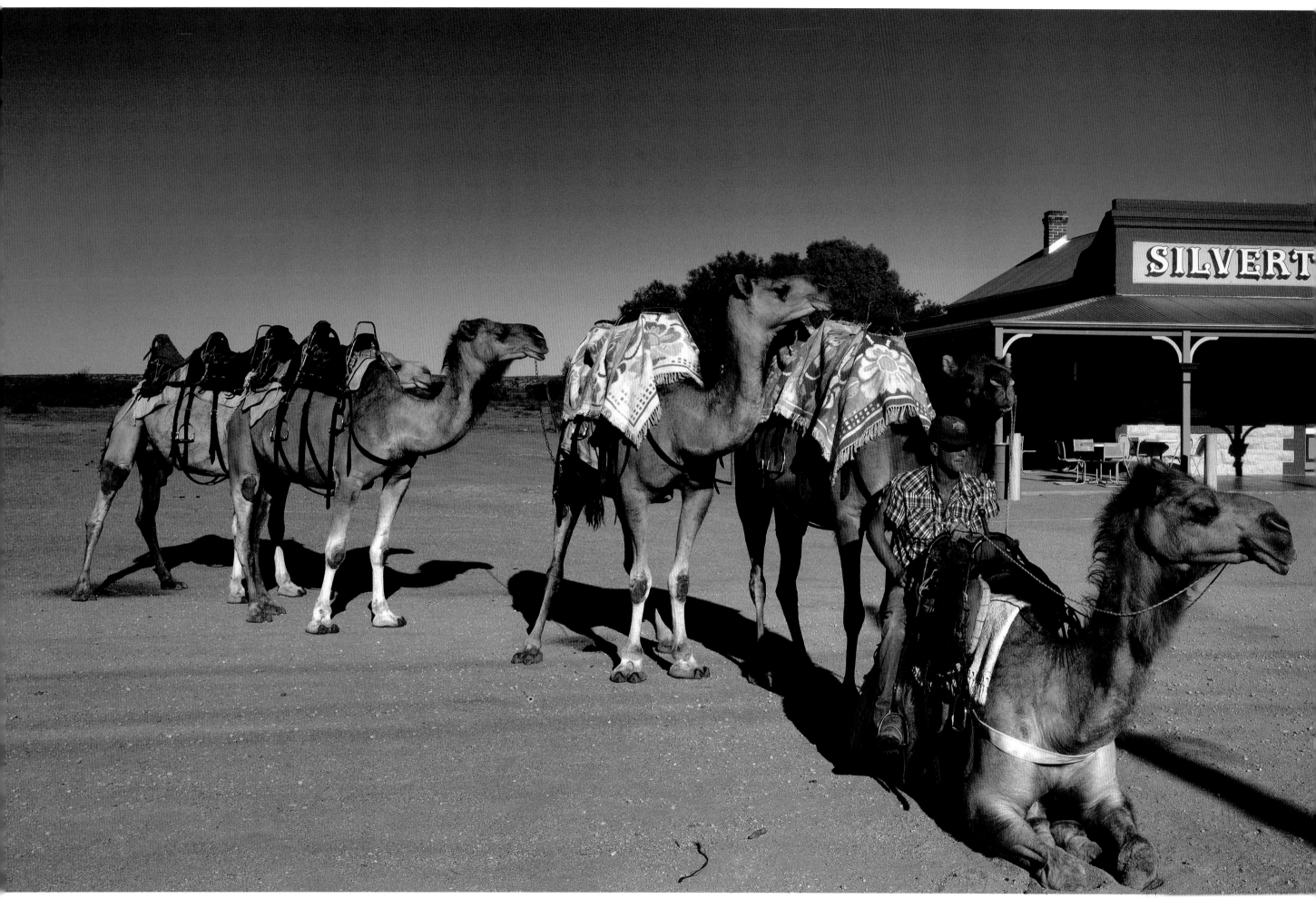

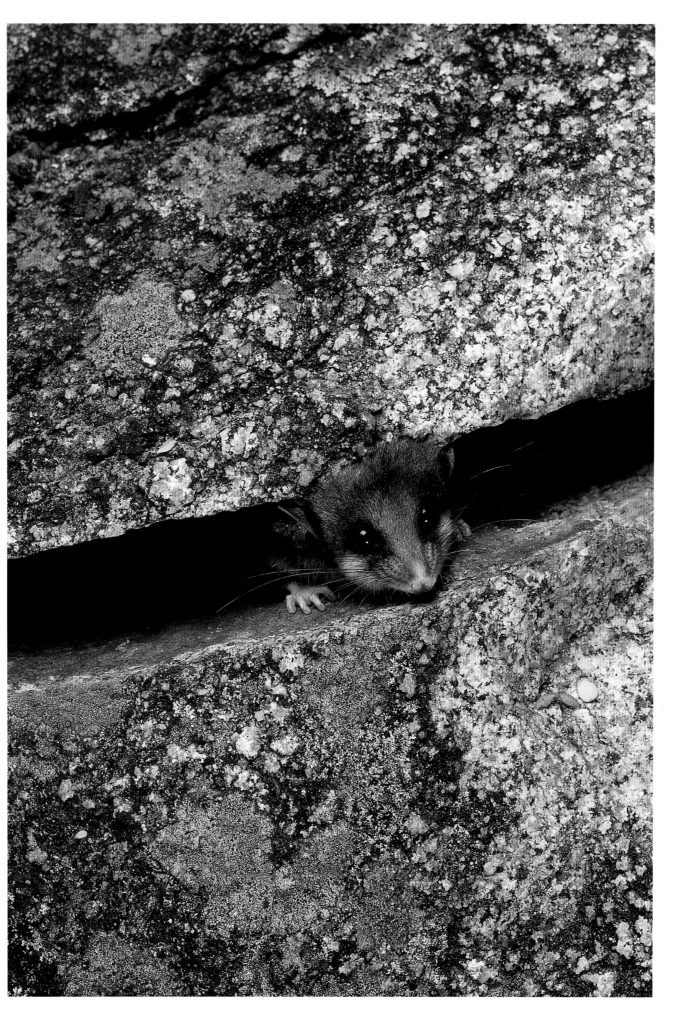

■ LEFT : Mountain Pygmy-possum, *Burramys parvus*

The Mountain Pygmy-possum, discovered in 1966, is the only Australian mammal wholly restricted to alpine and sub-alpine habitats. It survives in two small populations, one in the Victorian Alps, and the other at Mount Kosciusko, in the Snowy Mountains of New South Wales. It lives most of the three winter months beneath the snow cover, entering a state of torpor in periods of extreme cold. In summer it forages for insects and spiders.

■ OPPOSITE : Camels at the Silverton Hotel, western New South Wales

Large numbers of camels were introduced into Australia in the late 19th century and, in the hands of their Afghan camel drivers, they helped open the arid heart of the continent to European settlement. At least 6,000 were in use at the turn of the century. When camels were replaced by motorised transport, many were turned loose, and a large feral population remains today. Outback life has suited camels because they have been spared the diseases that have been a problem with traditional Middle East stock. In fact, so healthy are they that they are now exported back to the lands from which they came over a century ago. Moreover, the growth of tourism in outback regions in the past 30 years has enabled tour operators to reharness some of the feral population for both camel racing and outback safaris.

■ RIGHT : A Red Bloodwood, *Corymbia gummifera,* regrows after a bushfire

A feature of many Australian plants is their ability to withstand repeated burning. Specialised growth centres around the trunks and around the bases of many trees may burst into new life whenever the insulating layer of bark is sufficiently scorched. The crimson shoot erupting from this badly burnt Red Bloodwood typifies the process so common among eucalypts.

■ FAR RIGHT : A Strangler Fig, *Ficus watkinsiana,* strangling a Brush Box, *Lophostemon confertus*

Inverting the usual botanical rules, the Strangler Fig typically begins its life in the forest canopy, expending most of its energy in downward growth as its roots race for the ground in search of moisture and nutrients. These adventitious roots gradually envelop and strangle the host tree, which dies and rots inside its fig-root prison. The doomed tree in this picture is a splendid Brush Box.

■ RIGHT : Grass trees, *Xanthorrhoea glauca,* Warrumbungle National Park

Known as grass trees because of their foliage, members of the xanthorrhoea family are confined to the Australian continental raft, with all but five of the 75 species growing only on the mainland. They represent an early offshoot of the order that also produced the lily family. Their tolerance of aridity and poor soils enables them to grow best in semi-arid heathland and open forest.

■ OPPOSITE : Mount Lidgbird and Mount Gower, Lord Howe Island

Lying off Australia's east coast, about 700 kilometres (435 miles) northeast of Sydney, is a distant part of New South Wales. The crescent-shaped island, volcanic in origin, has a permanent population of just over 200, dependent largely on tourism. The island is dominated by the twin volcanic peaks of Mount Lidgbird and Mount Gower. A major tourist attraction is a large fish-filled lagoon on its western side which is enclosed by the most southerly of the known coral reefs. The island's most valuable asset, however, is its luxuriant vegetation, one third of which is endemic, including the four species of palm which have been exported around the world as "Kentia" palms.

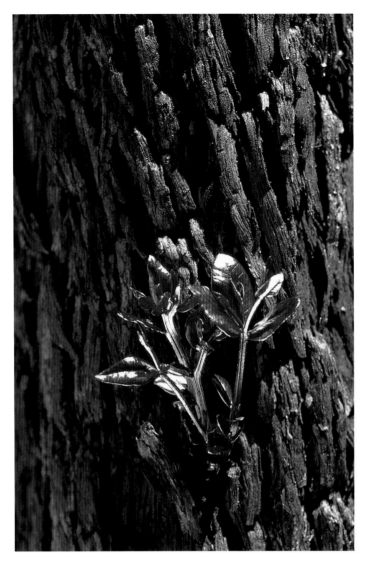

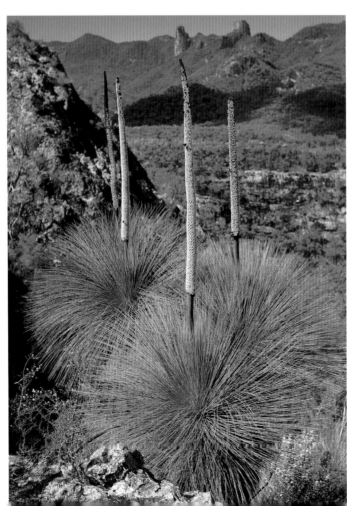

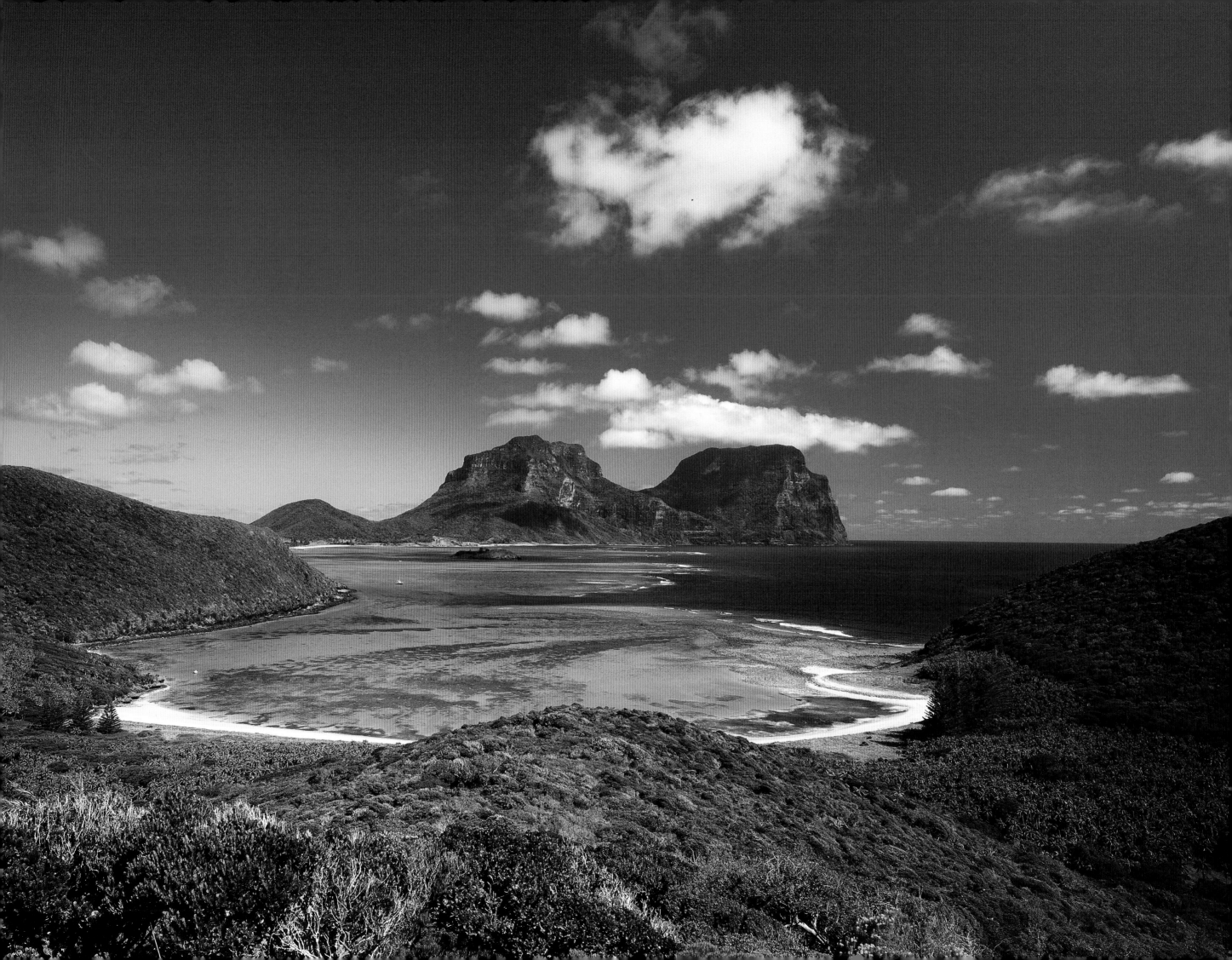

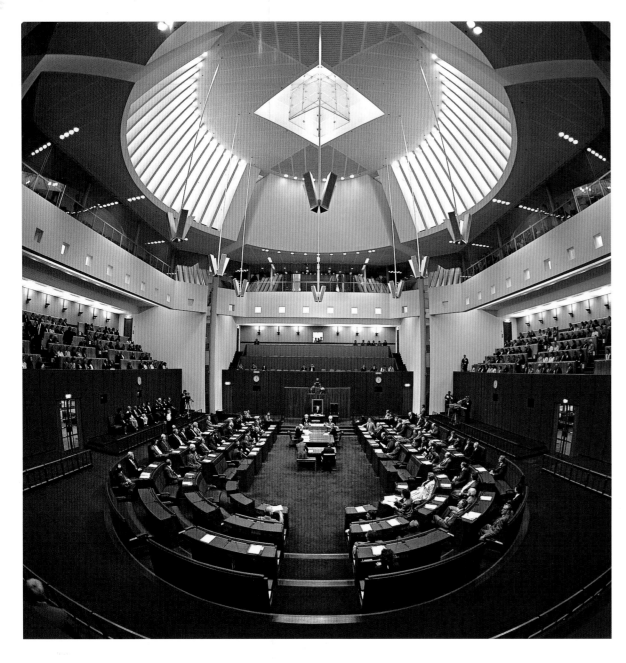

Australian Capital Territory

AUSTRALIA'S capital and seat of government is Canberra. This city of 250,000 people lies in the Molonglo Valley, an undulating stretch of the Australian Capital Territory, which covers a 2,300 square kilometre (900 square miles) highland region on the western slopes of the Great Dividing Range. Though geographically in New South Wales—Canberra is about 250 kilometres (155 miles) from Sydney—the ACT is a separate territory controlled by the Commonwealth Government.

Designed by American architect Walter Burley Griffin, the city is lavishly, decoratively, and precisely planned around a huge ornamental lake that bears his name. Its great modern buildings tend to the monumental, a showpiece for national pride and such institutions as the National Library and

the High Court of Australia. But it is the vast, new Parliament House, above which flies a huge Australian flag, that dominates the city from Capital Hill. Designed by U.S. architects Mitchell/Giugolo with Australian partner Richard Thorp, this lavish billion dollar project was completed in 1988. Of its 4,500 rooms, the most significant are the House of Representatives and the Senate Chamber, the halls of Australia's legislature.

■ Above : The Senate chamber
This is the house of review in which the States are equally represented. The engine room of Australian government is the House of Representatives.

■ Right : Parliament House
The Great Verandah and Ceremonial Pool at the main entrance to Parliament House.

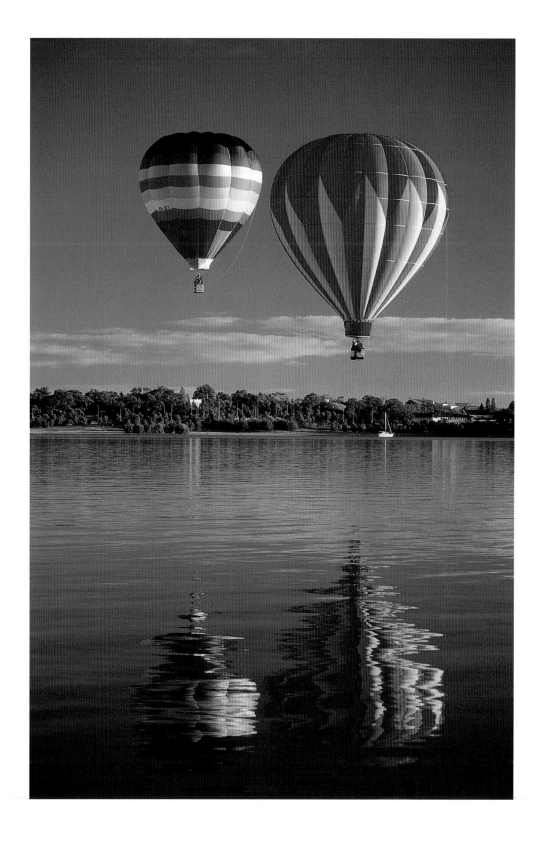

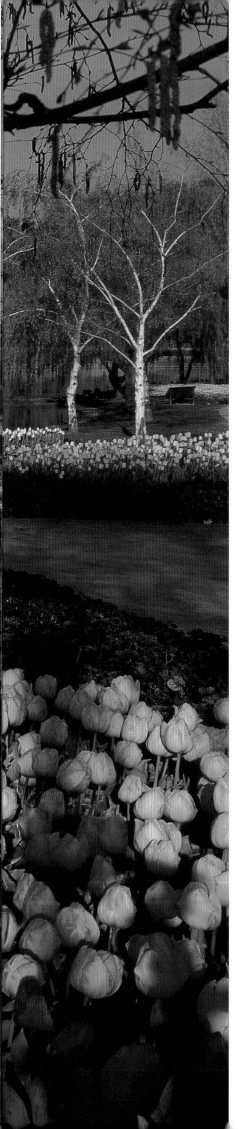

■ ABOVE : **Balloons over Lake Burley Griffin**
This broad ornamental lake, named for the planner of Canberra,
was man-made by damming the Molonglo River.

■ RIGHT : **Canberra's Floriade Festival**
The national capitol is a riot of floral colour each spring during the
Floriade Festival.

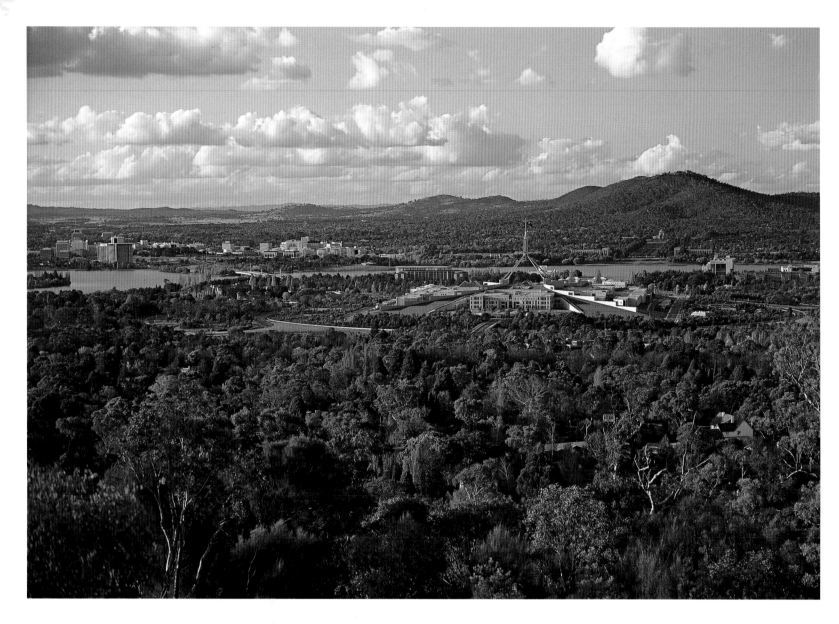

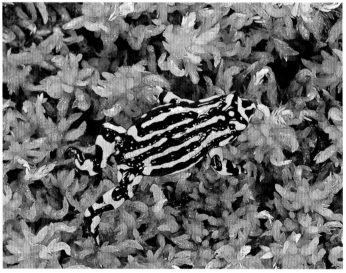

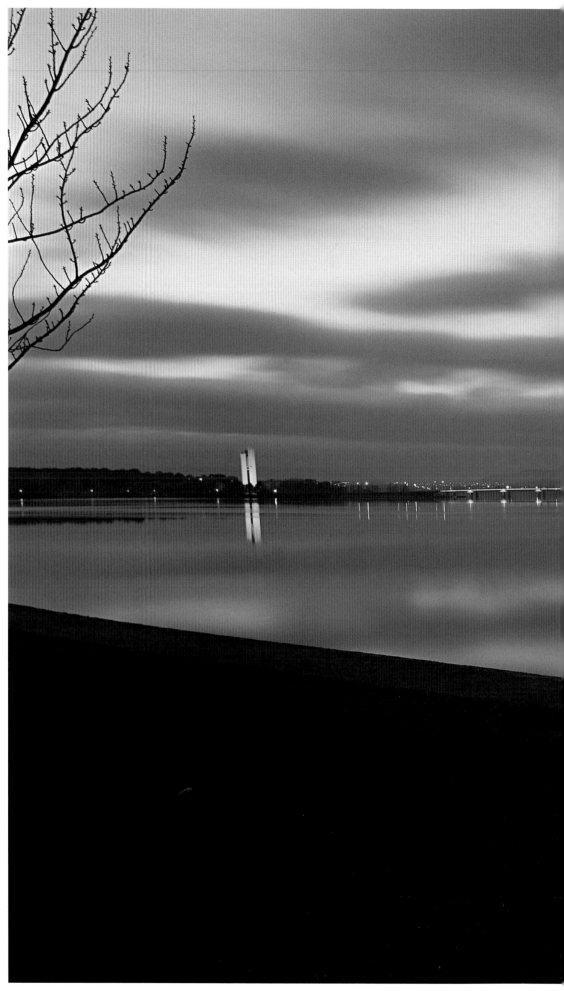

■ ABOVE : **Autumn, Canberra.**

Autumn in Canberra is more richly recognisable than in any other Australian city. Of the millions of trees planted around the city when it was converted from pasture, so many were introduced species that the gold and russet colours of dying leaves, so familiar in Europe and North America, herald winter. By contrast, Australian native trees are not deciduous, and the seasons indestinct. This picture shows Parliament House, on Capital Hill, which was sliced flat to set the building into it, and then replaced.

■ LEFT : Corroboree frog *Pseudophryne corroboree*

The corroboree is an Aboriginal ceremonial gathering, usually with dance. Participants invariably daub their bodies with distinctive decorative paint, hence the name for these frogs of eastern Australian alpine regions. This one was photographed at the Namadji National Park in the ACT.

■ OPPOSITE : **Twilight, Lake Burley Griffin**

The Captain Cook Globe commemorates the great navigator's discovery of the east coast of Australia, foreshadowing European settlement. On the distant banks are the National Library (*right*) and the High Court buildings.

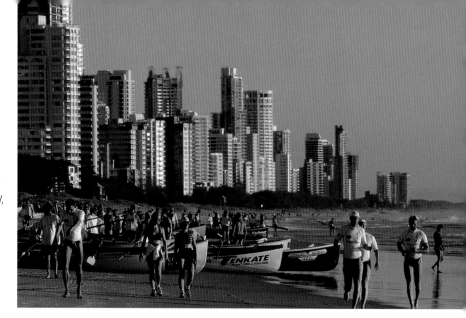

■ Right : Highrise development, Gold Coast
The waterfront holiday development that characterises Queensland's Gold Coast began as a small timber-cutting settlement in the 1840s. Today, the City of Gold Coast sprawls along the beachfront for some 40 kilometres (25 miles) to the border of NSW, incorporating 18 subsidiary townships, the best known of which is Surfers Paradise.

Queensland

Nothing, even among Queensland's many grand landscapes, compares with the Great Barrier Reef, a vast living organism that teems with marine animals of such dazzling array that the even the worms display splendid livery. Its magnitude is even more bizarre because this maze of nearly 3,000 reefs stretching 1,250 nautical miles was built by tiny coral polyps, usually less than 3mm (1/10 inch) wide. The reef's southern extremity stands 300 kilometres (185 miles) off Gladstone, gradually closing with the coast to 30 kilometres (18 miles) off Cairns, and closer towards Cape York. At the reef's leading edge, where the continental shelf plunges abruptly into the darkness of 500 fathoms, ribbon reefs absorb the battering of the Pacific. In the protected waters behind them, patch reefs and fringe reefs shimmer in a myriad of blue-green hues through the crystal shallows. Of the 300 islands scattered along the reef, most are sandy coral cays, occasionally crowned with verdant tufts. For those who prefer more complex greenery, Australia's most luscious tropical rain forests occur along the coastal aspect of the reef, between Townsville and Cooktown.

Queensland created a thriving tourist industry around the wonders of the Great Barrier Reef and luxurious island resorts, like those of Whitsunday Group, off Proserpine. Near Brisbane, the Gold Coast's sweeping surf beaches offer playgrounds of a racier kind, with high-density highrise accommodation, and popular entertainment. Surfers Paradise epitomises this region, one of the fast-growing in Australia, and second only to Sydney as a tourist destination, followed by Melbourne, and then Cairns, of Queensland's tropical north. Indeed, Queensland is the fastest-growing State in the nation. Though its population is little more than half that of NSW, it is the only State that could conceivably challenge it in the future. Certainly Queensland is rich in natural resources and its major urban centres are spread wider than other States. Decentralisation is a cherished national goal. Cairns,

Townsville, Mackay, Rockhampton, Bundaberg, Toowoomba, Brisbane and the Gold Coast all lie along the wide coastal belt, east of the Great Divide, which runs the length of the State. However, only Brisbane's population exceeds a million, the rest are between 36,000 and 150,000.

Queensland's beginnings were less inspired, when NSW, souring of the convict system by 1824, despatched some recidivists north to remote Moreton Bay. Poor soil and hostile Aborigines drove the expedition upriver to the present site of Brisbane, where it remained a particularly brutal penal settlement for 15 years. Yet squatters followed hard at their heels, ignoring government injunctions and pushing westward, initially to exploit the black soils and rolling grasslands of the elevated Darling Downs, 160 kilometres (100 miles) inland. So successful were they, and so rich the pastoral lands, that by the time Queensland separated from colonial NSW in 1859, its white population of 23,000 was already running more than 3.5 million sheep and 500,000 head of cattle!

In time, the tropical north was opened up, notably the rich volcanic soils of the Atherton Tablelands, in the shadow of the Bellenden-Kerr Range of the Great Divide, inland from Cairns. And the marginal lands of the Great Artesian Basin drew pastoralists further west, once its subterranean waters were better understood. Its area of 1.61 million square kilometres (620,000 square miles) underlies western Queensland, into NSW and northeastern South Australia. The artesian basin is a gigantic saucer of water-bearing sandstone, sealed by impermeable strata, above and beneath it. Water that collects in the pervious sandstone layer is put under increasing gravitational pressure as it fills to the higher sloping rim around the "saucer" shape. (Subterranean water is crucial in Australia, because so much of the meagre rainfall is lost to extremely high evaporation rates.) When the first bore was sunk in Queensland, near Cunnamulla in 1887, water gushed from 393 metres (1,050 feet).

Of 70,000 bores sunk in the Great Artesian Basin, 25,000 still flow, but many more require pumping. This use reduced water levels in the biggest aquafier on Earth alarmingly. Water absorbed in Queensland takes a million years to work its way to the southern extremity of the basin.

Pastoralists also picked their way southwest into the difficult Channel Country, so-named because of its lacework of tiny creeks and rivers, most of which run only intermittently. Like much of the arid inland, the Channel Country can burst into useful pasture after heavy rains, and as quickly reverts to the arid norm.

Queensland became Australia's biggest cattle producer, and remains so. Sugar, too, proved lucrative, cane being planted from the southern border as far north as Mossman. It flourished into a significant export industry, though not before a bitter lesson. When the early cane fields fell short of local workers, Pacific Islanders or "Kanakas", were recruited, the terms of their indentures making virtual slaves of them. If Southern States were appalled, only after Federation was "blackbirding" finally halted, by subsidising the industry and repatriating the workers.

Though Queensland is a significant producer of grain, fruits, cotton and nuts, huge coal deposits and minerals fuel a much stronger thrust to the State's economy. Gold was discovered on the Fitzroy River as early as 1858, followed by finds near Gympie, Charters Towers, the Palmer River, and the gold and copper riches of Mount Morgan. More copper, plus tin, lead and silver were discovered at Mount Isa, creating a mining city of 30,000, 2,000 kilometres (1,250 miles) northwest of Brisbane. It became the hub for a pastoral region extending into the Northern Territory, providing a local base for two institutions upon which outback Australia depends: the Flying Doctor Service, which calls at even the remotest home-steads; and the School of the Air, that formally educates the outback's isolated children through a two-way radio network. Both are uniquely Australian innovations. ■

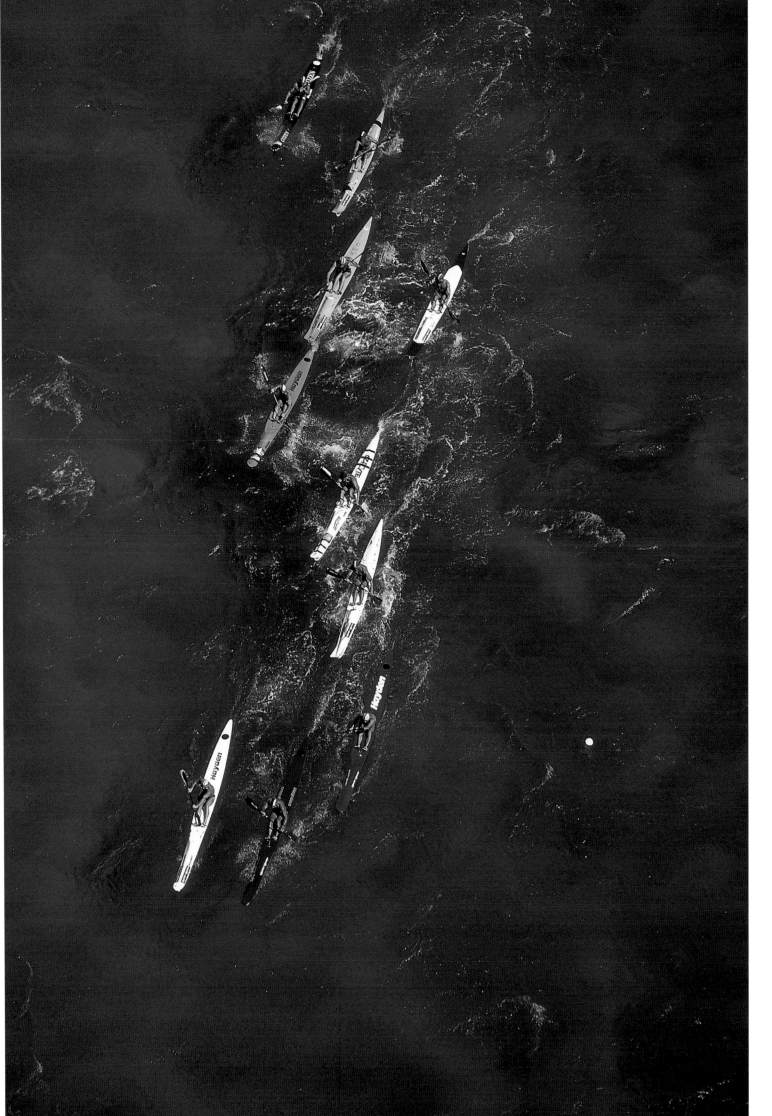

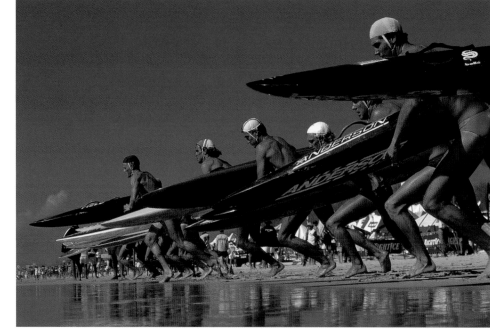

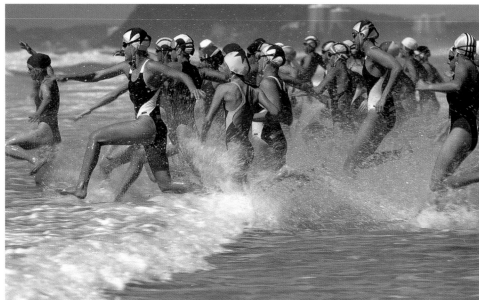

■ LEFT & ABOVE : Surf carnival,
Surfers Paradise

Queensland's subtropical climate, warmer
waters, and some sublime beaches attract a host
of holidaymakers to the "Sunshine State". Parts
of the coast, particularly the Gold Coast, depend
on this tourist trade. These pictures show a surf
race and a surf ski race at a surf carnival, part
of the national surf lifesaving competition. A
hazard to surfers in some parts of Queensland is
the infamous box jelly fish, whose agonizing sting
can be fatal. When the season arrives, burly surf
lifesavers brush aside inhibitions to pull on
women's pantyhose to protect their lower body
from the long trailing tentacles of the "stingers".

■ OPPOSITE : Fairfax Reef,
Bunker Island Group,
Great Barrier Reef Marine Park

The whisps of sand and coral shingle that form
the Fairfax Islands in the Bunker Island Group are
typical of the many coral cays that dot the Great
Barrier Reef off the east coast of Queensland.
Incorporating some 250 islands, and encompass-
ing an area of approximately 260,000 square
kilometres (100,000 square miles), the Great
Barrier Reef defines the northeastern edge of
the Australian continental shelf for about 1,900
kilometres (1,200 miles), between the Bunker
Island Group in the south and tiny Anchor Cay
in the Torres Strait, to the north.

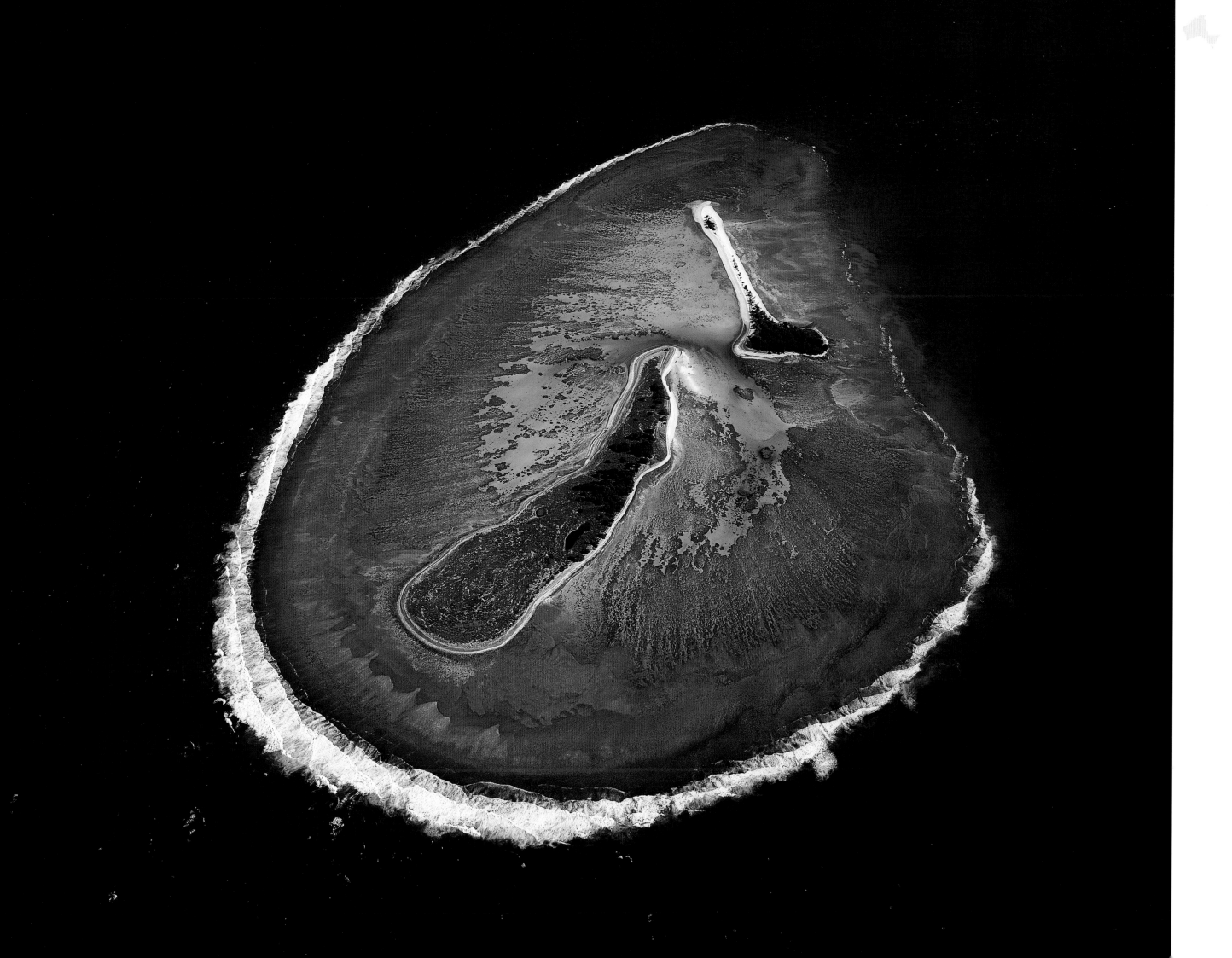

■ RIGHT : Green python, *Chondropython viridis*, Cape York Peninsula

■ FAR RIGHT : Fungi on fallen tree, Lamington National Park.
Rainforests depend absolutely on the recycling of the limited nutrients that are available to them—despite their apparently lush growth, the soil is in fact poor—and fungi play a vital role in regeneration. When a tree falls and its life cycle ends, armies of fungal and bacterial decomposers move in, and another cycle of life begins. Without fungi, rain forests such as this could not exist.

Queensland's rainforests

Australia's modern rainforests are small and scattered but of peculiar evolutionary significance. Confined as they are to the eastern and southeastern fringes of the continent, they represent remnants of much larger forests, both tropical and subtropical, that once cloaked vast areas of the continent when it was part of the ancient conjunction of southern continents known as Gondwana. In fact, part of the proof that continents drift, and that Gondwana ever existed, came from these forests.

Many of the species that live in Australia's rainforests have close relatives in other parts of the world, but only in those lands which were once linked in this fashion, such as New Zealand, New Caledonia, South America, Africa and India. And direct evidence of many of those intercontinental floral dispersals have recently been recognised in the fossil record of Antarctica, the lynch pin of the Gondwanan conjunction.

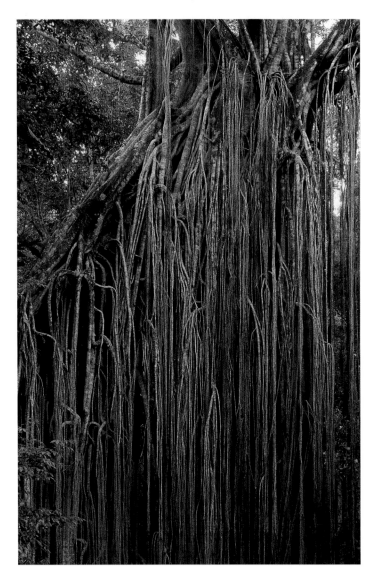

■ RIGHT : The Curtain Fig, Atherton Tableland
This remarkable living curtain is an old Strangler Fig *Ficus virens*, which uses a host tree to send its tenacious roots to the ground. So vigorous are these roots once they reach the soil, that they gradually strangle their host, which rots away, leaving the fig suspended on this maze of stilt-like roots.

■ OPPOSITE : Lowland tropical rainforest, Mosman Gorge, Daintree National Park
Daintree is arguably the most treasured (and most politicised) of Australia's rainforests. Rainforests of northeast Queensland take three forms: Lowland, Highland, and Cloud Forest.

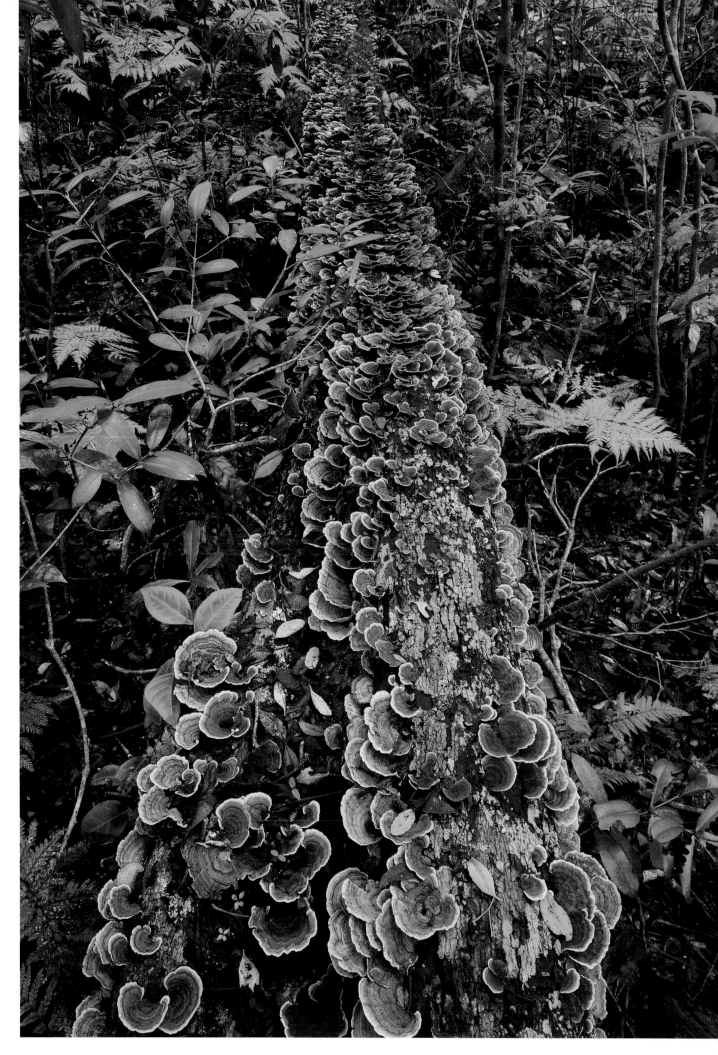

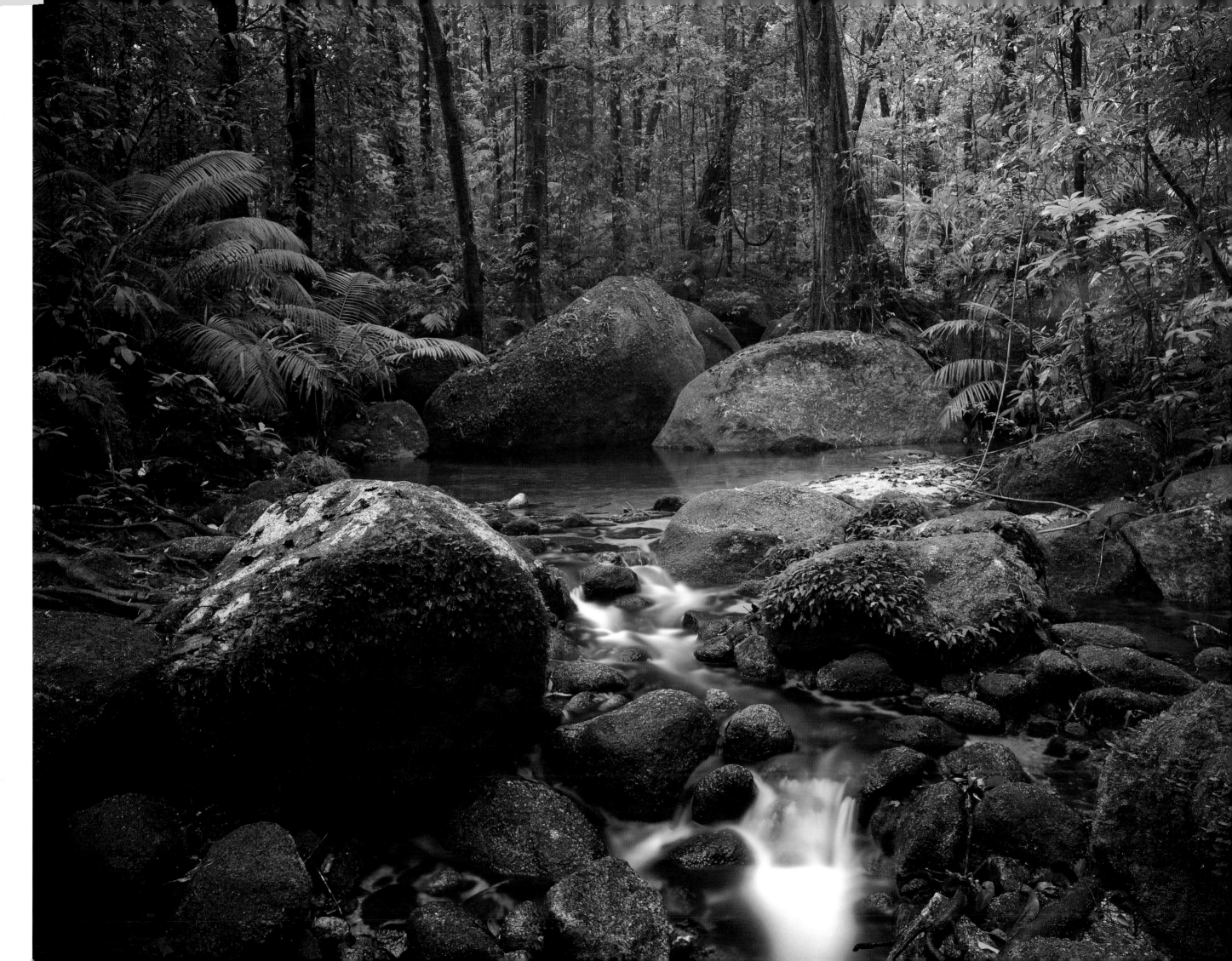

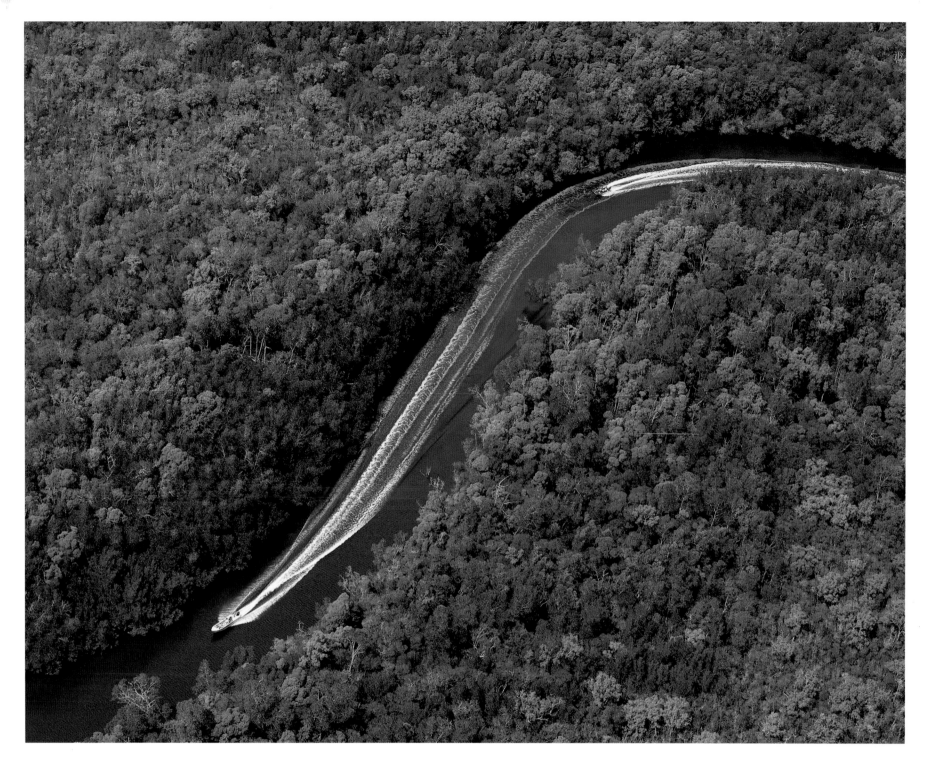

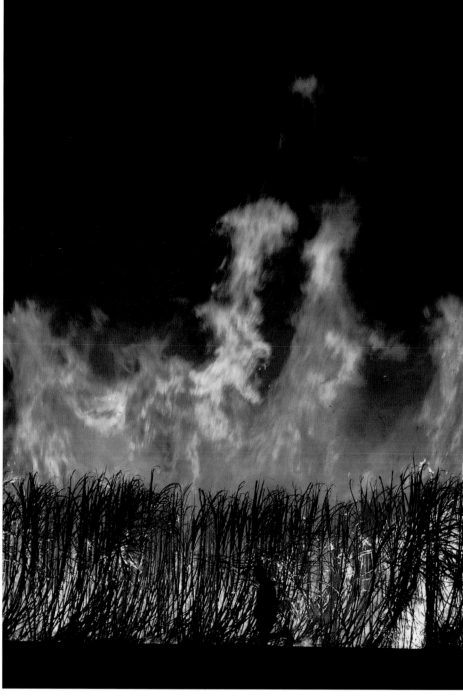

■ ABOVE : Fishing boats negotiate a tidal waterway off Kennedy Inlet, Cape York
Two features that make northern Australia's coastlines unlike any others, are the flatness of
the terrain and the huge tidal fluctuations that continually wash the gently-shelving intertidal
zone. This has produced vast mudflats and extensive mangrove forests, all of them veined
by complex tidal creek and river systems that alternately drain and flood the region twice a
day. Fishermen working in such regions prefer to use jet boats to avoid the twin problems
of mud and snags.

■ ABOVE : Burning the sugar crop, Queensland
Australia is one of the world's major sugar producers. Only Cuba and Brazil export more.
The vast majority of this industry is centred in tropical Queensland. The traditional pre-harvest
burning of the crop is to remove dead leaves and drive out vermin.

■ OPPOSITE : Pineapple plantations, macadamia orchards, near Glass House Mountain
Massive lava flows some 25 million years ago bequeathed many farmers in southeastern
Queensland a gift that is all too rare in the rest of Australia—deep, rich, volcanic soils. In
the shadow of one of the volcanic sources of this natural wealth, farmers of Glass House
Mountain now reap an abundance in the form of fruit and vegetables, in this case pineapples
and macadamia nuts. The volcanic plug in the background was called Coonowrin
(Crooked Neck) by the Aboriginal people of the area. Viewed from the heaving deck of
HMS *Endeavour* in 1770, the cluster of volcanic plugs that characterise the area reminded
Captain James Cook of the furnaces used for making glass in his native Yorkshire, hence
the region's English name.

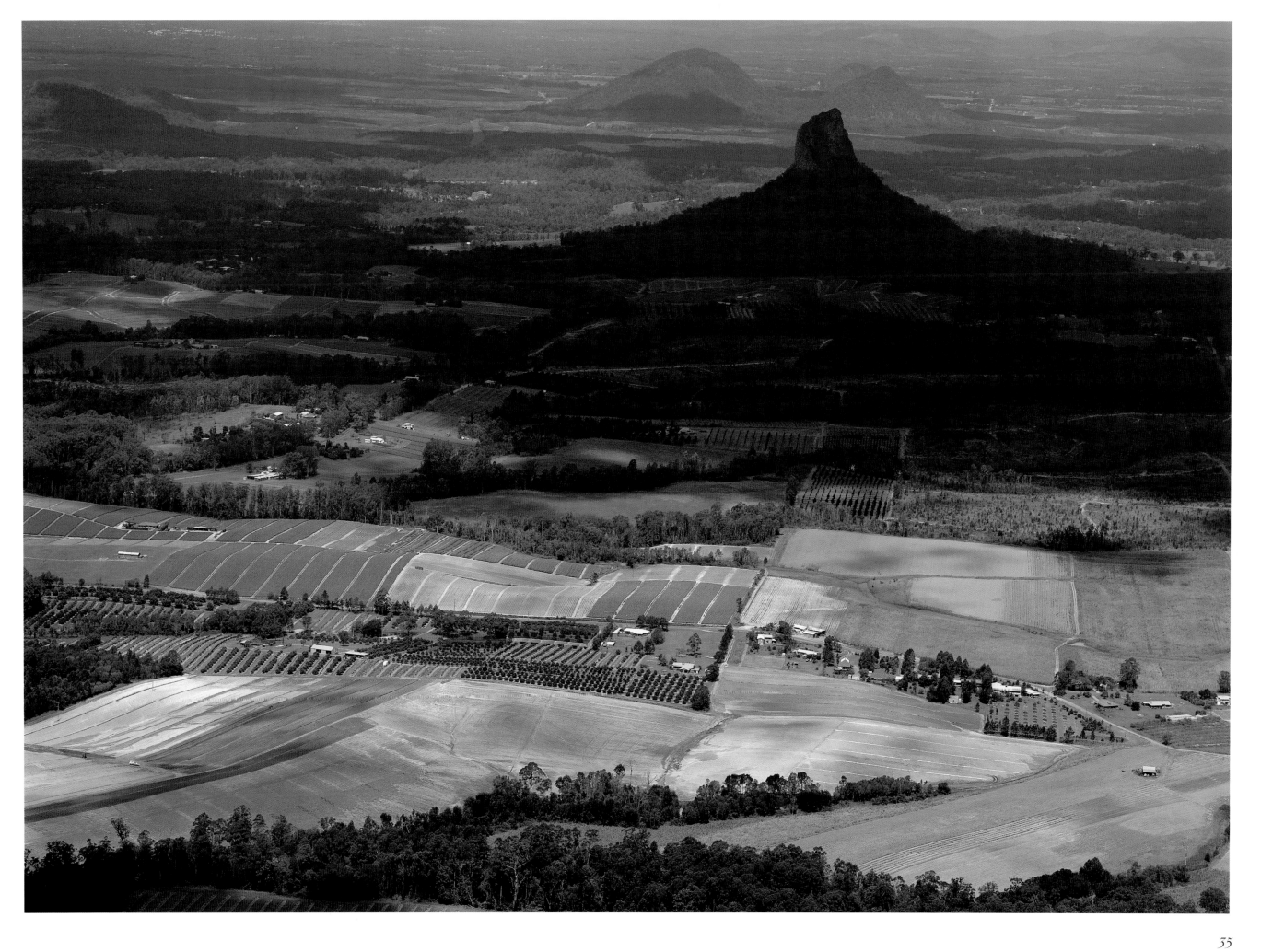

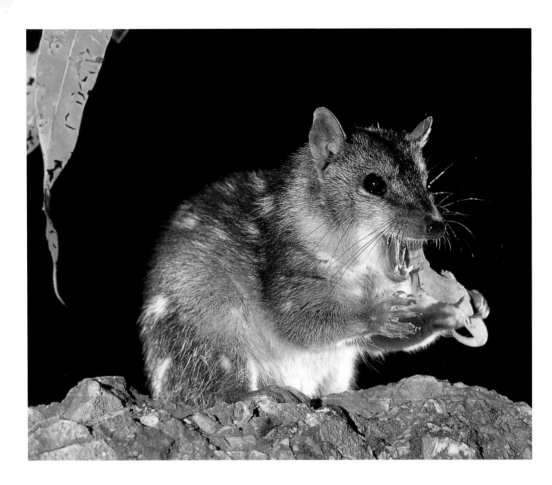

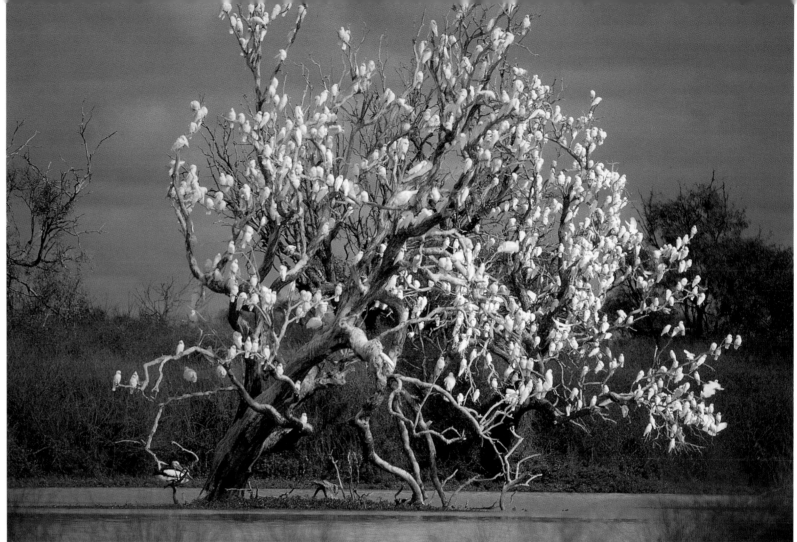

■ ABOVE : Northern Quoll, *Dasyurus hallucatus*

This Northern Quoll—devouring a gecko—belongs to one of Australia's four families of flesh-eating marsupials. Rarely more than 250mm (10 inches) long, the Northern Quoll is, nevertheless, an aggressive and successful hunter in its modern range, which includes most of northern Australia's coastal woodlands. It nests underground but climbs efficiently, and feeds on a wide variety of small mammals, reptiles and birds, as well as insects, eggs, and even carrion. Like others in its family, it lacks a permanent pouch for its young, but develops a supportive flap of skin round the area of its 6 to 8 nipples, just before the June mating season. At birth, each of its blind young is the size of a rice grain, and must swiftly attach to a nipple and remain there for the next 8 to 10 weeks for any chance of survival.

■ OPPOSITE : Central Store, Atherton Tableland

More than 85 percent of Australians now live urban lives, coping as best they can with the dramatic social changes imposed on them by our galloping technology. For some who choose to remain in "the bush", however, life has not altered so much during the past century. Machinery has come to their aid, but in essence, the chores that regulate their lives today are little different from those of their great-grandparents. Certainly most now converse easily with the wider world, thanks to communication satellites, the telephone, and computer. They are better informed on local, national, and international affairs than were their grandparents. But the mechanics of running a small family farm, or a tiny

roadside store like this one —"the highest store in Queensland"—still involve long hours of physical toil, very often in solitude. Like all who live in isolation and cope unaided with whatever life and the natural environment throws at them, the "battlers" of Australia's bush display a dogged, quirky, independence that seems to readily transmute to comradeship and tenacity in times of crisis, whether bushfires, floods, droughts or cyclones.

■ ABOVE RIGHT : Little Corellas, *Cacatua pastinator*, at Birdsville

Parrots that characterise Australia's arid heartlands are generally itinerant. Being seed-eaters, they must drink at least twice a day, so their movements and behavior depend entirely on the availability of water. Where there is semi-permanent water, such as this billabong near Birdsville, the flocks may grow so large that the dead trees in which they roost appear to be loaded with blossoms. The white "blossom" in this case consists largely of Little Corellas, with three Yellow-billed Spoonbills and an Australian Pelican.

■ RIGHT : Cooper Creek, southwest Queensland

Cooper Creek is the most dramatically unpredictable of Australia's larger rivers. It often dries up completely: yet its flow at full flood may be as great as the River Nile at Khartoum. In what is known as "channel country", southwest of Windorah, its floodwaters move through a network of tree-lined channels that is nearly 50 kilometres (30 miles) wide in places. Where the Cooper fans out into the dunefields of the Strzelecki Desert, its floodwaters may spread to 160 kilometres (100 miles) wide.

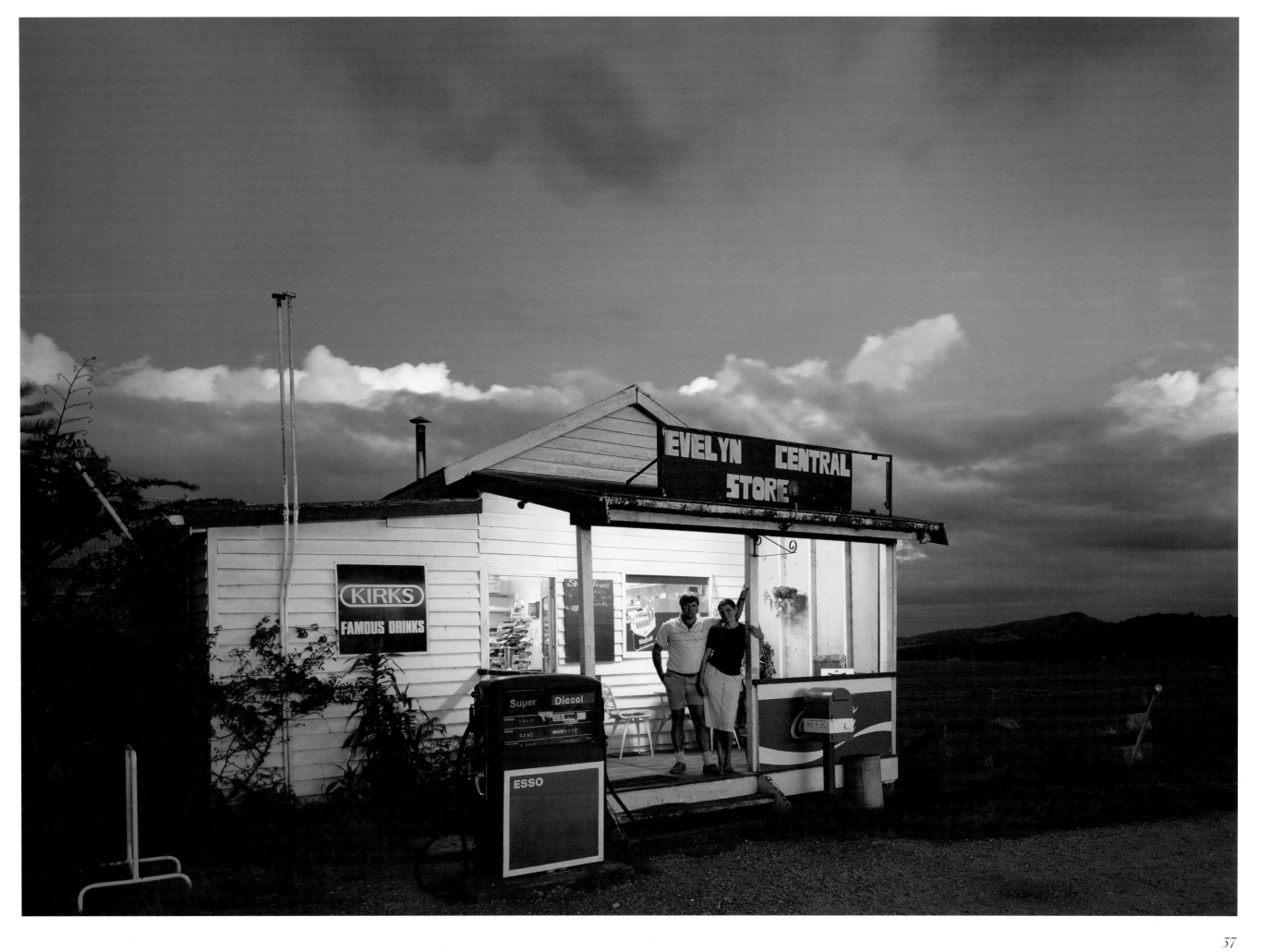

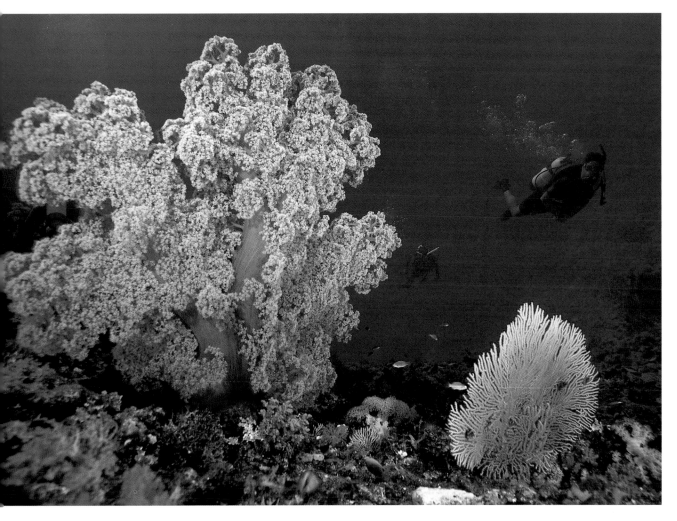

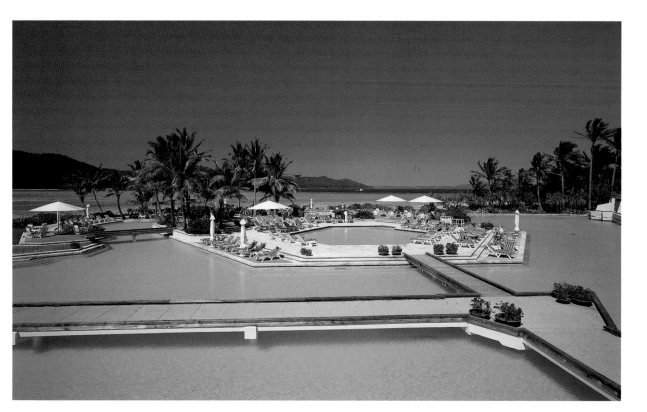

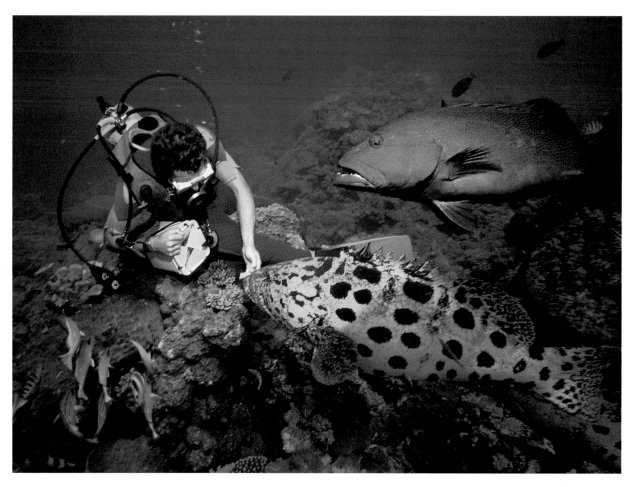

■ ABOVE : The rewards of diving deep on coral reefs
The deeper the water, the more splendid the specimens : this large coral tree (fam: *Siphonogorgiidae*) and a small fan was 50 metres (150 feet) deep.

The Great Barrier Reef

Often described as the largest biological structure on Earth, the Great Barrier Reef is not in fact a single structure, but a massive chain of complex reef systems. Incorporating some 2,500 reef systems, the Great Barrier Reef is the byproduct of hundreds of thousands of years of biological abundance in this region. It is built entirely of the skeletal remains of billions of marine organisms, many of which are microscopically small. Some of the coral ramparts near the edge of the continental shelf rise more than 100 fathoms from the sea floor, and since reef-building corals need sunlight and thrive only in the upper 30 metres (90 feet) of water, this shows that reef growth has managed to keep pace with some land subsidence as well as sea-level rises during this time. Also testifying to these events are the reef's numerous "continental islands"—the tops of coastal mountains that have become submerged. Most of these continental islands occur near the southern end of the Great Barrier Reef; several are thickly vegetated and sustain large populations of birds, lizards, and other small animals. Scattered

throughout the reef chain are smaller islands, mostly coral cays; some are vegetated, and some mere whisps of pristine sand. Isolation, and the absence of feral animals and reptiles, makes such islands ideal nesting places for seabirds, some of which are permanent rookeries.

The diversity and abundance of marine life on the Great Barrier Reef is a product of its warm waters and sunlight. Paradoxically, it thrives *because* these waters are actually deficient in nutrients; and in this respect the reef is the marine equivalent of tropical rainforests. Its waters lack nutrients because the continent itself, ancient, eroded, and cloaked largely in thin, impoverished soils, surrenders little of biological value to the sea from its rivers. Where agricultural fertilizers have been added to the land, the enriched run-off has allowed marine algae to thrive, which has killed many inner reefs. Among the outer reefs, however, the diversity of marine life remains prodigious and exquisitely colourful, the main attraction for the 17 million tourists that visit Queensland each year.

■ ABOVE : Feeding fish, Lizard Island
A diver feeds a Potato Cod and a Coral Trout off Lizard Island, near the northern end of the Great Barrier Reef Province.

■ TOP : The luxurious life, Hayman Island
Hayman Island, in the Whitsunday Group, is one of the more exclusive reef resorts that cater for the wealthy tourist.

■ RIGHT : Tiger shark, *Galeocerdo cuvieri*
The most feared of the many shark in Australian waters, the Tiger can grow to more than 5 metres (16 feet). A voracious predator, it is held responsible for a number of shark attacks.

■ FAR RIGHT : Surf race, Gold Coast
Lifesavers turn the seaward mark in boisterous surf.

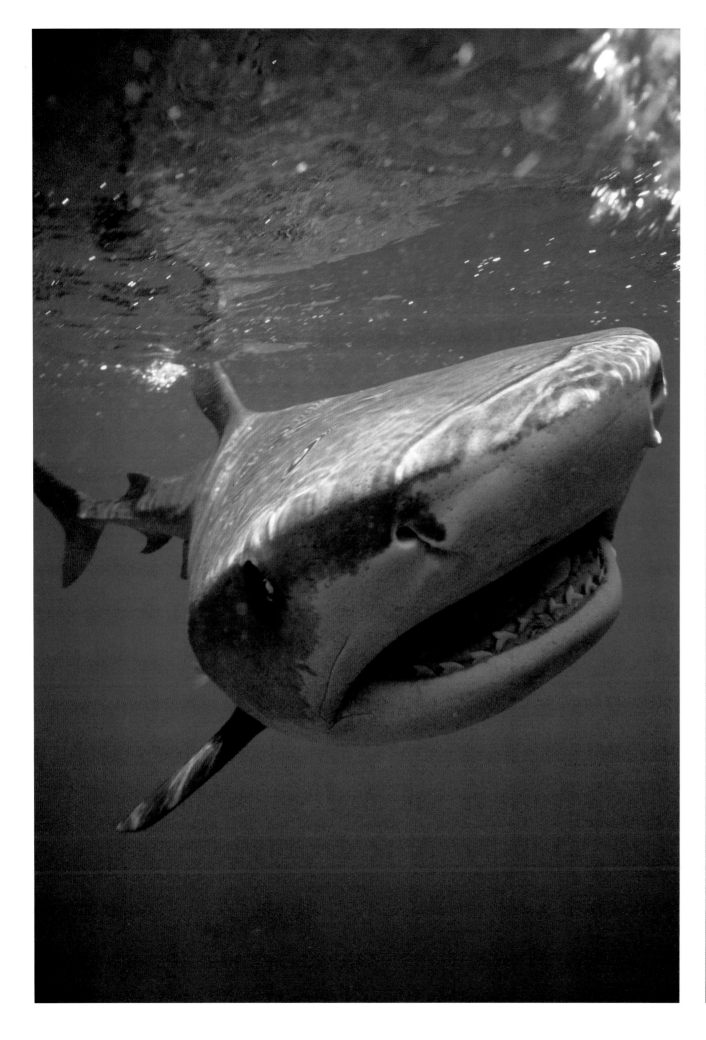

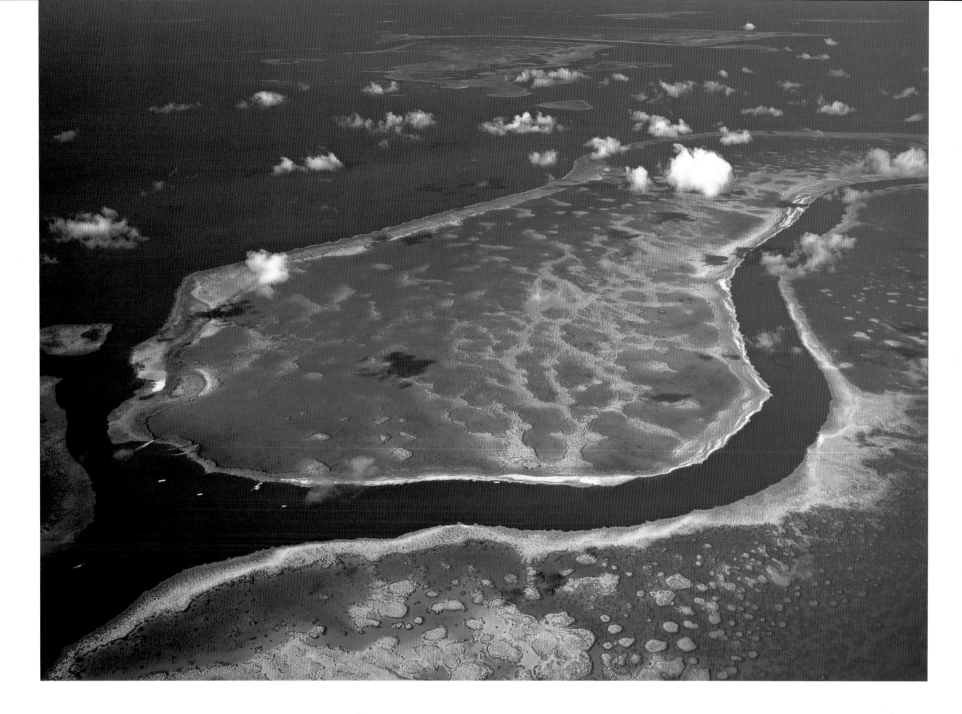

■ Right : **Hardy and Hook Reefs**
The Hardy and Hook Reefs, near the southern end of
the Barrier Reef National Park, are separated by a coral-
fringed ribbon of deep water that serves as a draining
channel during the ebb and flow of the tide.

■ Opposite : **Whitsunday Island**
Tongue Point, Hill Inlet, and the exquisite white sands of
Whitehaven Beach on Whitsunday Island, one of a cluster
of beautiful resort islands—and uninhabited islands—in
the southern reaches of the Great Barrier Reef.

■ Right : **Beach fishermen, Fraser Island**
Each September, anglers mass off the beach at
Fraser Island, south of the Great Barrier Reef, when
vast schools of tailor swim into the mangroves and
tidal marshes to spawn. Beach anglers, forbidden to
fish in the spawning zone, cluster in a veritable for-
est of rods at the edge of its boundaries. This nar-
row island, some 160 kilometres (100 miles) long,
stands off Hervey Bay. It is best known for its splen-
did sand dunes, some of which rise to 240 metres
(650 feet), deep freshwater lakes, and small pockets
of rainforest. Cherished by conservationists, the
island was the first to be registered on the National
Estate in 1976. Much of it is pristine national parks,
though there is a small tourist settlement.

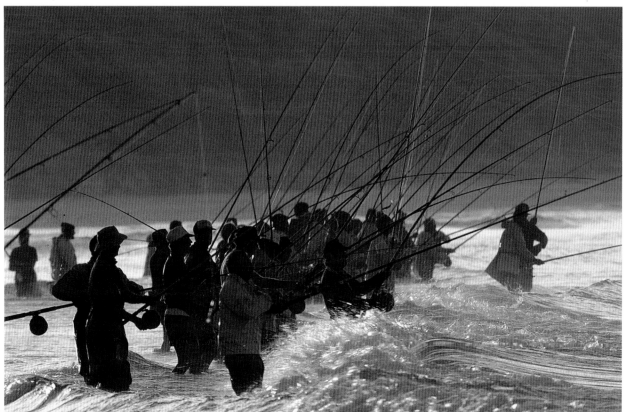

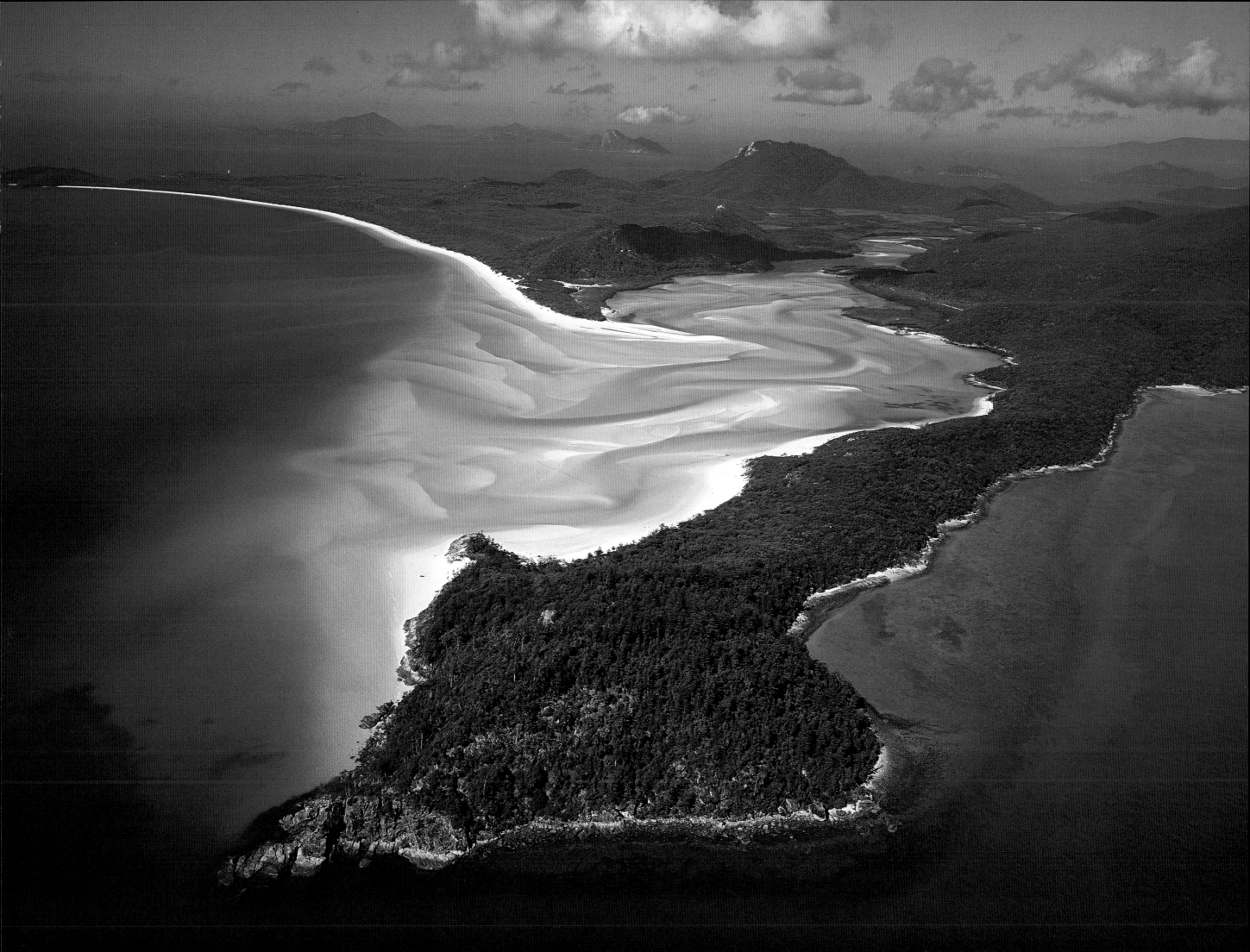

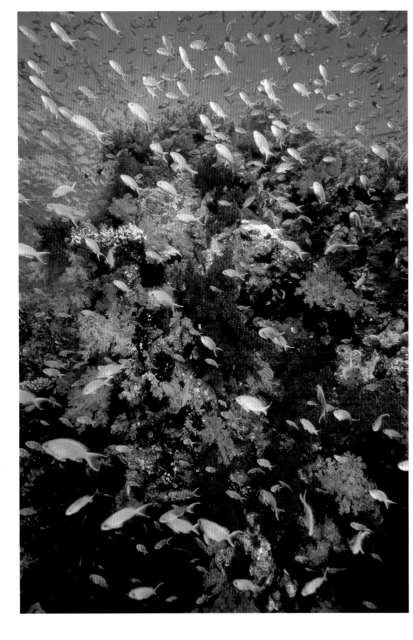

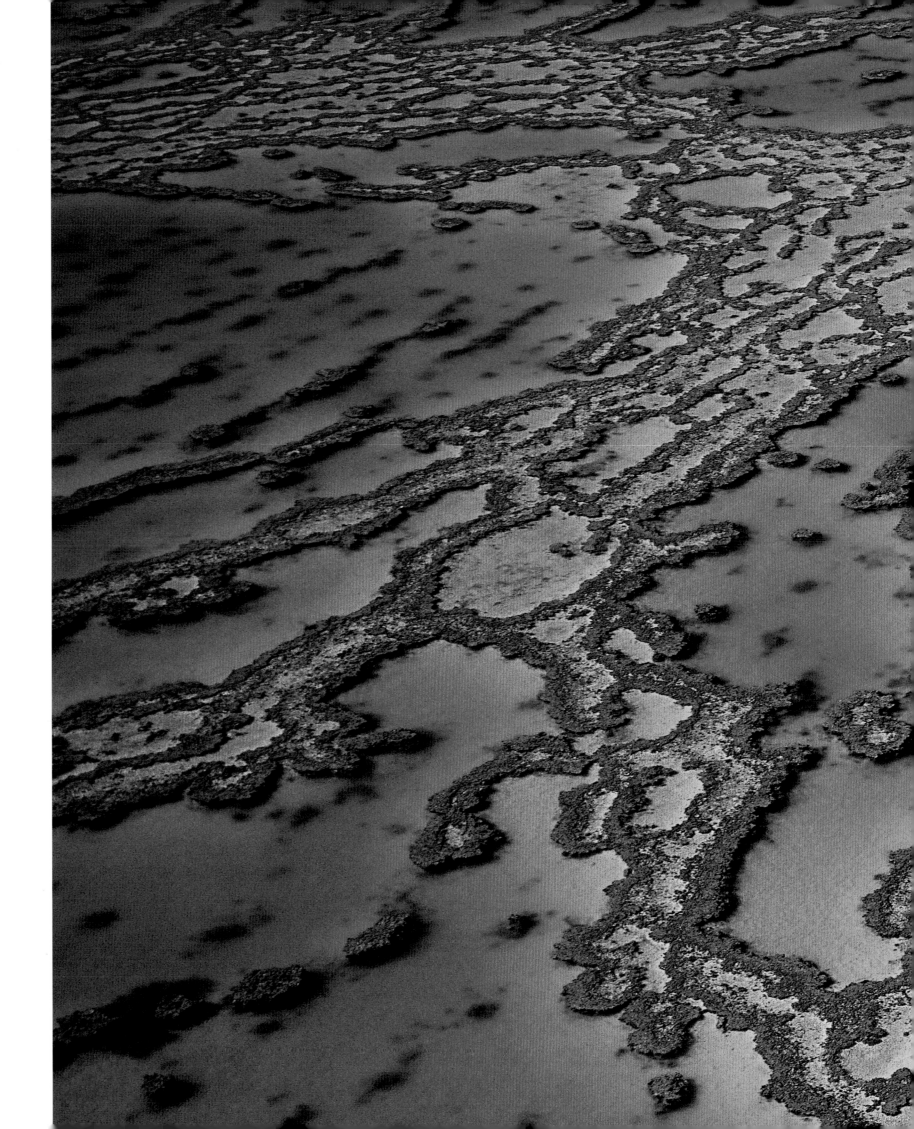

■ ABOVE : **Living colour**
A blizzard of reef fish, attracted by a diver, hovers above a
hard and soft coral garden on the Great Barrier Reef.

■ RIGHT : **Queensland's jewels**
Elegant coral lacework decorates the sandy shallows
of Hardy Reef. Apparent only from the air, such reticulate
patterns of coral growth are common to many reef
platforms at the western edge of the marginal shelf in the
reef's central region.

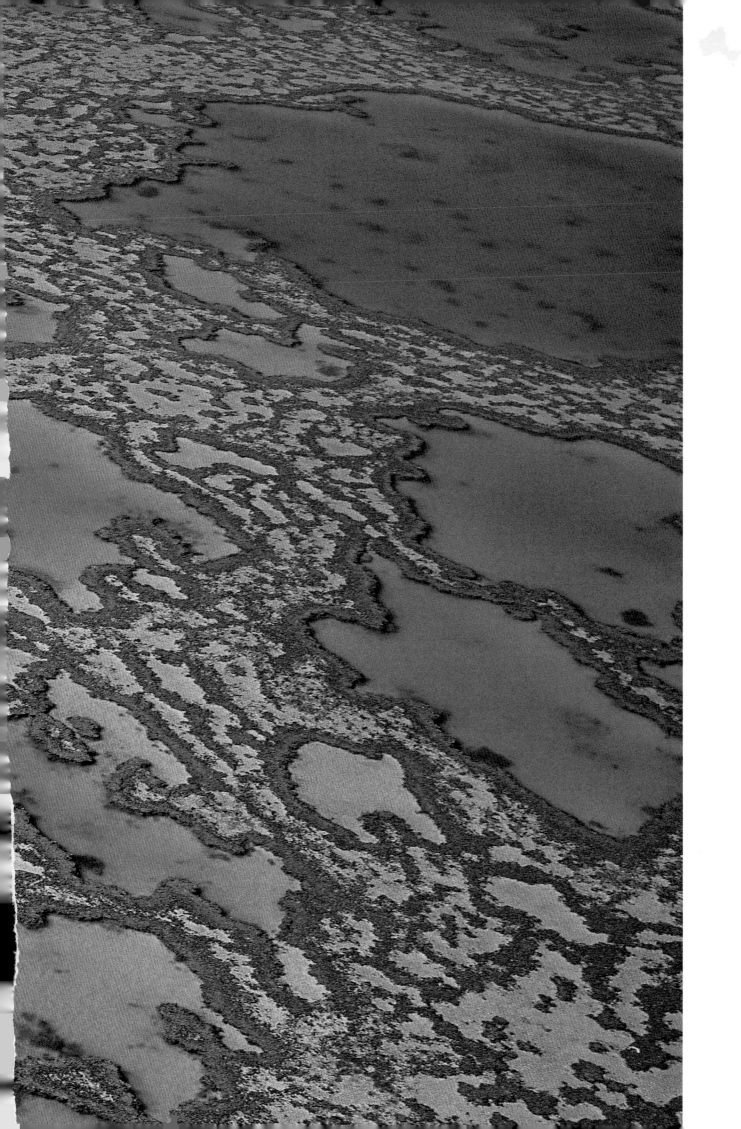

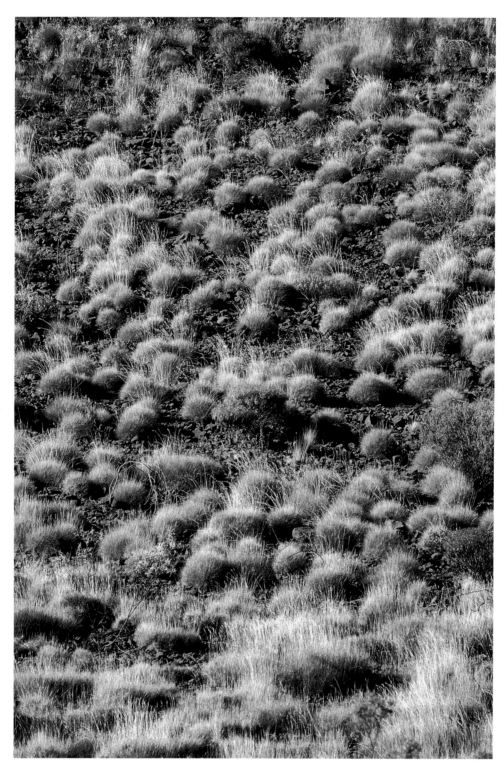

■ ABOVE : The ubiquitous spinifex of arid Australia.

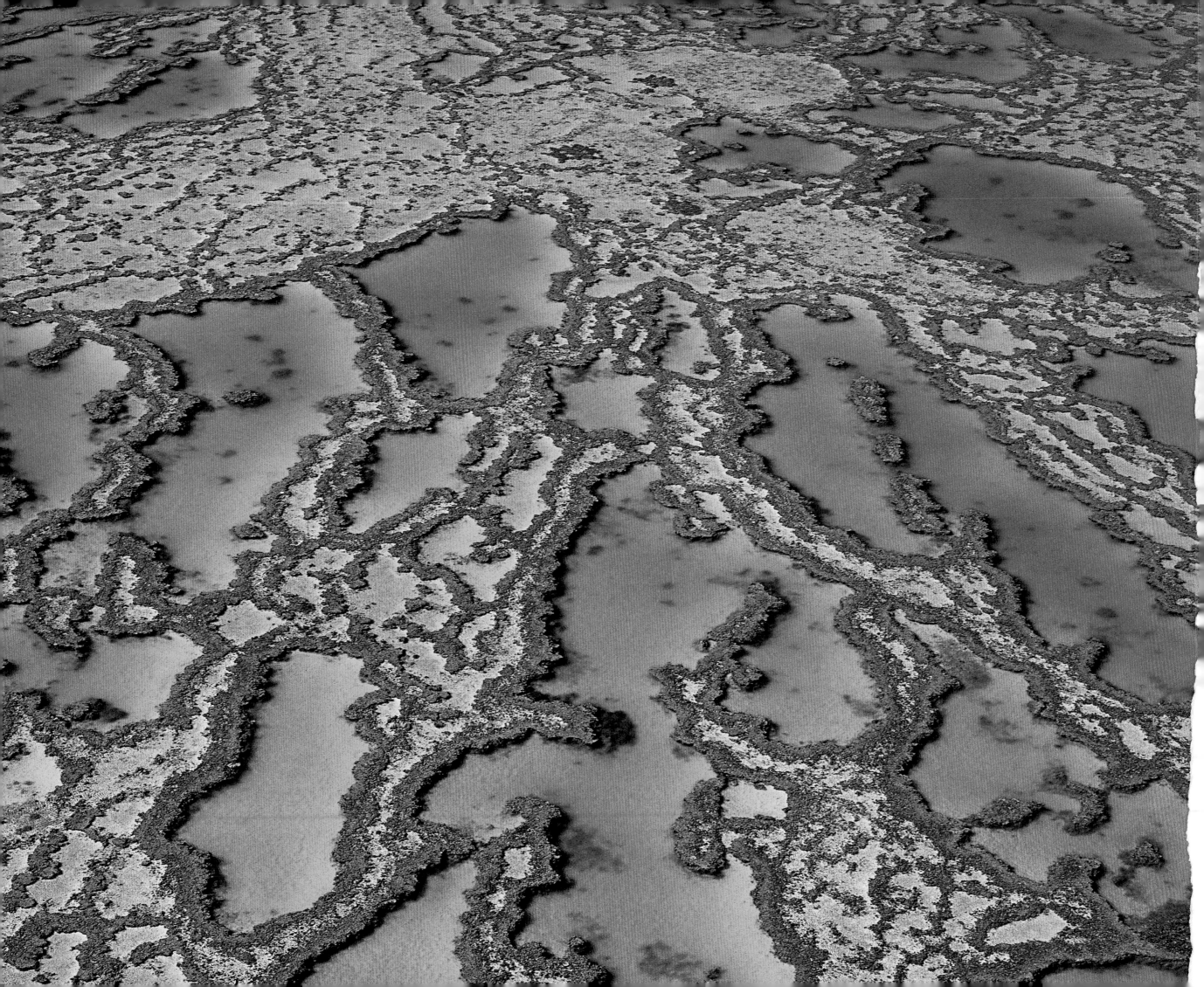

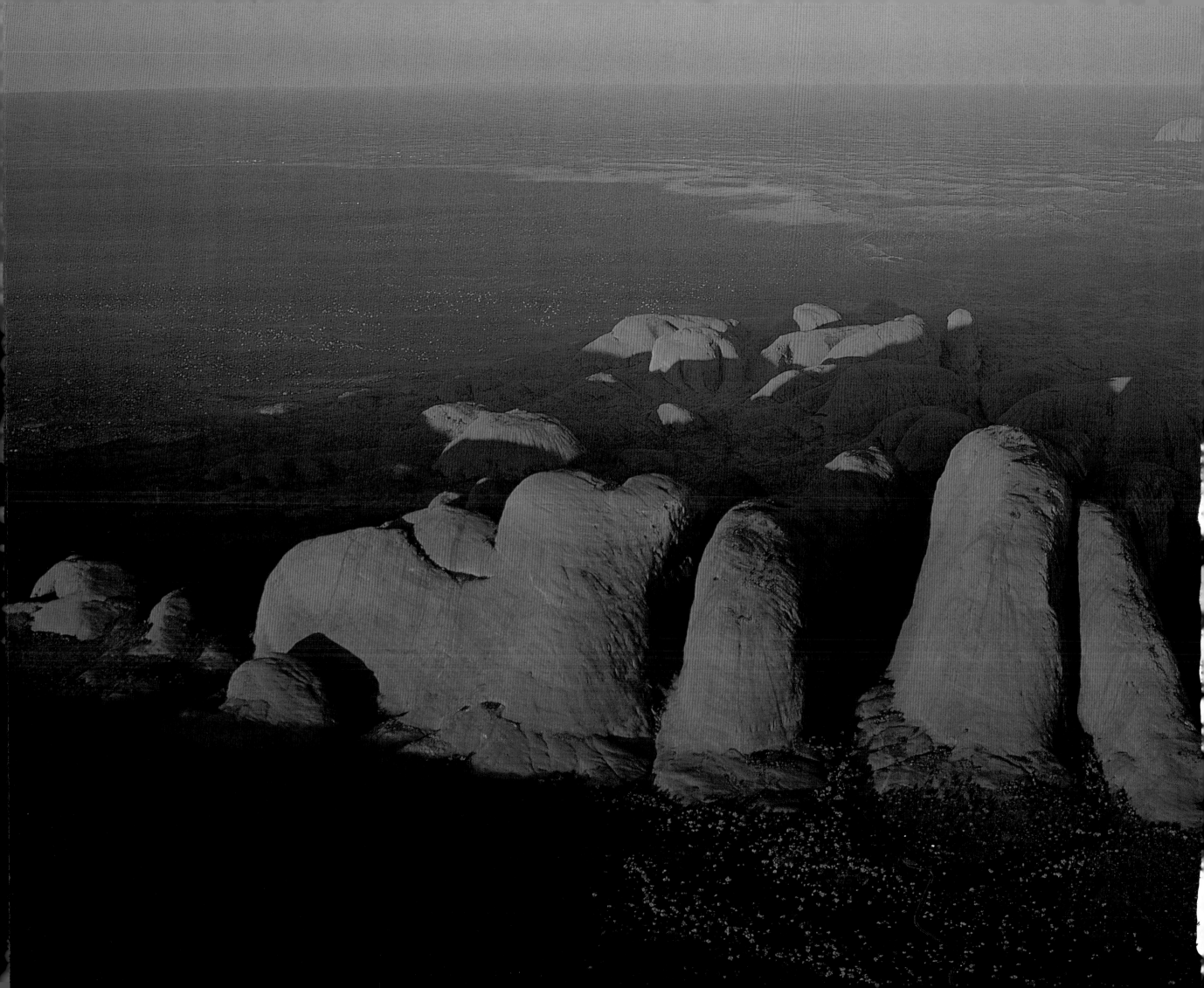

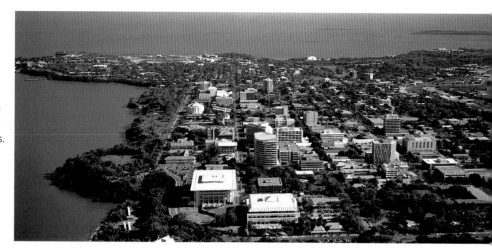

Northern Territory

The Northern Territory is Australia's last great frontier. The wide flat lands of its hinterland are so parched and so utterly remote that Territorians have had to be tough, and resourceful. Only the hardiest cattlemen of the late 19th century were prepared to take it on, claiming holdings measured in thousands of square kilometres, mostly in the more fertile Barkly Tablelands of the northeast.

Earlier attempts to establish a small colonial garrison at Top End—as the northerly region is known—failed miserably. Thereafter, when still part of New South Wales, the territory was remote enough to be ignored. Even when it was assigned to South Australia, this unforgiving land defeated that State's best efforts, which included laying the Overland Telegraph Line 3,000 kilometres (1,900 miles) northward across the continent, a gigantic undertaking for the 1870s. Yet it set new footprints in the Territory's wastes, establishing Alice Springs in The Centre and Darwin on the north coast—the final link to the overseas telegraph network.

Chinese "coolies" were brought in to toil on the Top End section of the telegraph line. Many made Darwin their home, as did itinerant traders and Malay fishermen. In fact, when an exhausted South Australia gratefully handed over the Territory to the Federal Government in 1911, Darwin looked as much a tiny Asian trading port as an Australian town.

The need for a northern fuelling point for the infant aviation industry gave Darwin further reason for existence, but it remained largely ignored, a steamy, backwater tropical port, on a coastal strip characterised by mangroves and estuarine swamps. The wet season dumps more than 1,200mm (4 feet) on Darwin each year, the season that brings tropical cyclones of such ferocity that the town had been flattened four times by World War II.

Less than 5,000 settlers plus 25,000 Aborigines were living in the Territory's 1.34 million square kilo-metres (500,000 square miles) when war broke out; even less when Darwin was evacuated, which was just as well. Darwin suffered the brunt of the first and only sustained bombing raids on Australian soil. When the townsfolk returned, they found their town devastated by 64 enemy attacks—and looted by the defenders!

The war also raised the Territory's profile. The military had built a basic infrastructure, including a sealed highway between Darwin and Alice Springs, and fears of invasion had jolted the vulnerability of an empty north into the national consciousness. Northern development became a federal priority.

Darwin's population had already grown to nearly 50,000 by Christmas Day, 1974, when Cyclone Tracy wiped out 90 percent of the town. Some 35,000 residents were forced to evacuate, but Darwin was swiftly rebuilt. So neglected for so long, Darwin was on everyone's mind in a nation deeply moved and determined to set things right. This time, engineers were instructed to design it strong enough to withstand the worst. Most Territorians returned. Others followed in numbers. And a markedly modern city sprang up.

Darwin became the seat of government when the Territory was deemed ready to govern itself in 1978, if not the full Statehood it had wanted. Since, Darwin's population now approaches 200,000 and the Territory is one of the fastest growing regions in Australia.

Cattle remains a major industry, with huge stations merging to form gigantic cooperative spreads, but it has been overhauled by the Territory's mineral wealth. Bauxite is mined on the Gove Peninsula, manganese on Groote Eylandt in Gulf of Carpentaria, and massive reserves of uranium have been identified, particularly in the Alligator Rivers region, 200 kilometres (125 miles) east of Darwin, the latter an ongoing source of angst and political uncertainty in the Australian community.

There is bitter irony in one of the Territory's fastest rising dividends. The harsh but spectacular landscapes that crushed so many lonely pioneers, now attracts leisurely visitors in droves, and in comfort. Tourism is booming. Hundreds of thousands visit Alice Springs in The Red Centre, largely because it is so handy—in Territorian terms—to Uluru and Katatjuta, about 400 kilometres (250 miles) to the southwest.

Uluru is a gigantic monolith, rising abruptly from a flat, still plain, near the huge salt pan of Lake Armadeus, and between the MacDonnell Range at the very centre of the continent, and the Petermann Range to the south. Its ochre hues glow burning red as the sun rises and sets. During rare rains, it is veiled by scores of rushing cataracts. This massive rock of haunting moods is deeply mystical to the Pitjantjatara Aborigines of the region, whose galleries of rock art can be found around the base.

The Uluru National Park, which includes "The Rock" and the weathered domes of Katatjuta, is in fact now owned by the Aboriginal people, gifted by the Commonwealth government in 1985 and leased back.

Aboriginal Land Rights is a national issue of tortuous complexity. Despite outstanding exceptions, indigenous Australians have had difficulty integrating with mainstream society. The two cultures are so different and previous policies of assimilation failed so badly, that a need for "National Reconciliation" became a social and political goal. The core to this issue is that Aborigines want traditional homelands returned to them to pursue their traditional ways, to become more self-sufficient, or to gain more indepedence. Substantial progress has been made among the Territory's 35,000 Aborigines, who now own about 50 percent of the land and 80 percent of coastline. Groote Eylandt's manganese generates royalties for the indigenous islanders, and Melville Island, off Darwin—only Tasmania is bigger—was handed to the resident Tiwi people in 1978. How cultural differences are ultimately reconciled, however, remains unclear, unresolved, and vexing. ■

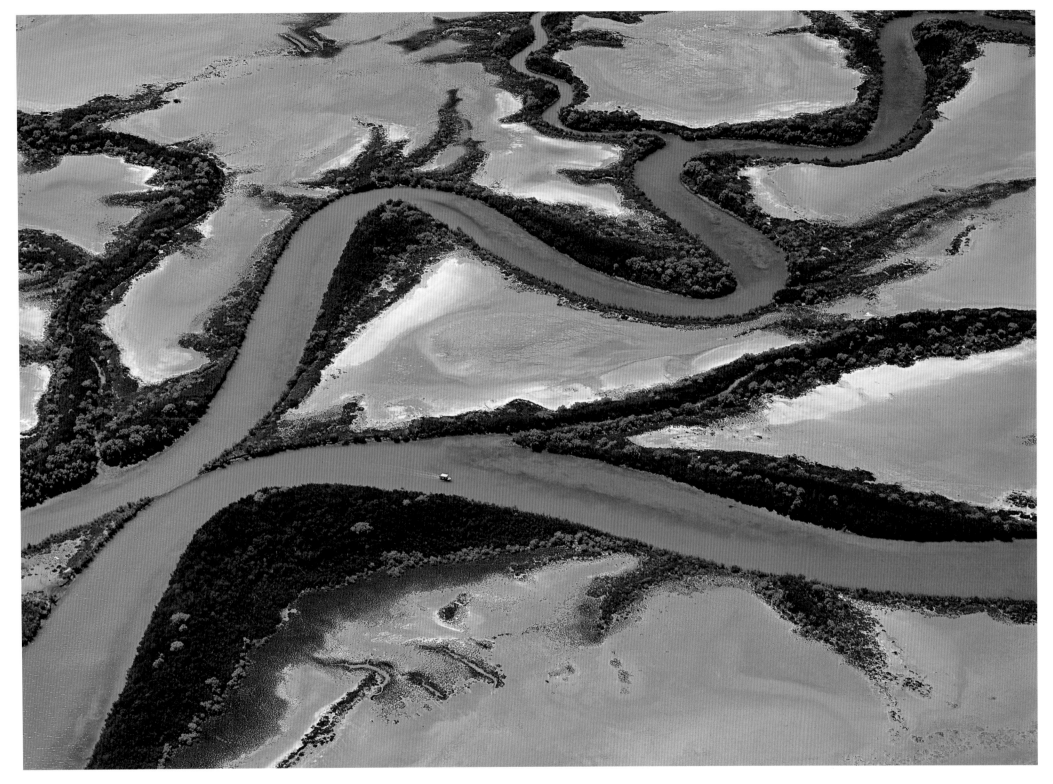

■ ABOVE : Fishing boat

Where the sea inundates the coastal plains daily, complex drainage patterns become established, each tidal channel clearly defined by a dark green fringe of mangroves. To early explorers these channels seemed a chaotic maze of crocodile-infested creeks, but an aerial view reveals the astonishing order inherent in the fractal nature of such systems. Looking closer, a lone fishing boat snakes its way along one the of countless waterways that flow through these Northern Territory saline flats. Barramundi fish and giant mud crabs are local delicacies that are prized by restauranteurs around the country. This creek is between the Wearyann River, Clarkson Point and South Vanderline Island, but those early explorers were right : from ground level it looks identical to a thousand other tidal creeks in the region—and they are infested with crocodiles.

■ OPPOSITE : Tidal flats, Roper River delta

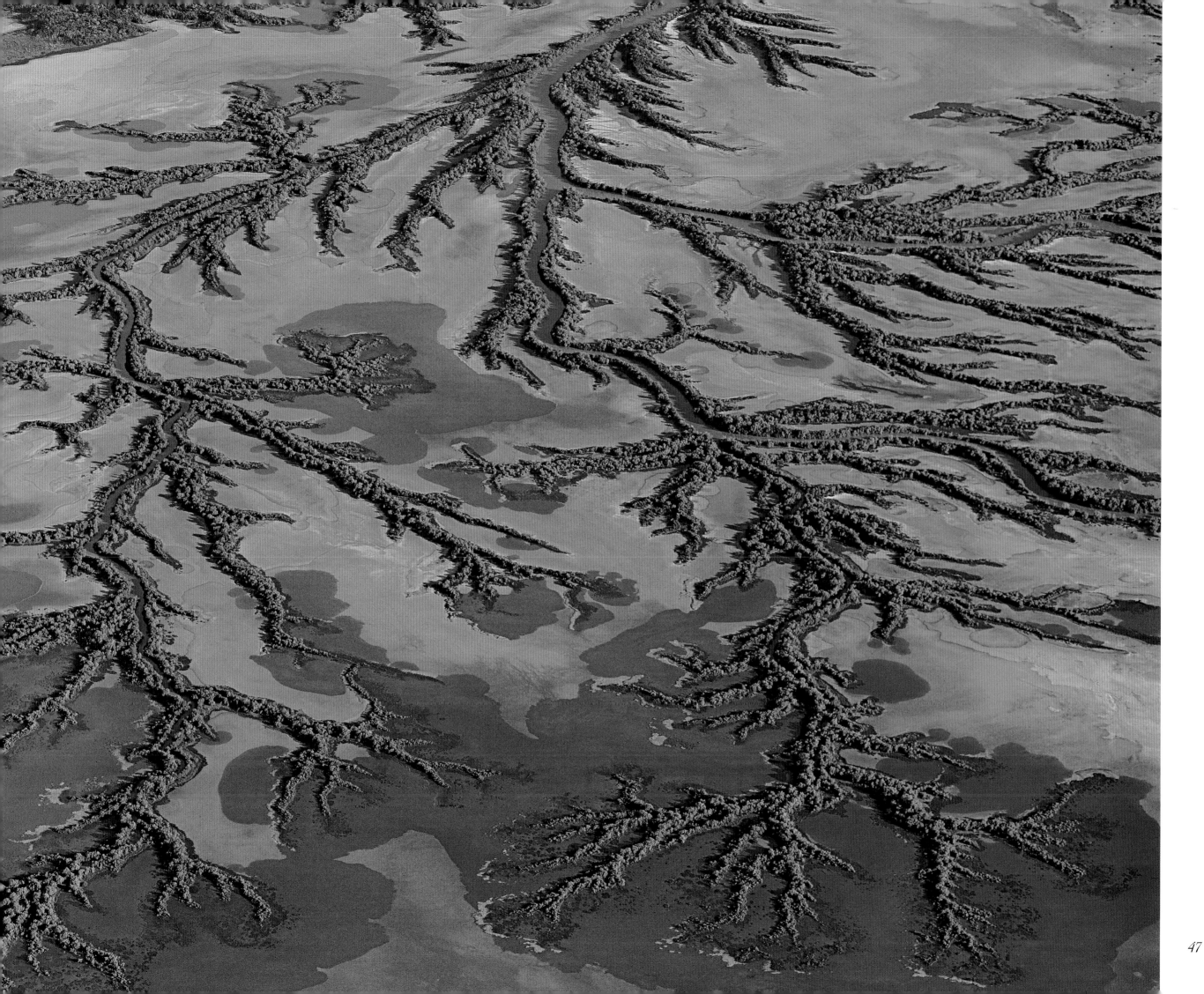

■ ABOVE : Parakeela, *Caladrinia remota*
Evident at Mount Liebig, this vivid succulent helps sustain
cattle in the marginal desert grazing areas of central Australia.

■ RIGHT : Mount Liebig, Central Australia
Draped now in a shroud of iron-stained sands, remains of the
continent's original spine still protrude in many parts of central
Australia. Mount Liebig is one of these old bones, formed from
sediments laid down almost a billion years ago in a shallow
central seaway. Mount Liebig came to mean very different
things to the Ngalia tribe that belonged to this region. It was
their source of children. Having no concept of the relationship
between intercourse and pregnancy, they believed that birth
was the result of a termite-sized child-spirit entering a woman's
body if she sat in the shade of certain trees in this region.

■ BELOW : Dunn's wattle, *Acacia dunni*
This tropical acacia known as Dunn's Wattle, found only at
the "Top End" of the Territory, produces a dazzling profusion
of blooms when The Wet arrives. The wattle family occurs
throughout Australia, the more common Golden Wattle being
particularly treasured as the nation's floral emblem.

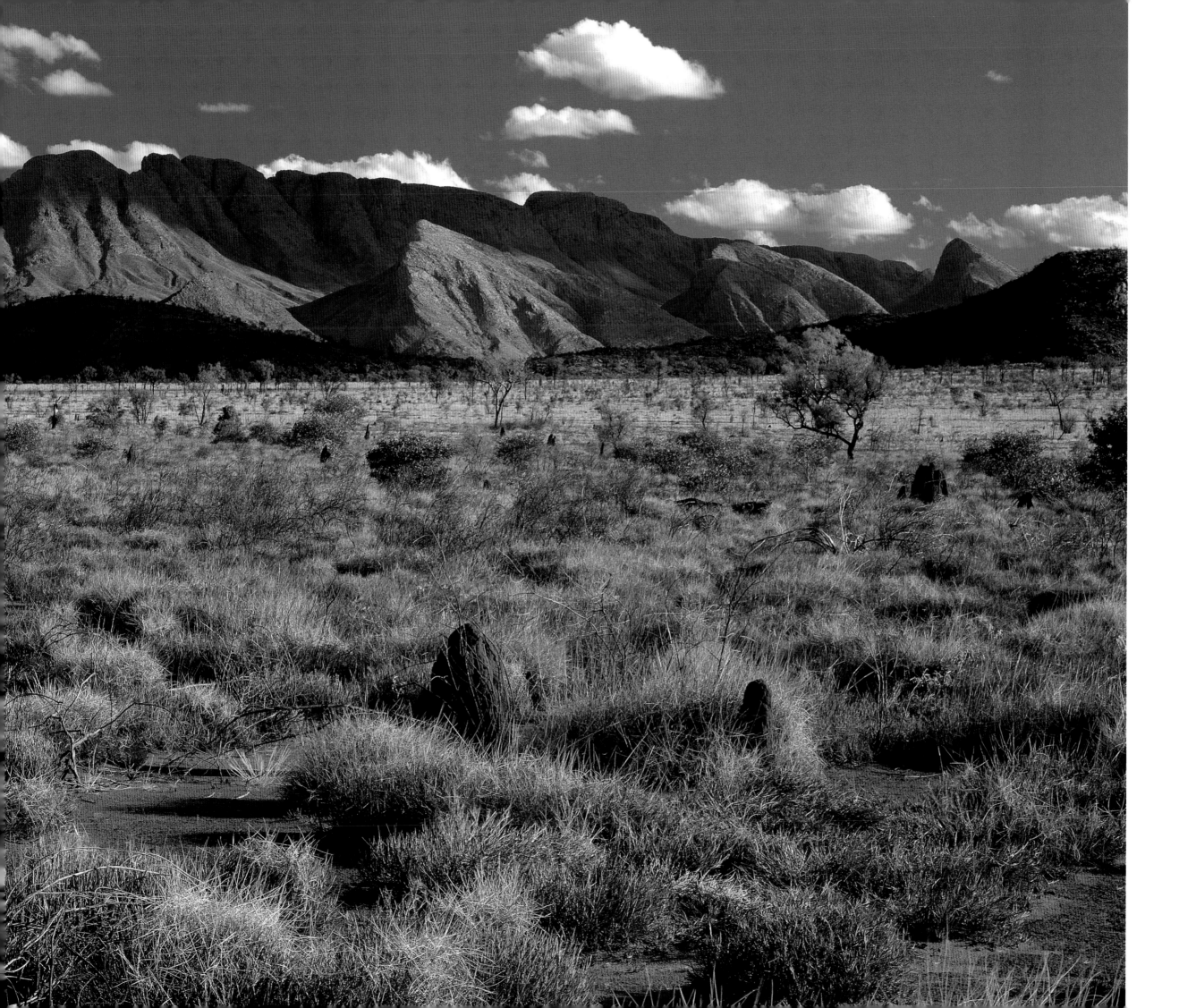

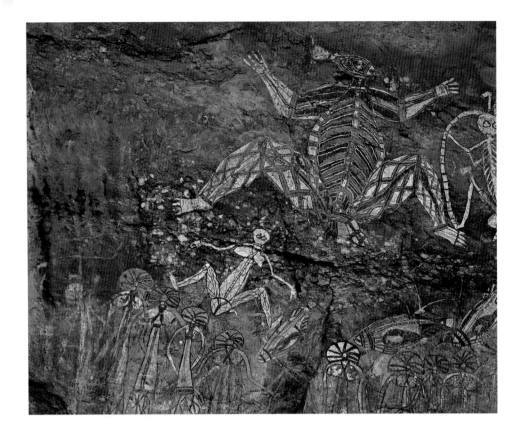

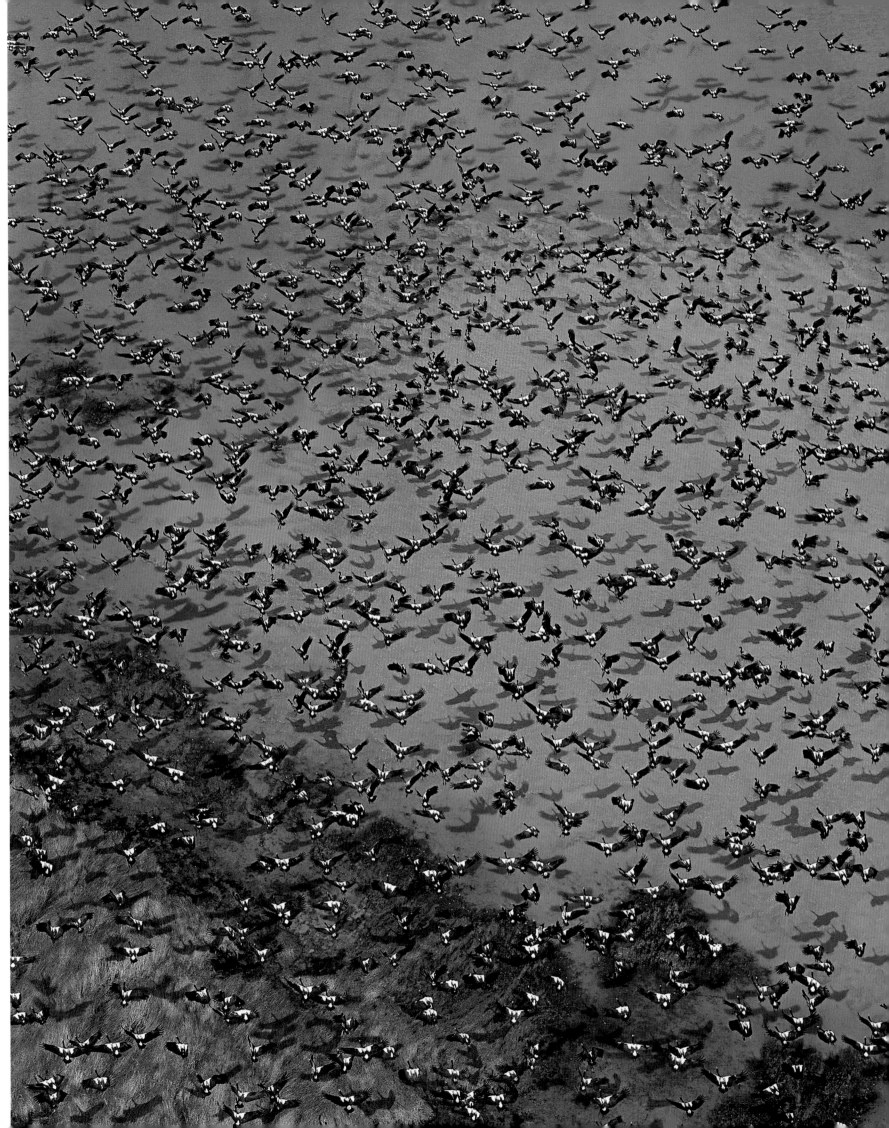

■ Aboriginal art, Nourlangie, Kakadu National Park : X-Ray art (TOP); Mimi art (ABOVE)

Two distinct styles of rock painting decorate caves and rock shelters in northern Australia. The most recent and common form is known as X-ray painting, because it depicts some of the internal structure of the subject. This X-ray painting shows a Dreamtime warrior wearing a white feathered headdress. Below him is the wife of the Lightning spirit Namarrgun, who is encircled by a white band of lightning and wears stone axes on his knees, for making thunder. Below them are three X-ray fish and a group of lesser spirit figures. By contrast, the older style (above) displays the spare grace and elongated forms adopted by earlier Aboriginal painters, whose art dates from about 9,000 to at least 18,000 years ago. Modern Aborigines disclaim ownership of these figures, attributing such paintings to the Dreamtime spirits, or Mimi, themselves.

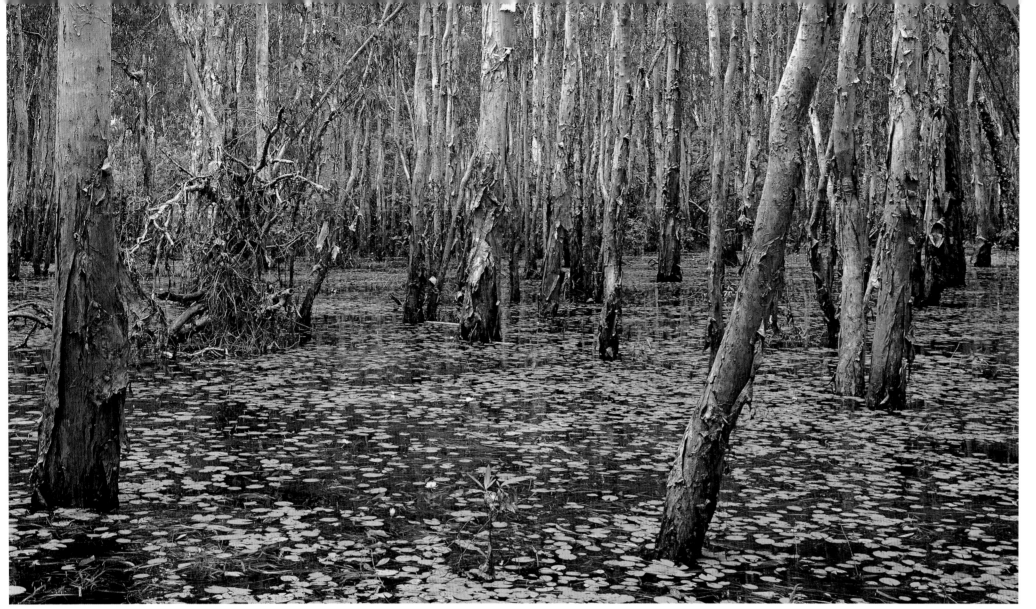

■ **Monsoonal paperbark swamp**

Monsoons that wash over northern Australia—just after Christmas each year—provide the mechanism that recharges the genetic batteries of all species in preparation for the scorching heat of the dry season. The Wet, as the monsoon is called, is a time of abundance, a time to breed. The trees of the floodplains, Paperbarks, Bloodwoods and River Red gums, fill with blossoms and reverberate with the screech of feeding parrots. In a thousand lagoons, beneath canopies of lily pads, fish grow fat, file snakes give birth to their wriggling young, and crocodile mothers ferry squawking hatchlings from their mudbank nests.

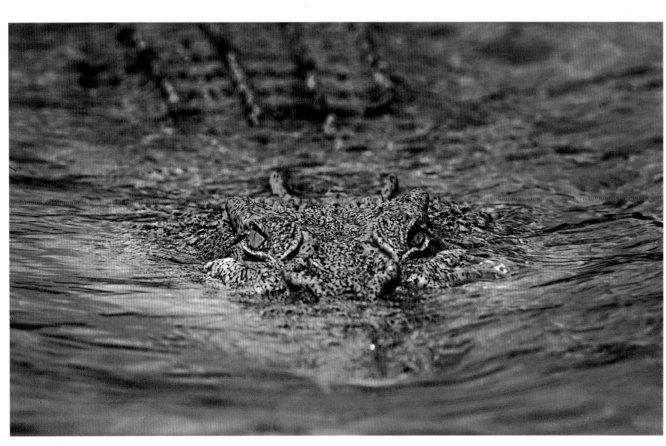

■ LEFT : **Freshwater mangrove,**
Barringtonia acutangular

The night-flowering Barringtonia, or Freshwater mangrove, dangles its elegant racemes of scarlet blossoms above the waterways of Northern Australia as bait for nocturnal pollinators, such as moths. Although Asian rather than Australian in origin, its family is nevertheless related to Australia's eucalypts and displays this link in its flower structure.

■ FAR LEFT : **Estuarine crocodile,**
Crocodylus porosus

The most feared predator of northern Australia's coastline and waterways is the Estuarine crocodile. The species ranges far inland, via the region's monsoon-swollen rivers, and has also been seen swimming strongly far out to sea. Adults can grow to more than 7 metres (20 feet) long and will readily attack unwary humans. To minimise the risk of ambush, traditional Aborigines avoid returning regularly to the same patch of river or coastline when collecting water or spear fishing.

■ OPPOSITE : **Magpie geese,**
Anseranas semipalmata

In October, when the dry season finally ends, Magpie geese flock in incredible numbers to the South Alligator floodplains of Kakadu.

■ RIGHT & BELOW : The Amphitheatre, Palm Valley, Central Australia
Some extremely ancient plant species that would not normally cope with the blistering summers of modern Australia's heartland have managed to survive in tiny refuges in the James Ranges. The most notable of these plants is a tiny population of unique Livistona palms (*Livistona mariae*) that cluster in narrow gorges carved by the Finke River and its tributary, Palm Creek. These are rare survivors of the tropical flora that once covered most of the continent.

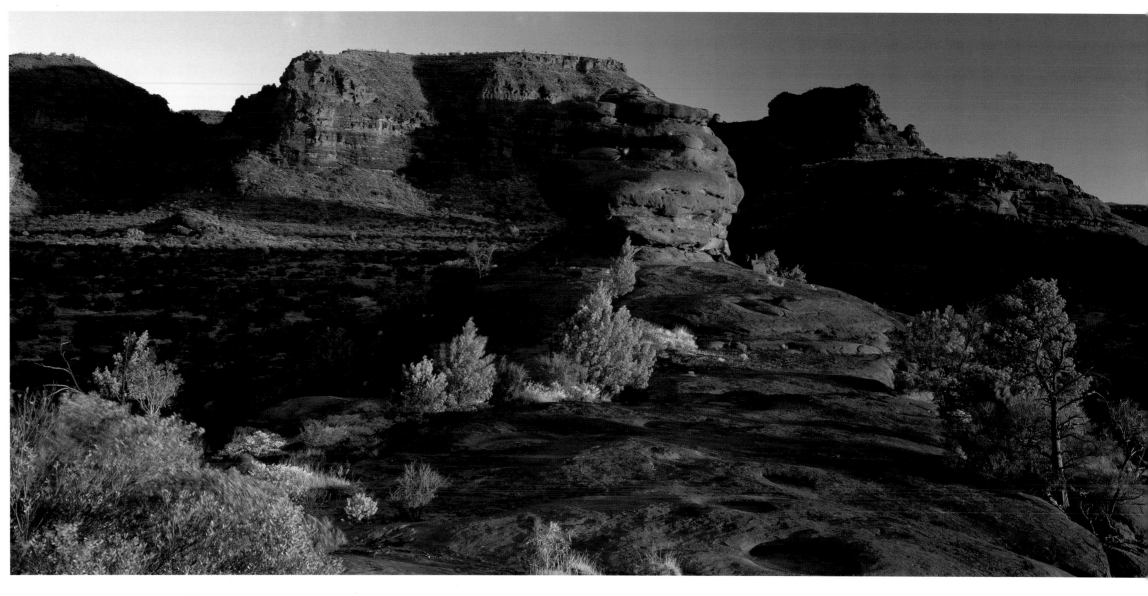

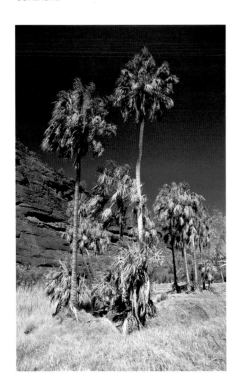

■ LEFT : Camel herdsman in the James Range
Noel Fullerton, seen here sheltering in a cave in the James Range, was a pioneer in reviving the use of camels in central Australia. Camels were brought to Australia—along with their Afgan drivers—as a practical means of transportation in the arid inland. When motorised transport made them rendundant, the abandoned camels went feral, building up into significant wild herds. Now they are being tamed again or specially bred, largely for the tourism, including camel races. In fact, the camels have fared so well in the outback that exporting animals back to their traditional lands is in prospect.

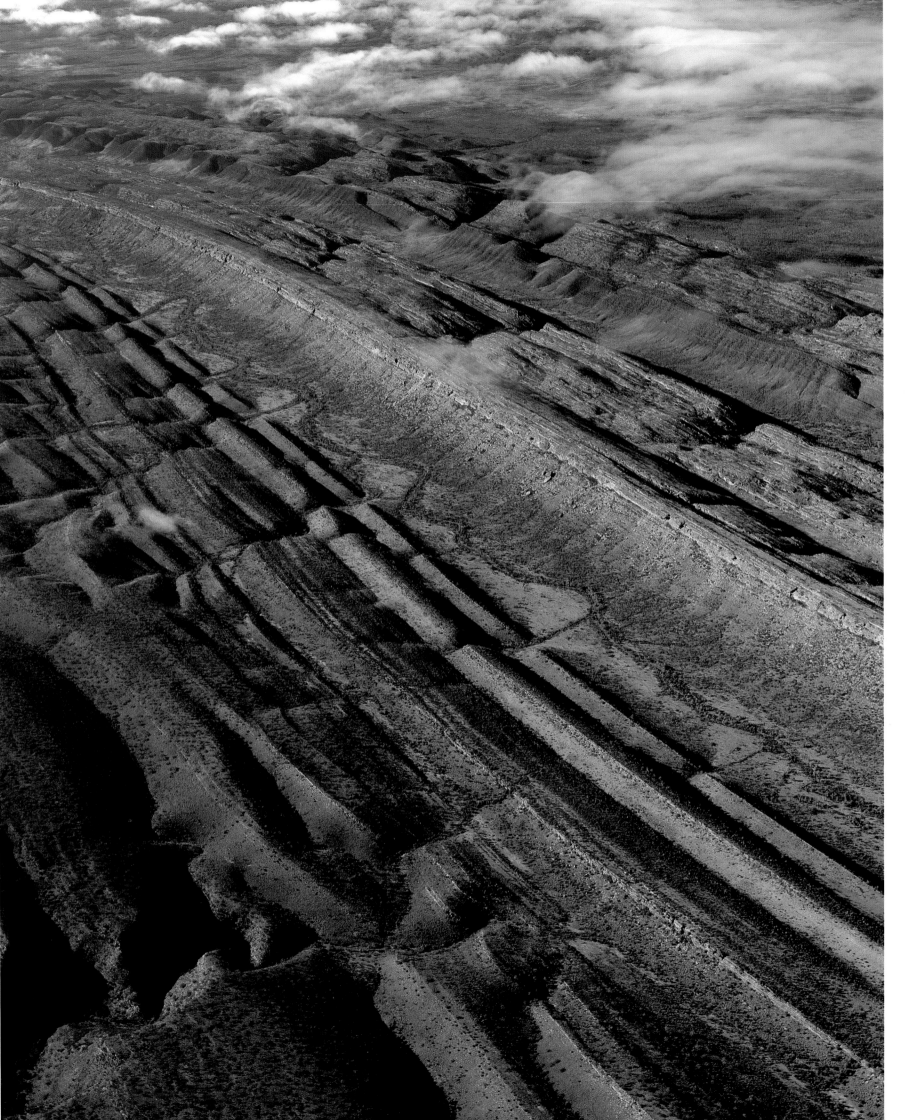

■ LEFT : James Ranges, Central Australia
The neatly scalloped rows of eroded bedding of the
James Ranges are the stubby remains of a massive fold
that rippled through central Australia some 330 million years
ago, during the continent's last internal mountain-building
event. Planed down by a continental ice sheet that closed
over the region some 30 million years later, and filleted
by erosion, the modern ranges give little hint of their
former size.

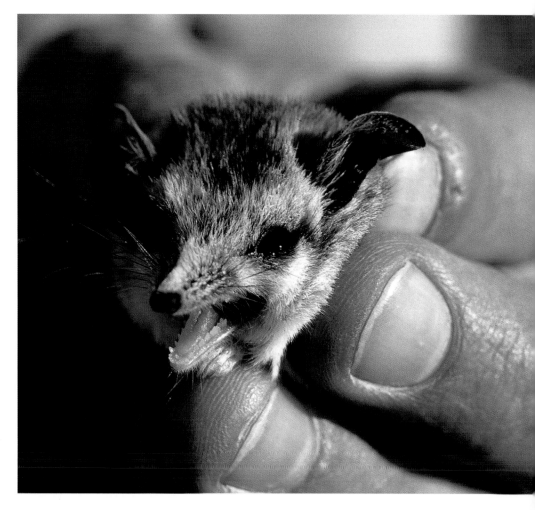

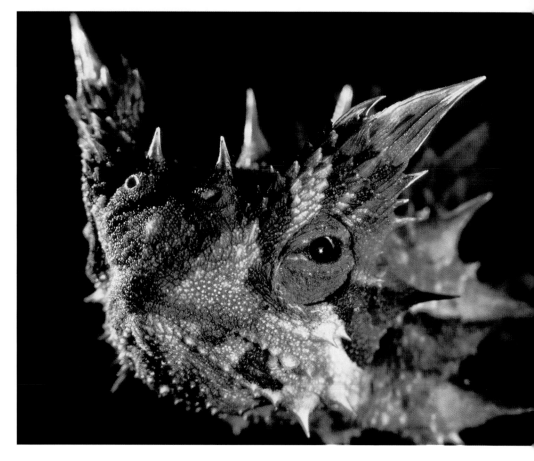

■ ABOVE : Shield Sprimps of the desert, *Triops australiensis*

■ ABOVE RIGHT : Youngson's dunnart, *Sminthopsis youngsoni*

■ RIGHT : Thorny Devil, *Moloch horridus*

■ OPPOSITE : The Simpson Desert

Australia's deserts

Australia's three major sand deserts, The Great Sandy Desert of Western Australia, and the Simpson and Strzelecki Deserts of central and eastern Australia, are products of the current ice age. Groomed by an unrelenting pattern of prevailing winds, the dunes in these regions rise more than 30 metres (80 feet) high in rigidly parallel rows, unbroken in some cases for 200 kilometres (125 miles) or more. Yet despite the lack of surface water and summer's savage heat, the apparent sterility of these regions is deceptive, for the deserts' gigantic genetic engines are concealed beneath its barren surface. Apart from a few lizards, such as the daunting Thorny Devil—which is harmless, feeding solely on ants—most terrestrial animals live underground. They emerge only at night. Most are predators, the most fero-

cious of which are the dunnarts, minute members of an ancient marsupial family which, in wetter times, hunted through Australia's woodlands in much larger form. Only during major flooding does the desert reveal the extent of its staggering biological wealth. Almost before the last storm cloud has passed, a silent explosion of seeds and eggs begins, as a new generation of opportunists races to establish a genetic foothold on the future. Then, the barren dunes are submerged beneath a tide of flowers, pools fill with minute life, and the air hums with the beat of insect wings. But such abundance is necessarily brief. In a matter of weeks the pools evaporate, the pulse of life slows, and the desert's giant engines wind down, leaving the wind to distribute the genetic harvest—billions of new, drought-proofed seeds and dust-sized eggs.

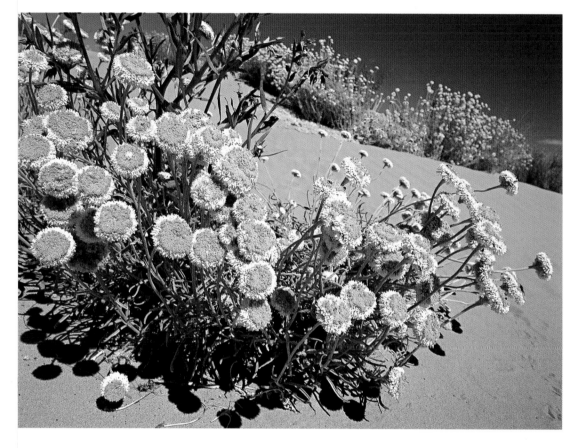

- **ABOVE** : Poached-egg Daisies, *Myriocephalus stuartii*

- **RIGHT** : Lake Amadeus, Central Australia

- **OPPOSITE** : Lake Lewis, Central Australia

The extreme age and stability of the Australian continent is printed all over its flattened face, as is its long history of invasion by the sea. Where the pattern of drainage is inward the land is characterised by clusters of salt lakes, some of them small like Lake Lewis, and some, like Lake Amadeus, sprawling over more than two hundred square miles of Central Australia, and containing salts left by receding seas, hundreds of millions of years ago.

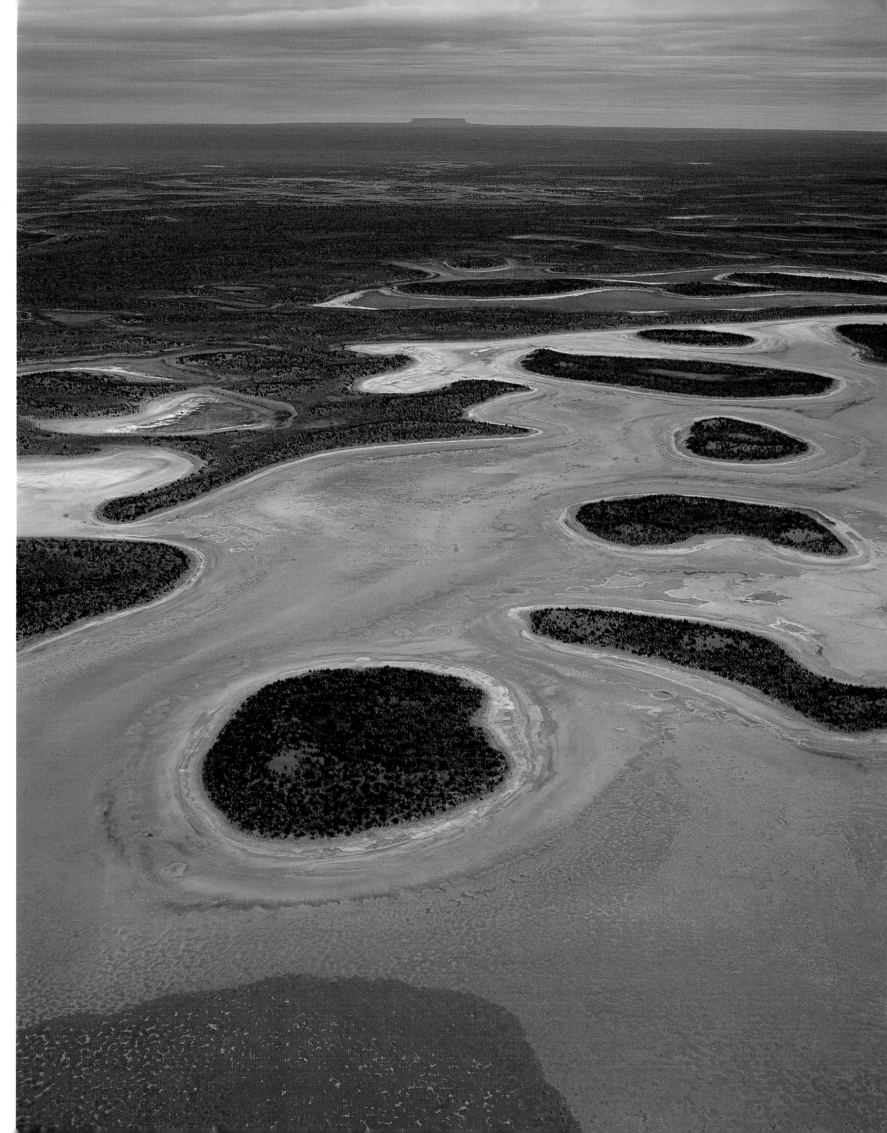

■ RIGHT : Jim Jim Gorge, Kakadu National Park
The assaults of innumerable monsoons have carved the edge of the ancient Arnhem plateau into a palisade of rugged battlements and precipitous gorges. Larger gorges, like this one at Jim Jim, never entirely dry out and harbour remnants of the tropical forest that once covered much of northern Australia. The Aboriginal inhabitants of the Kakadu region invested such places with great mystical significance, depositing the bones of their dead in the deeper grottos, and decorating the walls of their rock shelters with ochre images of the plants and animals that sustained them and the spirit figures that peopled their Dreamtime legends.

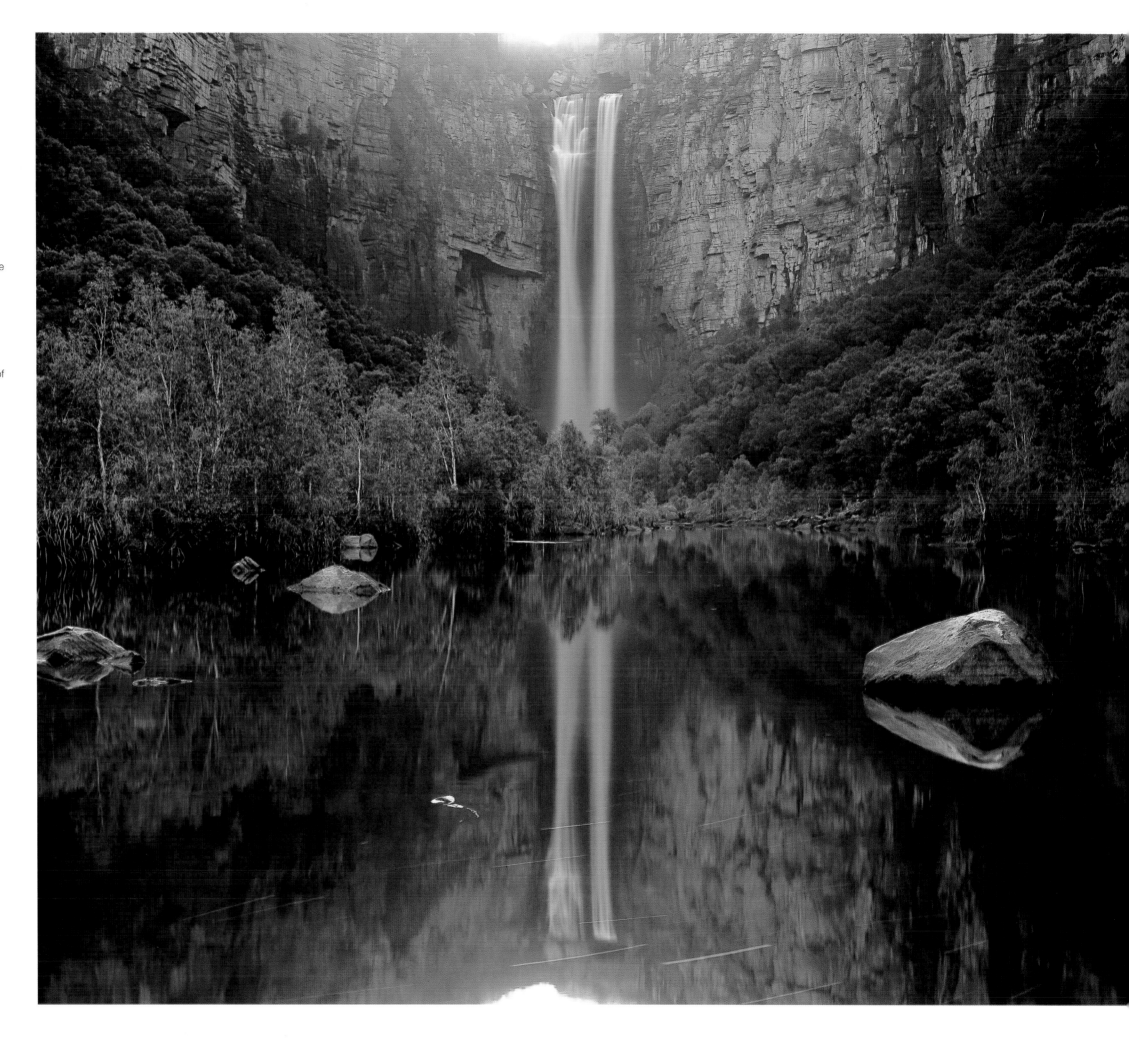

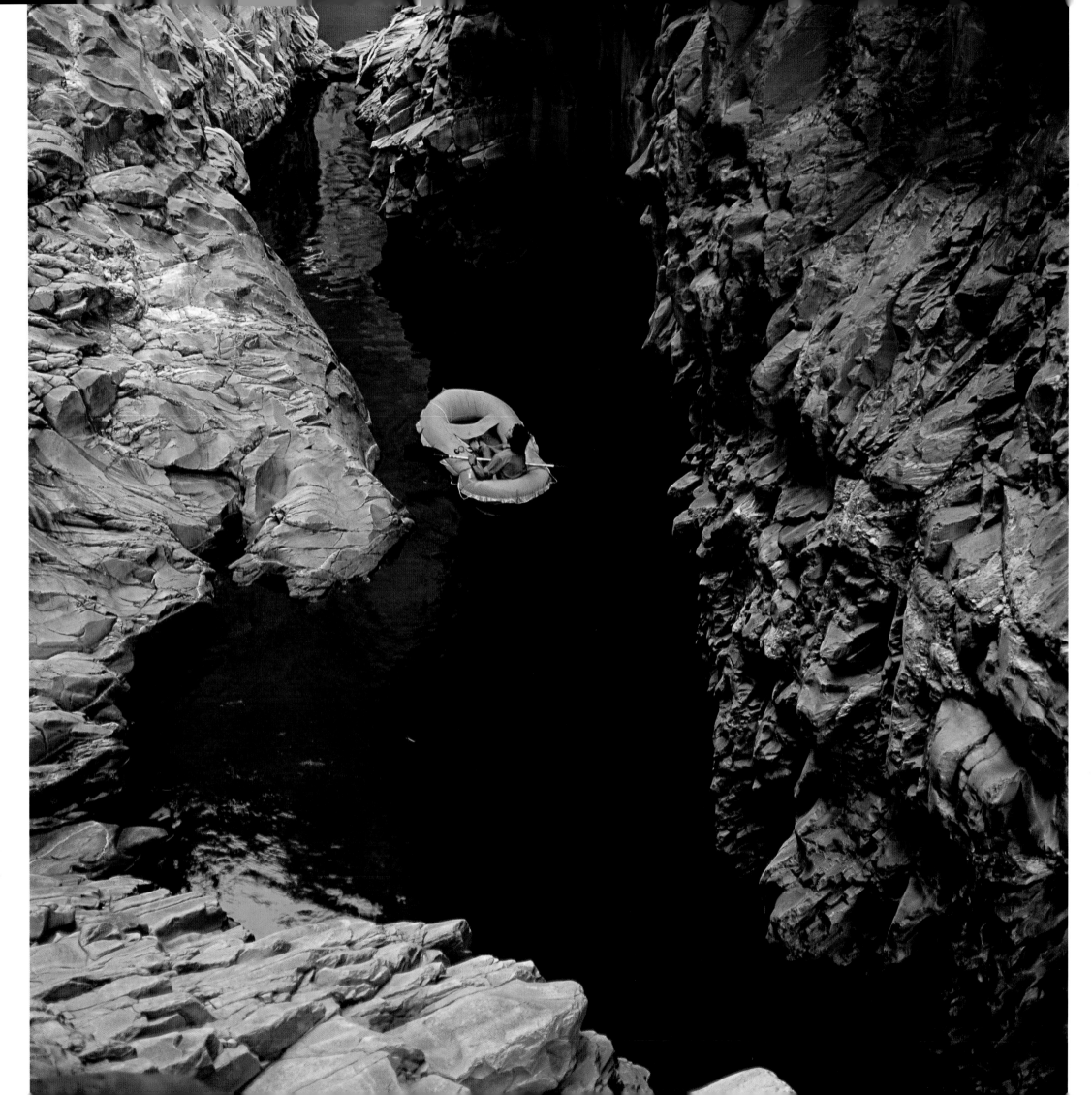

■ LEFT : Serpentine Gorge, MacDonnell Ranges, Central Australia

Many rivers in central Australia are older than the hills. They do not rise in the highlands as do most rivers, but wind right through the ranges from one side to the other via narrow water-worn slots like this one at Serpentine Gorge. It is as though the modern ranges have risen later—which, in a sense, is true. The Todd River, for example, is known to have maintained its present course for at least 15 million years, perhaps much longer. Subjected in the meantime to grinding erosion, the ranges through which the Todd and its tributaries flow have migrated several miles in directions dictated by the strike and dip of their bedding planes.

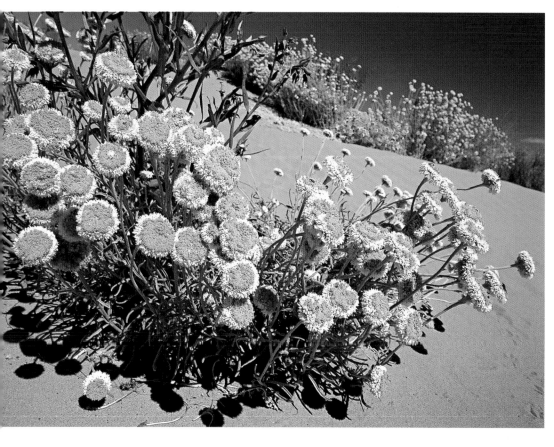

■ ABOVE : Poached-egg Daisies, *Myriocephalus stuartii*

■ RIGHT : Lake Amadeus, Central Australia

■ OPPOSITE : Lake Lewis, Central Australia

The extreme age and stability of the Australian continent is printed all over its flattened face, as is its long history of invasion by the sea. Where the pattern of drainage is inward the land is characterised by clusters of salt lakes, some of them small like Lake Lewis, and some, like Lake Amadeus, sprawling over more than two hundred square miles of Central Australia, and containing salts left by receding seas, hundreds of millions of years ago.

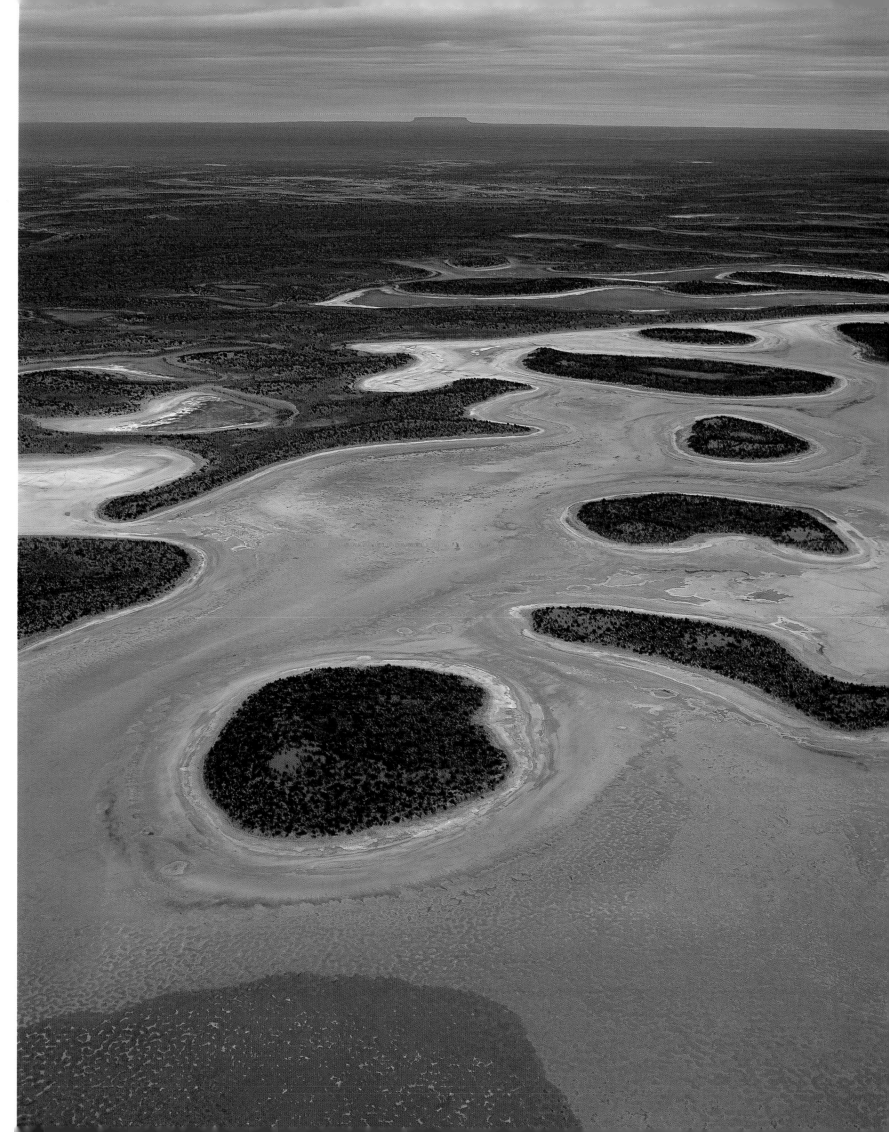

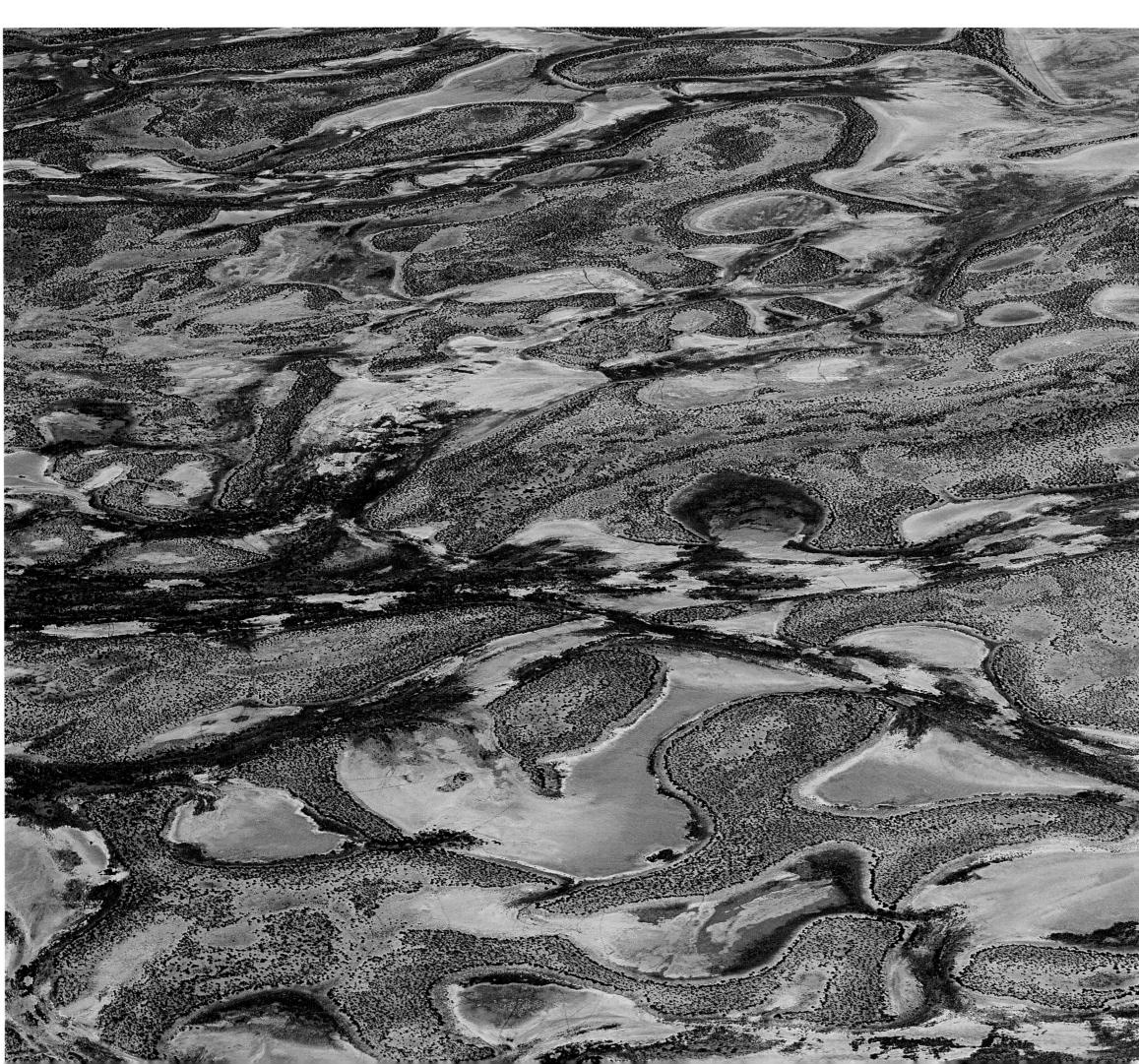

■ Opposite : Perth city, on the Swan River
■ Right : City centre, Kings Park beyond

Western Australia

The western third of the continent was the first discovered and the longest neglected. Though the Dutch named it New Holland in 1644, they coveted no part of the treacherous shores that had brought so many ships to grief. Near the end of the 17th century, Willem de Vlamingh consigned it to history as a "barren, bare and desolate region." English buccaneer William Dampier, who explored the northwest at that time, was similarly scathing. So the land languished unwanted for yet another century. Even when colonial NSW extended westward in 1825, its new border, set at Longitude 129° East, deliberately excluded the western third.

The first British foray there a year later was more to deny the French any foothold than to open up the region. Twenty soldiers and 24 convicts were dispatched 2,500 nautical miles from Sydney to King Georges Sound. Their implausible purpose was to give the inquisitive French the impression that the western third of the continent—an area the size of India!—was already settled. Such were the times.

Ironically, the first European to be enchanted by the west was cruelly deceived. When Captain James Stirling explored the Swan River (1887), he thought the profusion of vegetation along its banks indicated richly fertile soil. Nevertheless, Stirling's enthusiastic advocacy led a reluctant British government to agree to a settlement, but without convicts. This was to be the first free settlement in Australia, and largely self-financing, with land allocated in accordance with the goods and chattel that settlers brought.

It was a disaster. The native vegetation that so beguiled Stirling was in fact highly adapted to very poor soil. Land beyond the river was worse, characterised by sand, limestone ridges, and swamps. While surveyors searched in vain for arable acres, the well-off but ill-prepared newcomers, surrounded by treasured possessions, were stranded in exposed camps where they were whipped by blustering winds, burnt by the sun, and tormented by flies and disillusionment. Many fled the colony at the first chance but the stubborn discovered better soil in the Avon Valley.

Fremantle and the Perth grew very slowly. Constant harassment by local Aborigines petered out after a bloody skirmish known as the Battle of Pinjarra. But a shortage of labour so stifled growth that the colony begged the British Government for convicts, enraging established east coast colonies that were imploring the same government to end Transportation. Yet WA owed much to the 9,500 convicts that came before the practice stopped in 1867. They put substance into the flimsy settlements of Perth and Fremantle, with roads, bridges and such buildings as Government House, the original Town Hall, and the Fremantle Mental Asylum (now a museum), which still stand. Moreover, government money paid to maintain the convicts injected sorely needed cash into a threadbare economy based on sheep, sandalwood, and pearling in the north.

Gold turned WA's fortunes, the most fabulous finds being 500 kilometres (300 miles) east of Perth at Coolgardie and Kalgoorlie in the 1890s. A massive influx of diggers ratcheted up a stagnant population, generated wealth, and when the easy pickings had gone, increased the pool of labour. It also exacerbated the colony's most poignant shortage. The ratio of men to women, four-to-one at its worst, did not settle to parity until 1947. A more prosaic need was water!

The Kimberley tablelands in the far north receive 70 percent of the State's water. A deluge of 1,500mm (5 feet) falls between December and March. This does not suit crops, but it sustains grasses that feed 600,000 head of cattle and 100,000 sheep there. Monumental effort to harness the annual Wet season flooding of the otherwise parched northern rivers have been inconclusive. The Ord River was dammed in the 1960s to create Lake Argyle, nine times the size of Sydney Harbour, but it is yet to yield suitably profitable crops.

Another 20 percent of the State's water resources falls in the southwest corner. The rest of the State, indeed the vast majority of it, shares the remaining 10 percent, including the Pilbara, the Great Sandy Desert in the northeast, the central Gibson and Great Victoria deserts, and the Nullarbor Plains in the southeast.

In the north, fertile flats along the Gascoyne River at Carnarvon support banana plantations, but it is the intensively cultivated southwest that overshadows all other agricultural production. There, clover, crop rotation, superphosphates and trace elements are used to improve the light soil's carrying capacity. The result is a vast wheatbelt stretching from Northampton down to Esperence in the southeast. More than 4 million hectares (10 million acres) yield Australia's biggest wheat crop of more than 7 million tonnes, and carry 30 million sheep and 600,000 cattle.

The State's economic powerhouse, however, is mining. Iron ore more than compensated for a decline in gold. There are literally mountains of it in the northwest; Pilbara deposits alone may exceed 100 billion tonnes. Oil may be less promising, but natural gas reserves on the Northwest shelf are clearly gigantic. Bauxite, coal, nickel, tin, manganese, and Argyle diamonds all contribute to a bursting minerals portfolio.

Local rock lobsters ("crayfish") and prawns drive a robust coastal fishing industry and Margaret River's fine regional wine of the southwest is much admired. But the most regal of the State's natural treasures are the 2 million hectares (5 million acres) of "King" karri and jarrah forests in the southwest. The karri, towering 80 metres (220 feet), is one of the tallest on earth, but the shorter flint-hard jarrah is equally prized. Generations of logging come at a cost, however, and environmentalists have become increasingly protective.

West Australians are so fiercely proud that they once voted 2-1 to secede from the federation, though good sense prevailed. It is by far the biggest and one of the fastest growing States, even if its capital Perth—the nation's fourth biggest city—remains one of the most isolated cities in the world. Unquestionably handsome, affluent and confident, it is hard to reconcile with the lonely colony that started so very badly.■

■ RIGHT : Scarlet Banksia, *Banksia coccinea*
The southwestern region of Western Australia is the flower
basket of this botanically rich continent. Not only is this
region unrivalled in the diversity and gaudy abundance of
its spring display, but nowhere else are there so many
endemic species, most of them imbued with great
evolutionary significance. A flower that now blooms only on
a single hilltop in the Southwest may have close relatives in
India or South Africa, in South America, New Caledonia or
New Zealand, indicating a former physical linkage that goes
back more than 100 million years in some cases. This
Scarlet Banksia which now survives only along Western
Australia's southwestern coastine, owes its genetic origins
to South Africa's protea family and is descended from a
common ancestor that spread to Australia via Antarctica.

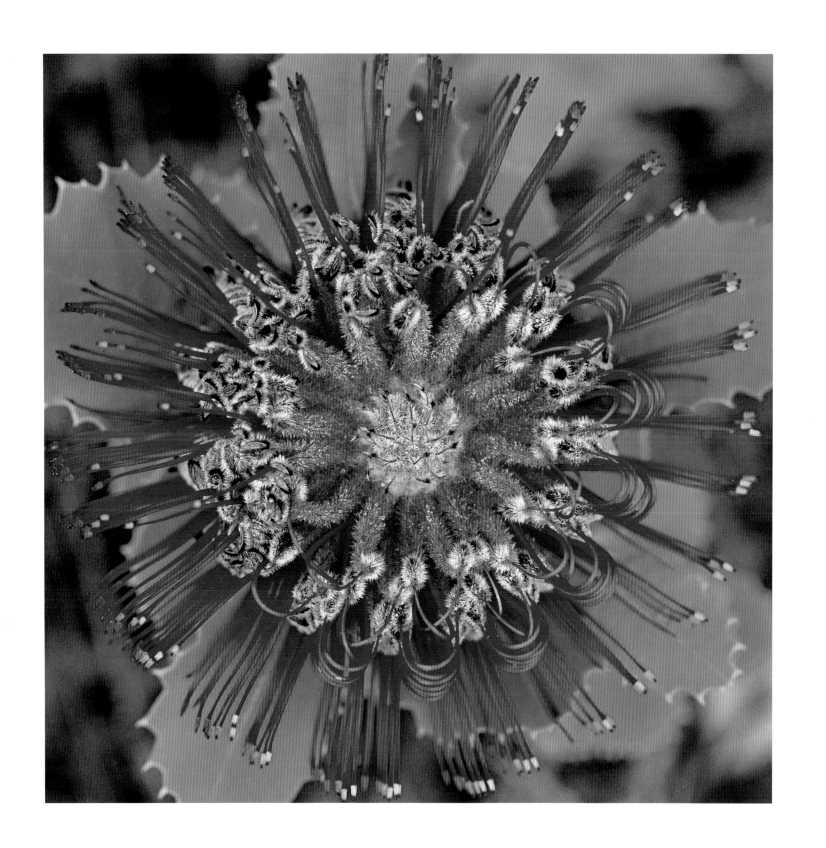

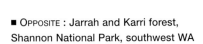

■ OPPOSITE : Jarrah and Karri forest,
Shannon National Park, southwest WA
The forests of the southwest of Western Australia contain
some of the continent's last great stands of hardwoods.
Endemic and best known are the Jarrah, *Eucalyptus
marginata*, and Karri, *Eucalyptus diversicolor*. Before the
tallest specimens—in excess of 90 meters (about 250
feet)—were cut for timber early this century the Karri vied
with the Mountain Ash, *Eucalyptus regnans*, of southeast-
ern Australia, as the tallest flowering plant in the world.
Jarrah was particularly popular for building because of its
resistance to white ants, always a problem in WA.

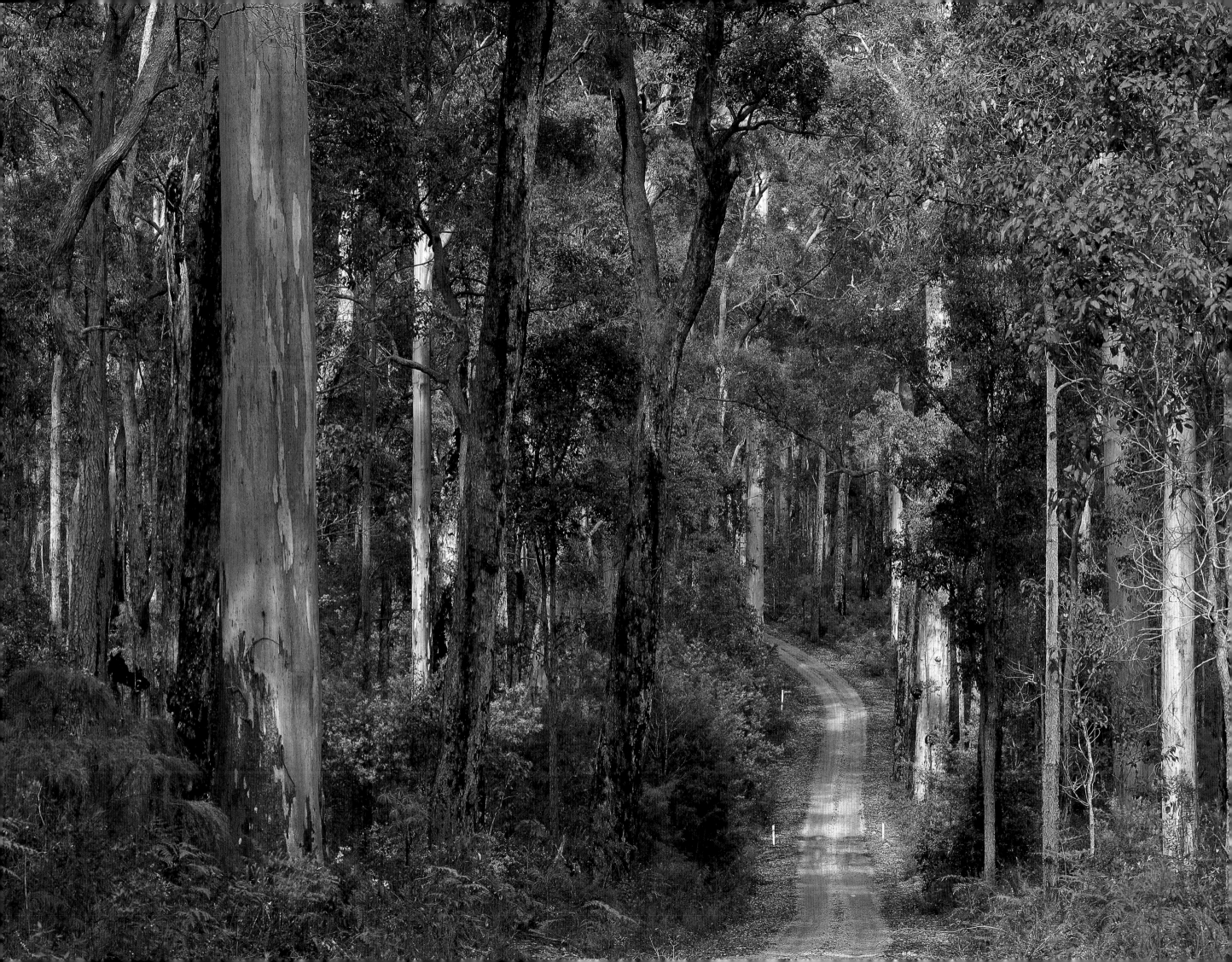

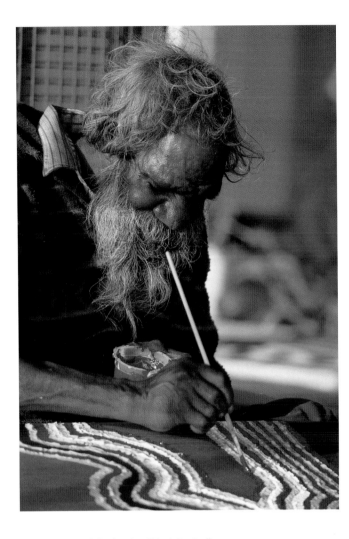

■ ABOVE : Aboriginal artist, West Australia
Australian Aboriginal art, once ignored as primitive daubing, is now highly regarded, bringing undreamed opportunities to remote outback artists. In fact, so valuable has the authentic traditional art form become, that this newcomer to the art world is already being corrupted by fakes and copies. Exhibitions of Aboriginal art, sometimes created in dusty camps by artists with little knowledge of the world beyond their desert region, have been hung in galleries in London, Paris and New York.

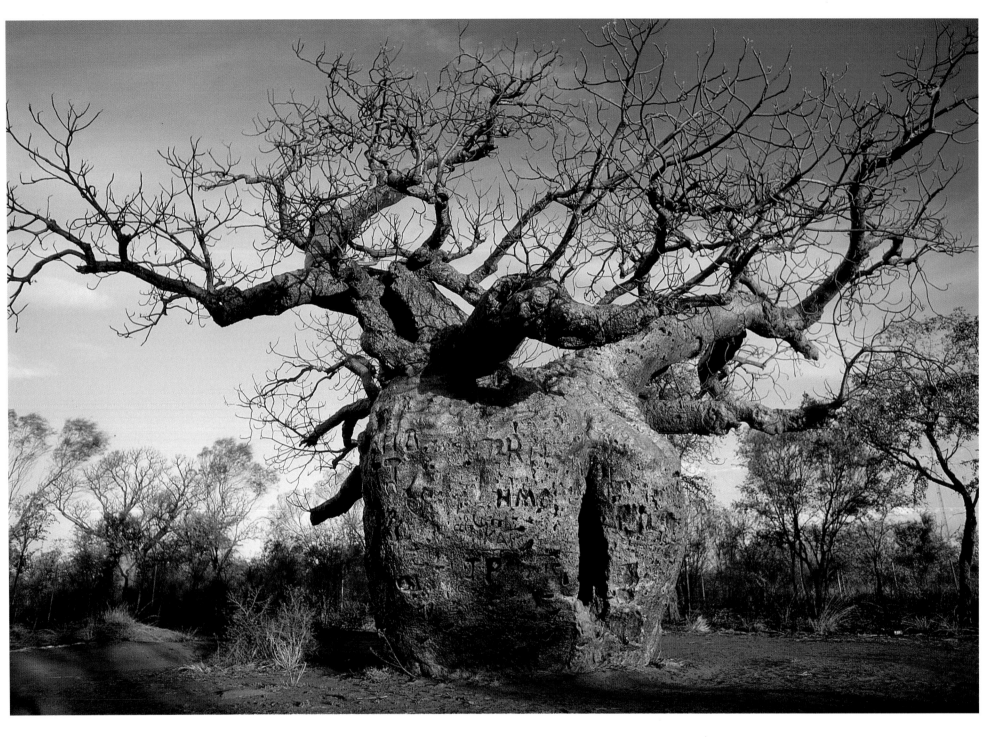

■ ABOVE : Boab tree, *Adansonia gregorii*
During the early days of colonial rule, Aboriginal prisoners were sometimes temporarily imprisoned in the hollow trunk of this ancient boab tree near Derby in northwestern Australia. Boab trees were also called baobabs because of their similarity to the African baobab, with which they are related. In this they offer yet another example of a floral link that is best explained by the theory of continental drift.

■ OPPOSITE : the Bungle Bungles, Purnululu National Park
The banded, bee hive domes of the Bungle Bungles cover 700 square kilometres (270 square miles). They were carved from a slab of layered sediments that were deposited in a rift valley some 400 million years ago. The great maze of valleys and slot canyons, which developed along the sandstone's eroding joint lines, provide shady refuge for many relictual forest species, both plant and animal, that would otherwise have perished under the onslaught of the past 10,000 arid years. This strange landscape and its biological treasury, originally and popularly known as the Bungle Bungles, has recently been redesignated the Purnululu National Park.

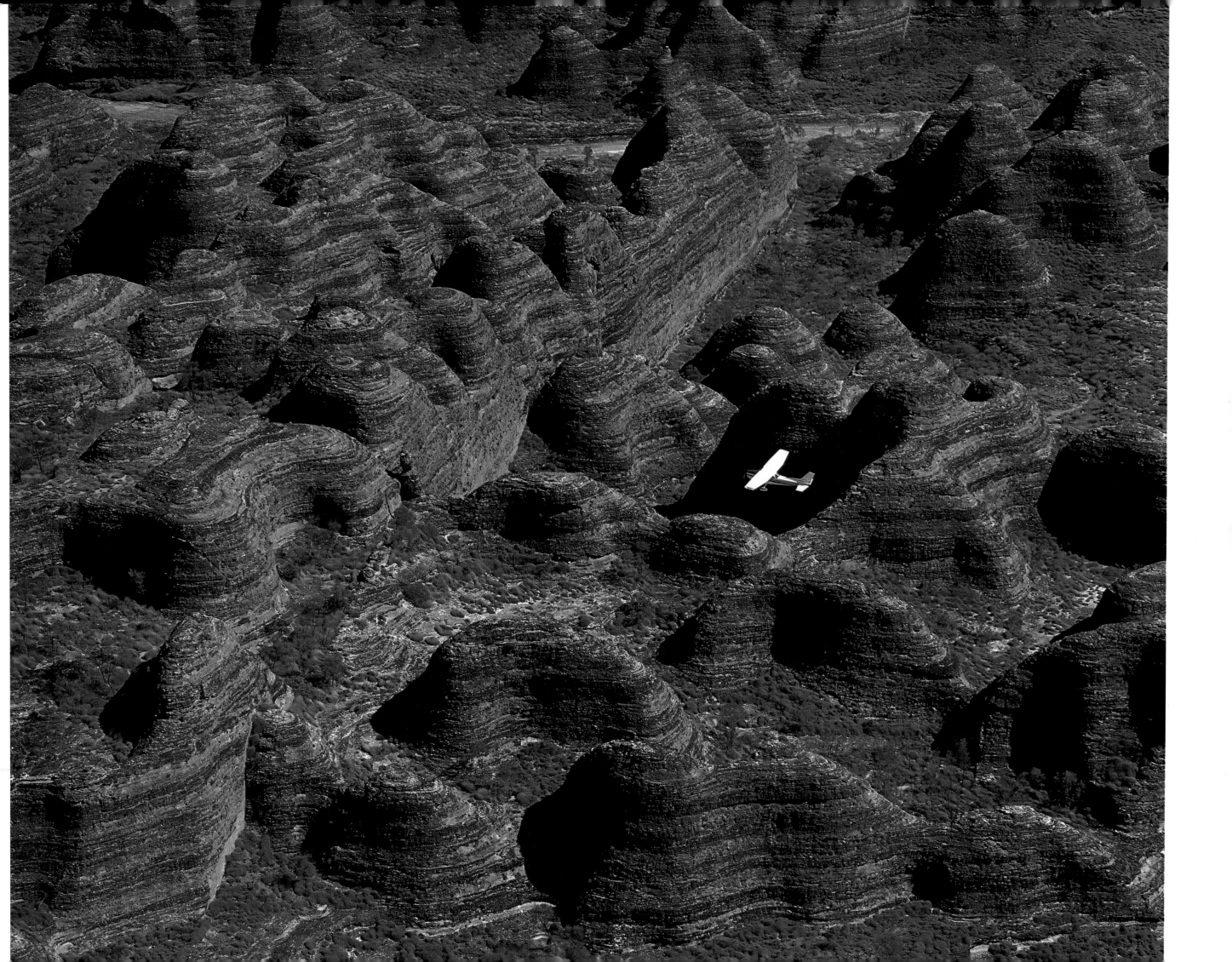

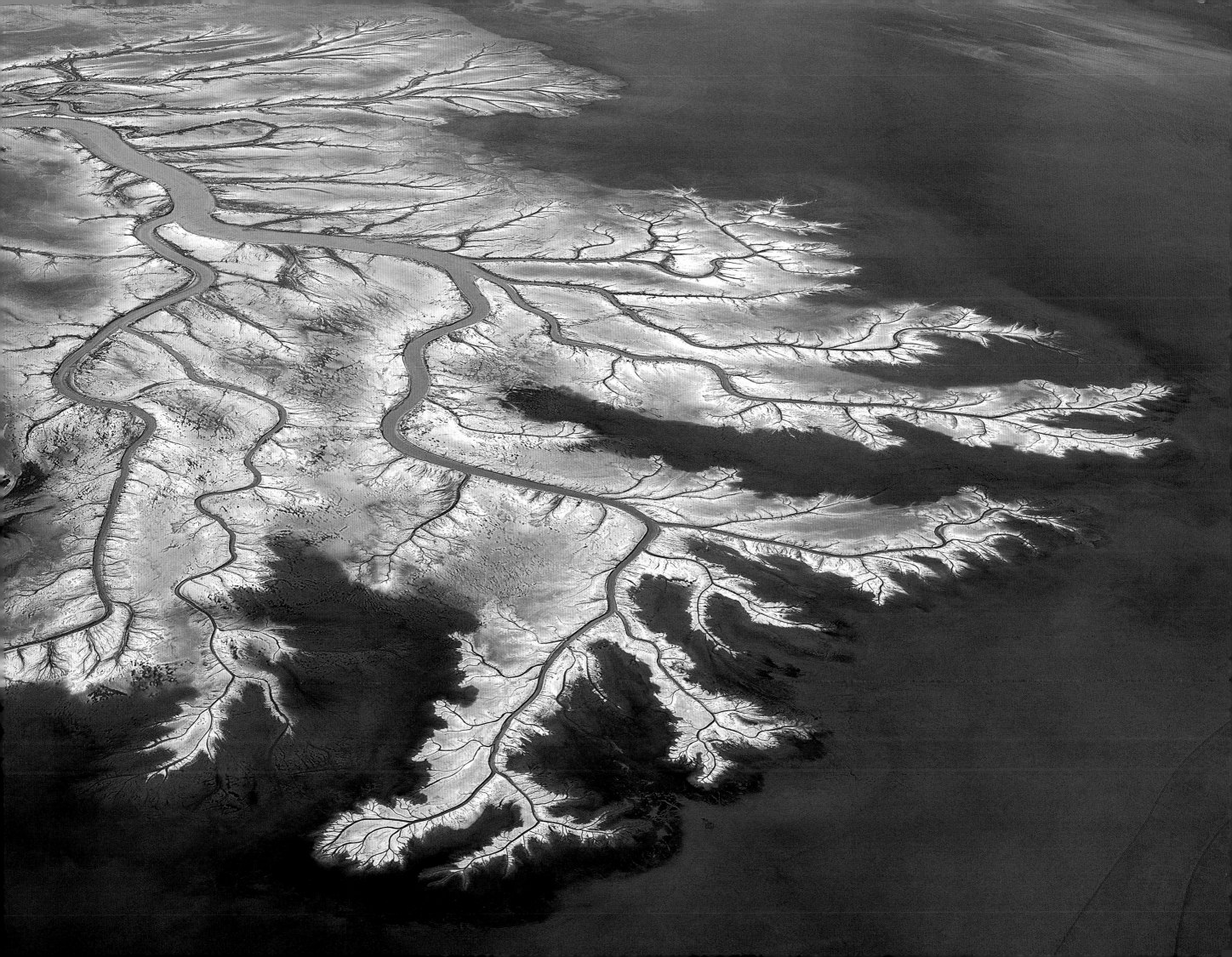

■ ABOVE : Desert watercourse
Two million years of increasing climatic instability and
growing aridity have reduced Australia's complex
drainage systems—and once verdant plains—to a
few dry watercourses lined for the most part by a single
species of hardy gum tree, the River Red Gum,
Eucalyptus camaldulensis. Such dried creek beds dashed
the optimism of many a pioneer, though in fact water
often flows there still. But it is far below the surface, in
the impervious beds of paleodrainage channels that once
would have watered grazing dinosaurs.

■ RIGHT : Fortescue River floodwaters
This congregation of Australian Pelicans, Black Swans,
and ducks amid floodwaters of the Fortescue River in
northwestern Australia signals that the deserts genetic
engines have stirred into life. For the wildlife of inland
Australia, opportunism is the way of life. Regional flooding
not only lures itinerant waterbirds into congregations, but
it often triggers mating and nesting behaviors in many
species, enabling their offspring to take advantage of the
brief biological flourish that such flooding brings.

■ OPPOSITE : Talbot Bay, Buccaneer Archipeligo,
Kimberley coast
Created by rising sea levels at the end of the last glacial
episode, the drowned coast of Talbot Bay hints at the
significance of the inundation that occurred at that time.
Surrounded, as much of it was, by low-lying coastal
plains, the Australian continent lost about one seventh of
its former area between 10,000 and 8,000 years ago,
forcing major changes to Aboriginal tribal boundaries.
Formerly the domain of several different clans, this part of
the Kimberleys is now virtually deserted.

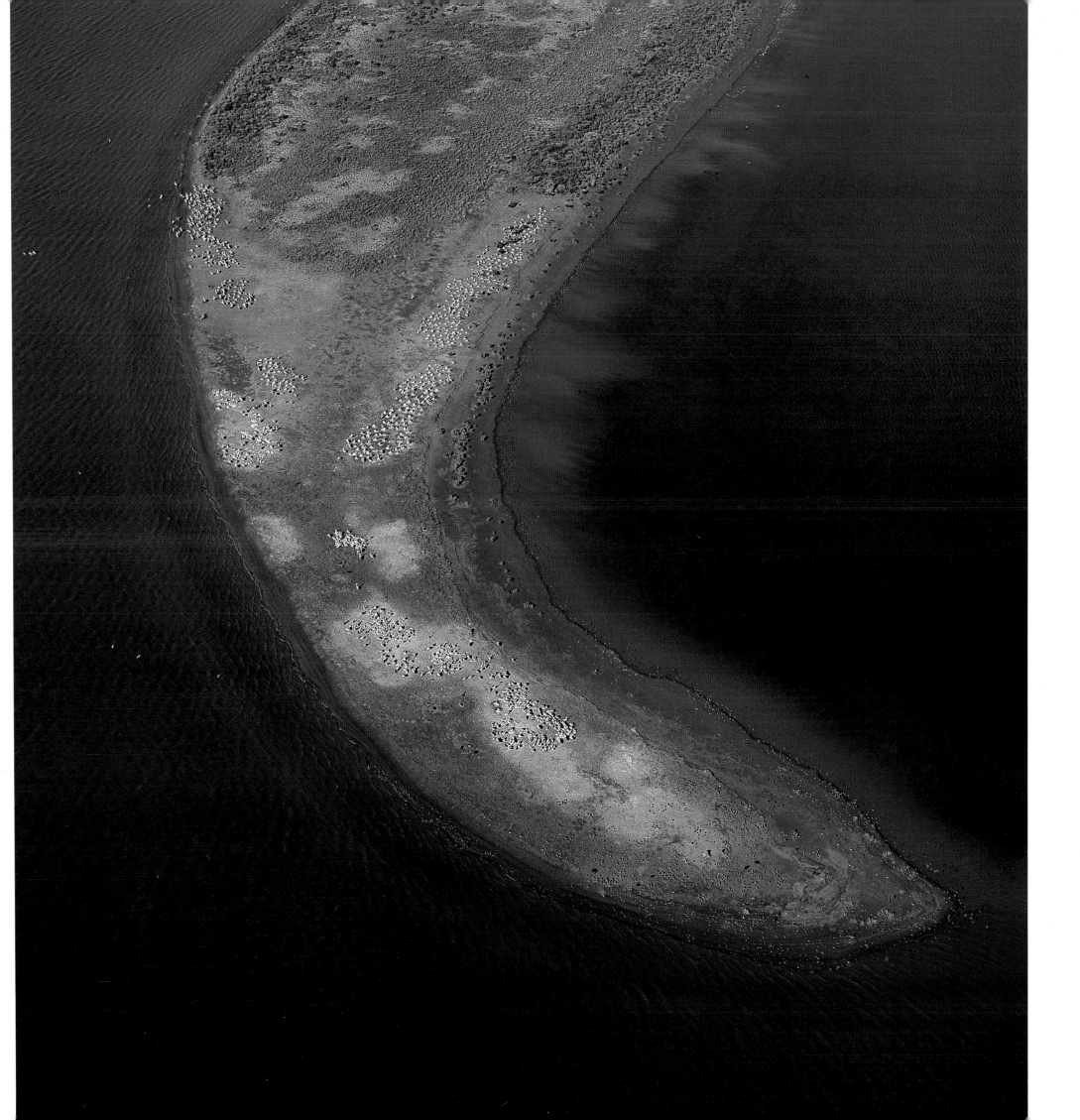

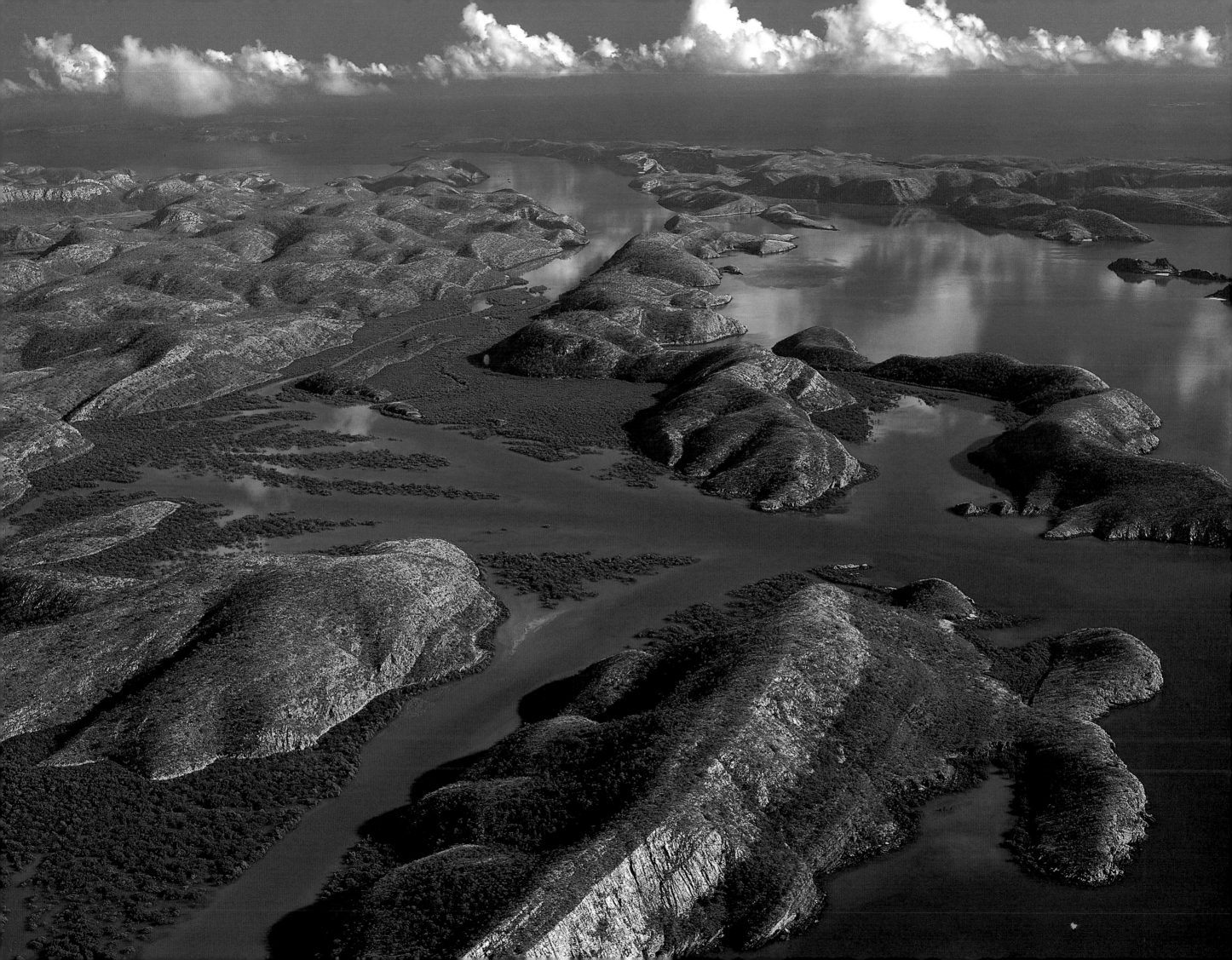

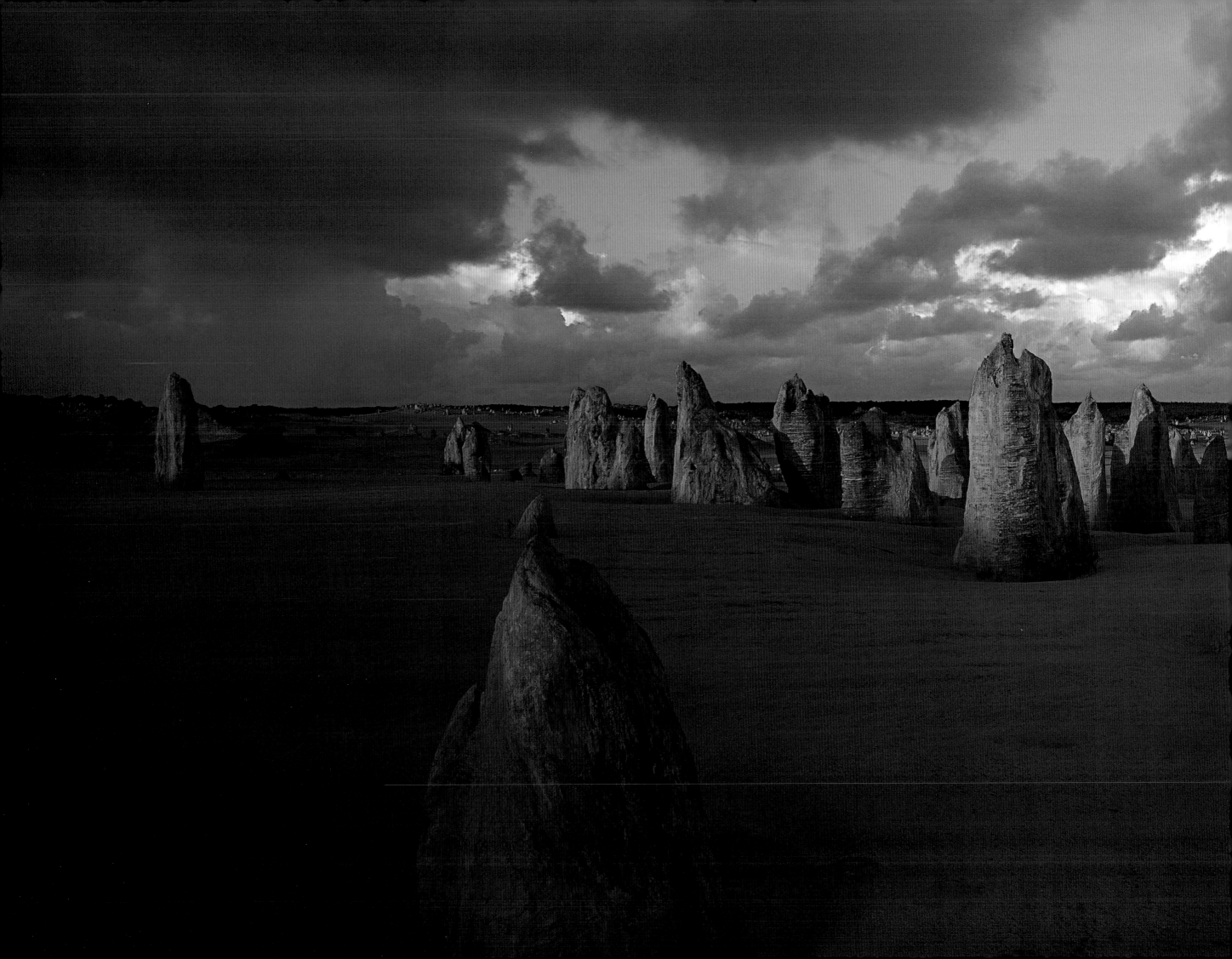

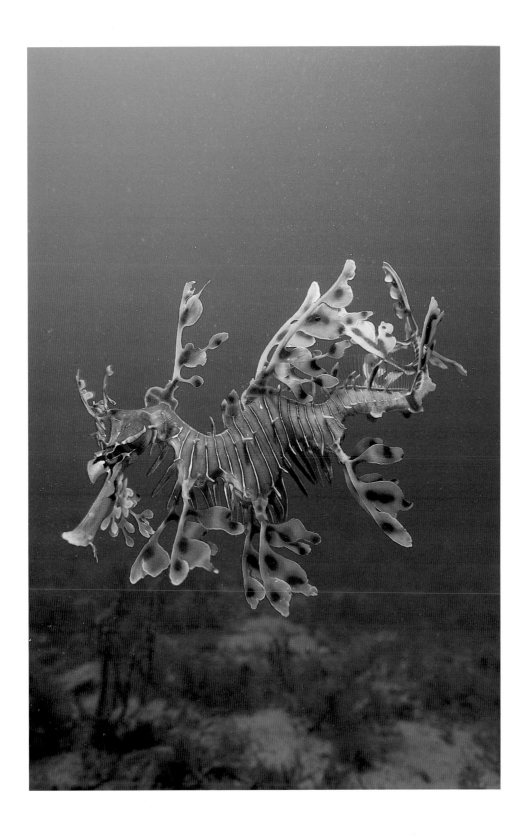

Victims and survivors of climate change

Perhaps more than any other continent, Australia, and particularly Western Australia, shows graphic evidence of the climate changes that have ravaged the world in the past two million years. Formerly cloaked in vegetation—woodland, grassland, and forest—the Australian continent has been laid almost bare by the unrelenting assault of dessicating Ice Age summers and whithering droughts induced by the intermittent weather disturbance commonly referred to as *El Niño*. The coming of human hunters, who used "fire sticks" to burn the bush to smoke out prey, helped complete the transformation.

Telling evidence of the desertification of Australia can be seen at a popular tourist site in the Nambung National Park, near Geraldton on the central west coast. The haunting spires of The Pinnacles are in fact the graveyard of a forest. Each spire of cemented sand represents a vertical seepage channel that formed directly below the place where ancient tree roots once broke through the surface. When the trees died, after the last Ice Age, their rotted roots left drainage holes. Carbonates, dissolved from the crust, then filled the seepage channels below these holes, forming solid carbonate columns. In time, when the surrounding sand hills were blown away, the columns were exposed.

Not all trees perished, of course. Some adapted splendidly. The West Australian Snappy Gum (*above*) clinging stubbornly to its rocky cliff in the Hamersley Ranges of the northwest, epitomises the tenacity that enabled so many branches of the eucalyptus family to survive the epidemic of extinctions of the past 2 million years.

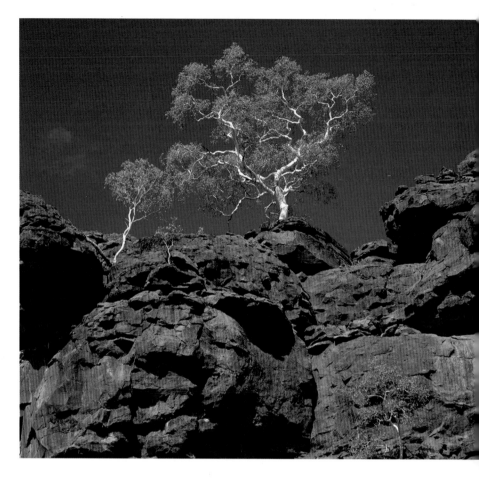

■ Above : West Australian Snappy Gum, *Eucalyptus leucophloia*

■ P.72 : Leafy Sea Dragon, *Phycodurus eques*
Of the millions of life forms that currently inhabit this planet, there surely are few more worthy of wonder than the Leafy Sea Dragon. Hiding among the forests of seaweed that fringe the coastline of South Australia, this spectacular sea horse depends entirely on its flamboyant camouflage to protect it from predators. Moreover, its weed-like appendages represent a pinnacle of adaptive development among the world's modern fauna, a fauna whose evolutionary origins were first recognised in fossil form at Ediacara, on the flanks of the nearby Flinders Ranges in 1946. Representing evolution's earliest experiments with multicelled animal life some 600 million years ago, such fossil fauna is now known around the world as Ediacaran.

■ Left : The Pinnacles, Nambung National Park

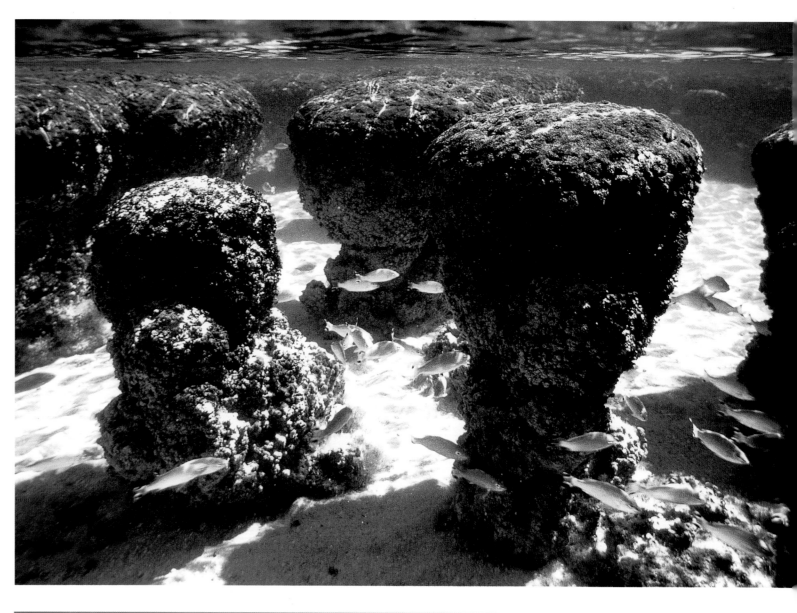

- ABOVE : Fossilised stromatolites, Pilbara region
- RIGHT : Stromatolites, Shark Bay
- RIGHT : Salt works, Useless Loop, Shark Bay
- OPPOSITE : Big Lagoon, Shark Bay Marine Park

A complex of warm, shallow bays on the west coast—known collectively as Shark Bay—spawns an abundance of marine life that includes one of the world's most extraordinary living fossils. Fringing the sandy shoreline of one of the innermost recesses of the bay are colonies of primitive bacteria, each colony living on the upper surface of a bulging pile of limy waste material. The forest of domes and columns the bacteria have built are known as stromatolites. They are repli-cating, in giant form, the oldest traces of life on Earth, the fossils of which have been discovered in the Pilbara (*above*). The bacteria that build them are filled with chlorophyll, their life processes driven by the energy in sunlight. They shut down when the light fades and reactivate with the new dawn, extricating themselves from the night's accumulation of seaborn silt and their own biological wastes, to reestablish the colony on the upper surface of the stromatolitic mound once more. Judging by their slow growth rate of little more than a millimetre a year, the current size of the Shark Bay stromatolites (*right*)—some of which are more than 1.2 metres (4 feet) tall—suggests that they have been growing in this bay for several thousand years. They display a chemistry of life that began at least 3.5 billion years ago, judging by the small fossilised version in the picture above. It was the oxygen gas produced by the descendants of those original stromatolite builders that set the stage for the first oxygen breathing life on Earth.Salt ponds at Useless Loop (*right*) partly explain why Shark Bay is one of only two places in the world where vast populations of stromatolite-building bacteria still thrive. Apparently the multitude of predators that normally graze on such bacteria are deterred by the high salinity and warmth of the bay's innermost recesses.

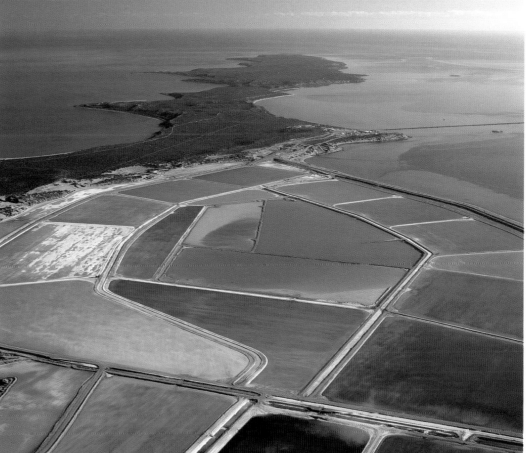

- Opposite : The Shark Bay Marine Park

The marine park on the Peron Peninsula, is part of the François Peron National Park, a World Heritage Area. It was named for the notable French naturalist who visited Australia at the turn of the 19th century with Nicolas Baudin on the *Géographe*. That voyage of exploration yielded more than 100,000 specimens, mostly from Australia, for the Paris Natural Museum of History.

The World's Time Capsule

Western Australia contains, in a sense, a time capsule of the planet, as the following four pages show. Locked within its rocks is the most complete record of early planetary development anywhere on Earth. Here may be found the oldest crustal material of any kind, the oldest known land crust, and the oldest tangible signs of life. Here too, is massive evidence of life's first brush with the resource limitations of our planet, an event that would charge the atmosphere with oxygen, alter the course of evolution, and enable life to emerge from the sea and develop in ways that would eventually give rise to human beings.

■ ABOVE : Zircon crystals from Mount Narryer
Glowing with polarised color, these dust-sized crystals of zircon are the oldest known remnants of the Earth's primordial crust. Some of them began to grow almost 4.2 billion (4,200 million),years ago on a fragment of land that eventually became embedded in the western edge of the Australian continent. They were extracted from rocks at the foot of Western Australia's Narryer Range and individually dated at the Australian National University in Canberra. Meanwhile, the rocks from which they came were also analysed and found to have been formed from river sediments that were laid down some 3.5 billion years ago, making the Narryer Range an outcrop of the world's oldest known land crust.

■ RIGHT : Hamersley Gorge, Karigini National Park, Pilbara
The rusty color of this eroded seabed is surviving evidence of an ancient biological event that led eventually to the evolution of all "higher" life, including ourselves. The rock is colored by oxides of iron that fell out of Earth's primitive seas under the impact of the global explosion of photosynthetic bacteria that occurred some 2.5 billion years ago. A result of that biological explosion was a massive disharge of bacterial waste (see also page 74) in the form of oxygen, which eventually rusted the iron-rich seas and then entered into the atmosphere, where it remains today.

■ OPPOSITE : Hamersley Range, Pilbara region
These ancient rusted mountains of the vast Hamersley Range are now mined for their iron ore, and exported, at great value to Australia's modern economy.

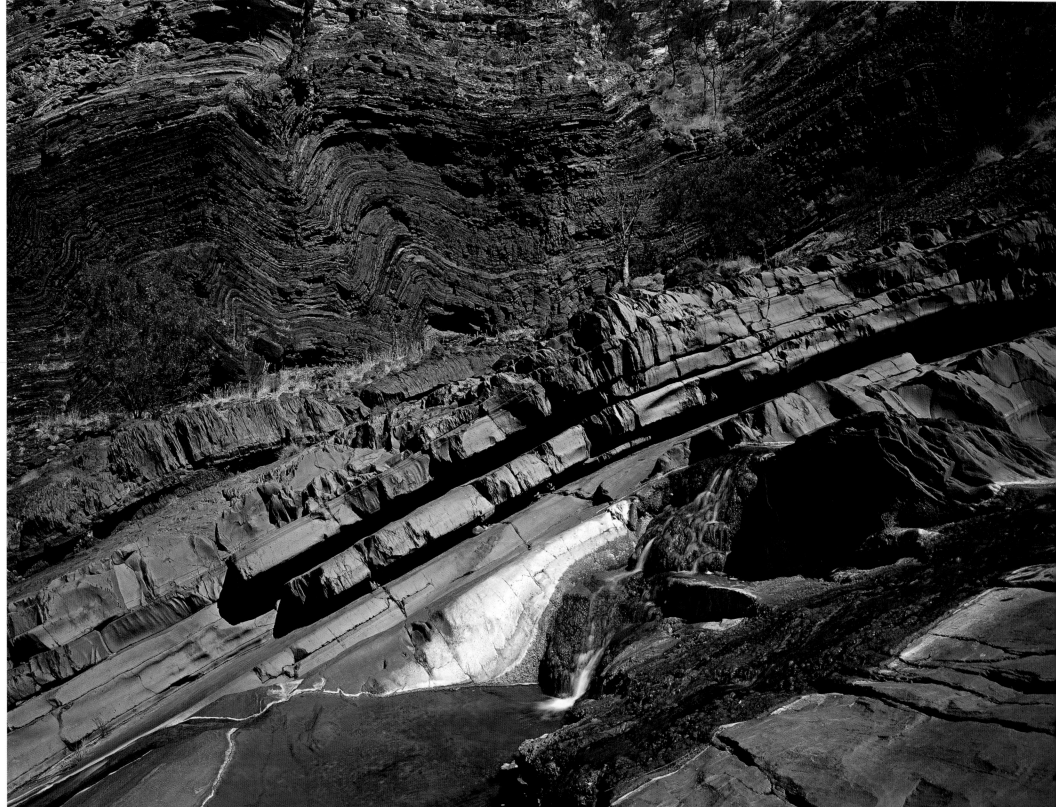

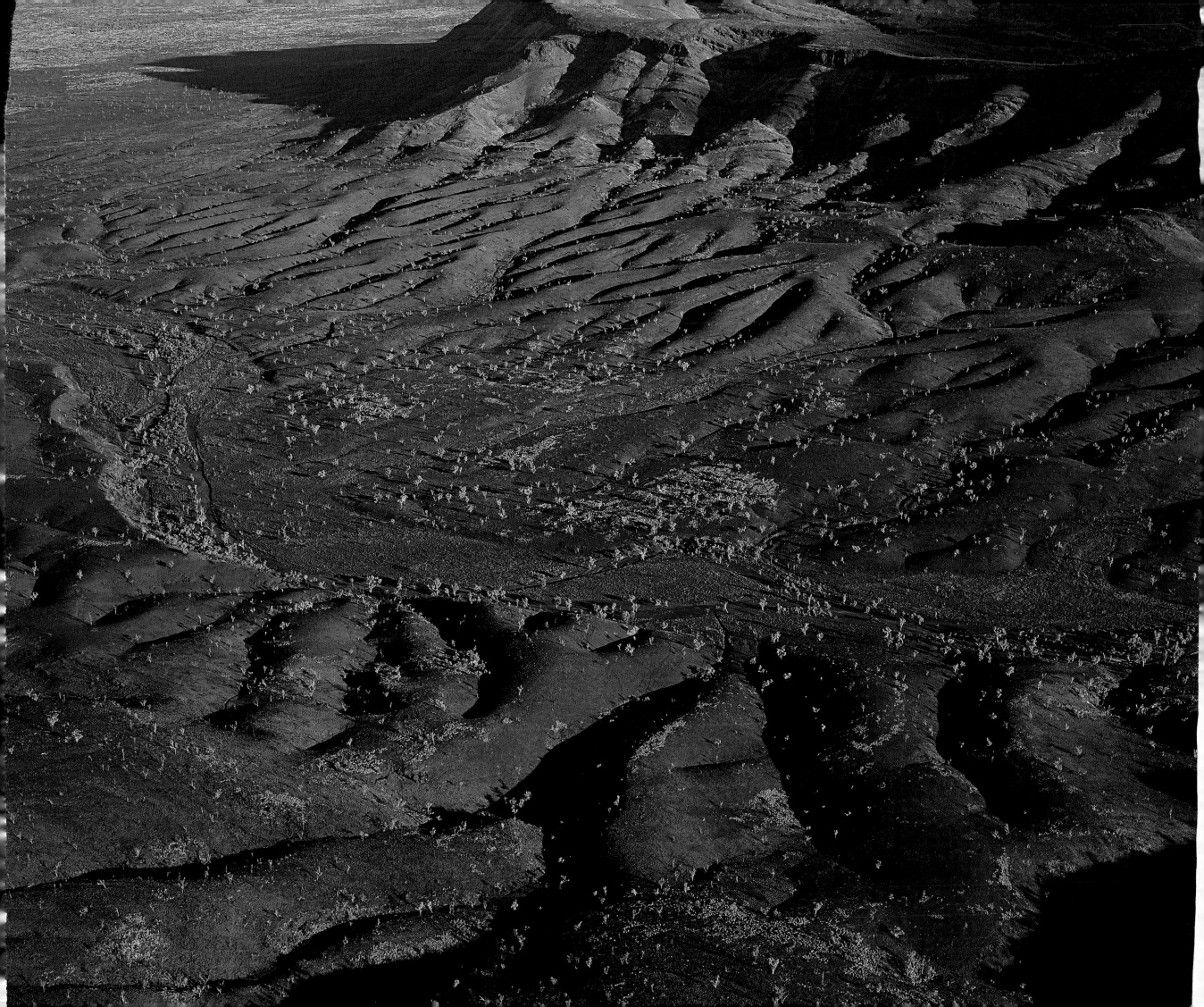

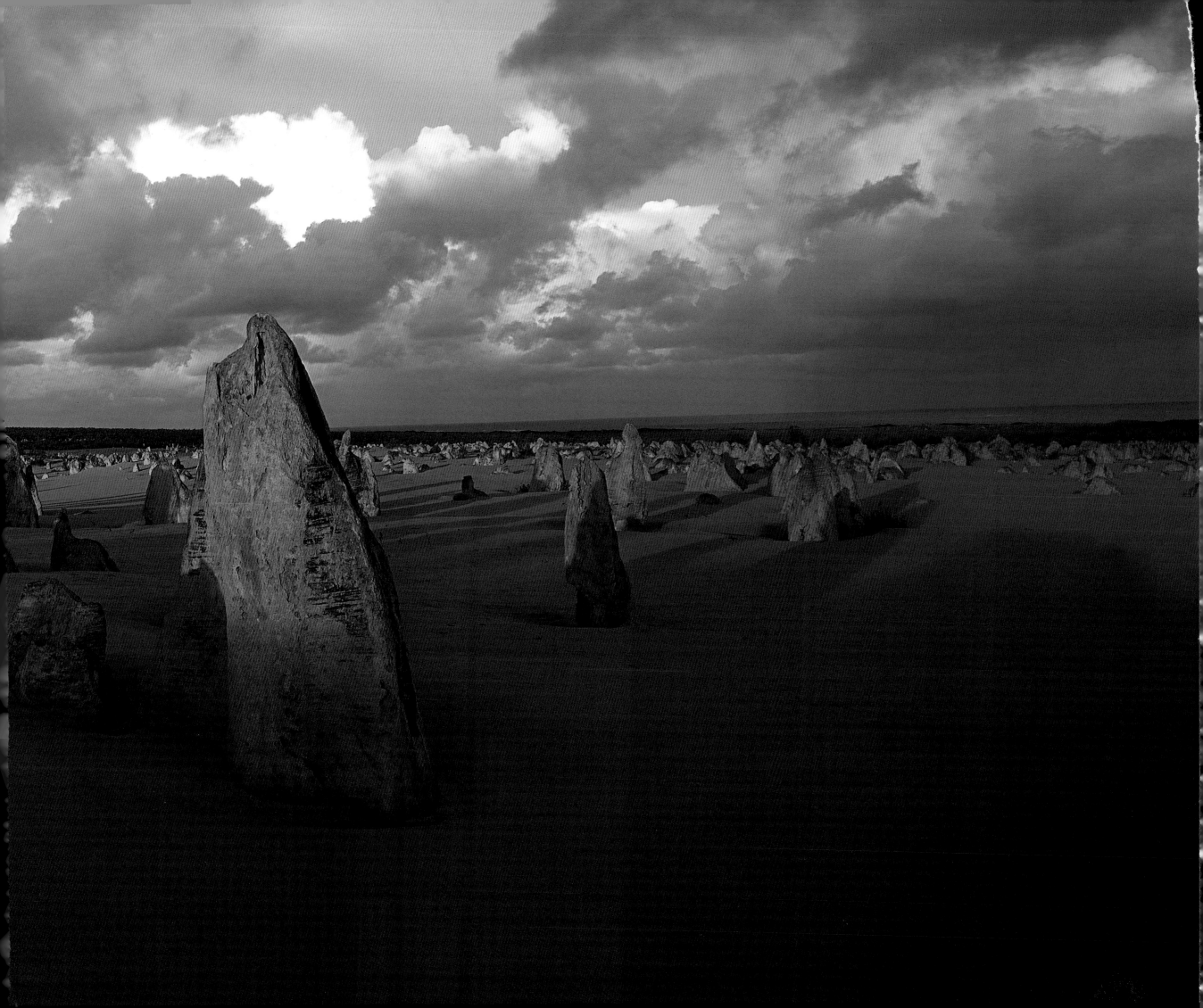

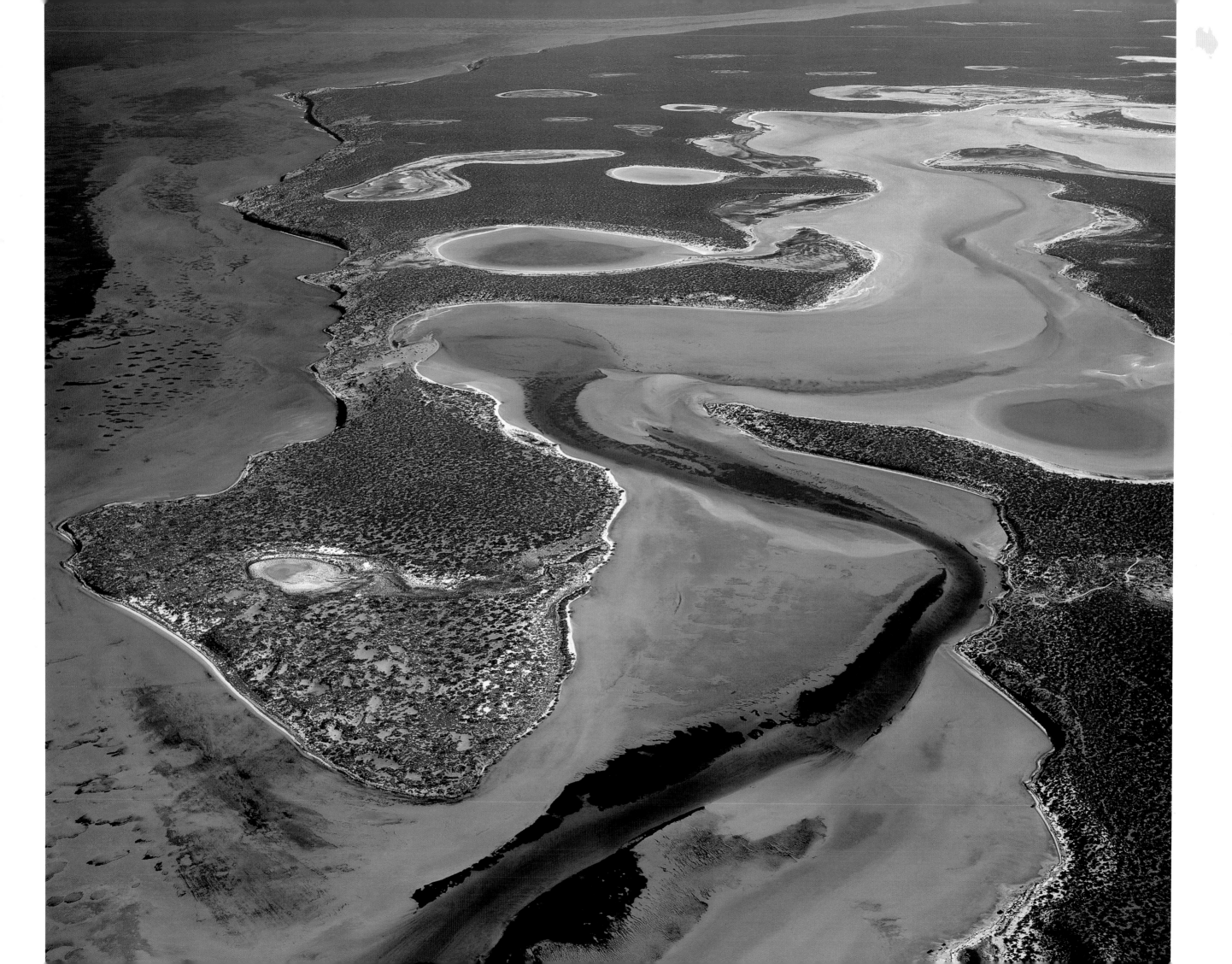

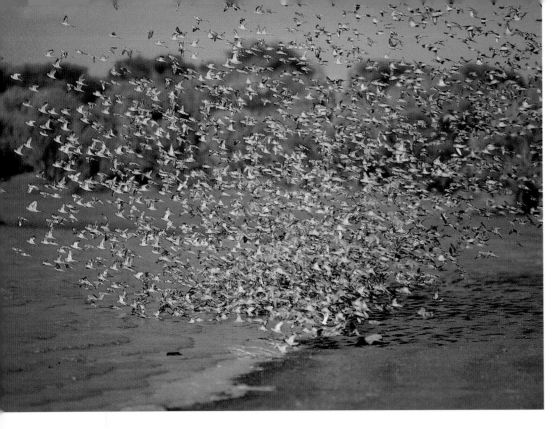

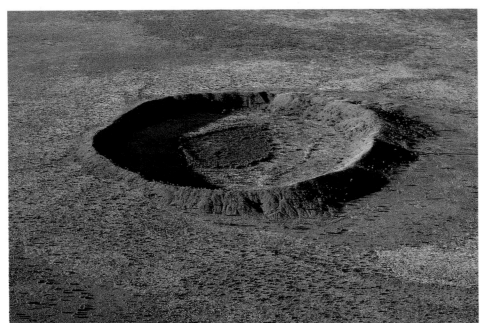

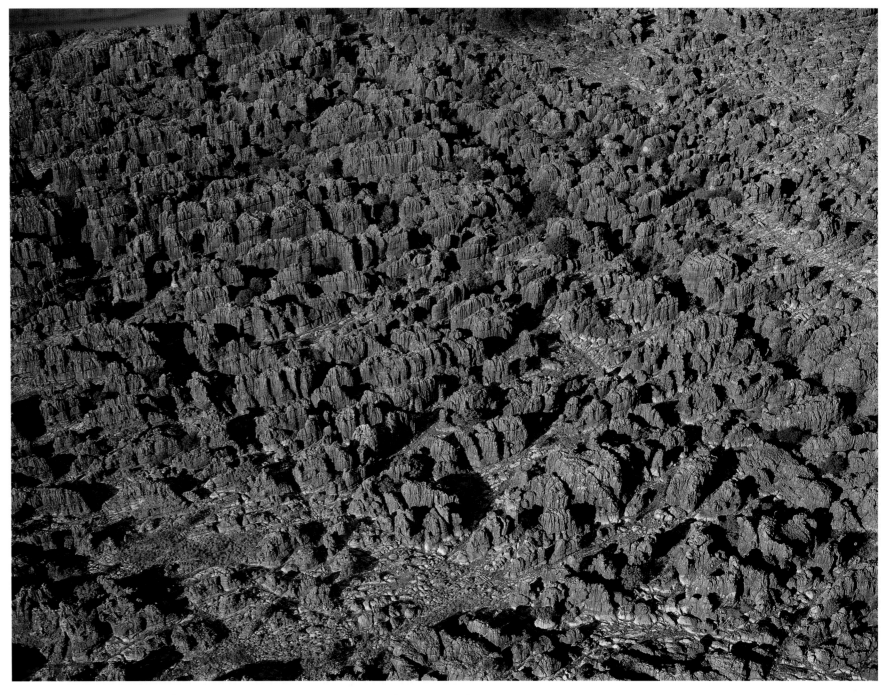

■ Top : Budgerigars, *Melopsitticus undulatus*
This blizzard of budgerigars, disturbed from an
ephemeral pool in Western Australia's arid interior,
is typical of the species, which is believed to be the
most numerous of all Australian parrots. As many as
10,000 to15,000 birds may congregate into a single
flock in good years. Such dense flocks may darken the
horizon for miles, wheeling and swirling like smoke as
they change formation with instinctive precision

■ Above : Wolf Creek meteorite crater
This cosmic impact site at the northwestern edge of
the Tanami Desert is one of the few meteor craters on
the Australian continent that remain relatively intact.
About 800 metres wide and 45 metres deep (half a mile
wide,150 feet deep), it is now filled with erosion debris.
It was between 120 and 150 metres deep (400 to 500
feet) when it was basted out some 300,000 years ago

by an iron-rich meteor the size of a small battle
cruiser. At least 20 other impact sites of various sizes
are scattered across Australia.

■ Above right : Oscar Range, Kimberley region
These rain-carved limestone pillars, part of the Oscar
Range in the Kimberley region, is a remnant of a reef
that once rivalled its modern counterpart, the Great
Barrier Reef off the coast of Queensland. Extensions
of this fossilised reef appear to have encircled the
entire Kimberley region when the foundation of this
ancient continental component was partly submerged
some 360 million years ago.

■ Right : Wildflowers near Shark Bay
Bearing out the adage that hardship is evolution's
spur, arid heathlands often produce the best spring-
time wildflower displays for which Western Australia is
so rightly renown. This one is near Shark Bay.

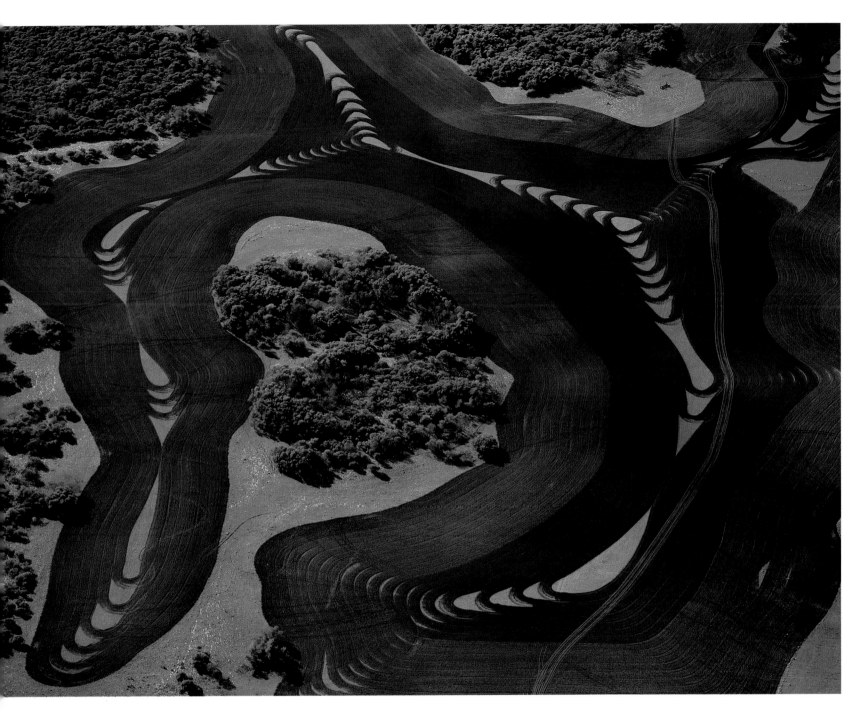

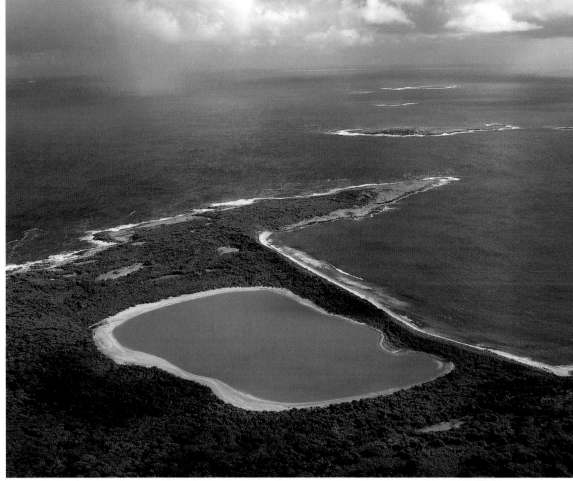

■ ABOVE : Ploughing patterns, near Geraldton
Reliably watered by winter westerlies, and lying at the
northern edge of Western Australia's vast wheat belt,
the fertile coastal plain south of Geraldton is one of
the most productive grain-growing areas in Australia.

■ RIGHT : Red Kangaroo Paw,
Anigozanthos manglesii
Much of Australia's flora has been shaped by its
inordinate dependence on birds to pollinate it and
spread its seeds. This partnership has been instru-
mental in producing many of the continent's strange
and unique wildflowers. Many have evolved to suit
specific birds and so lock them into genetic servitude.
Meanwhile, these pollinators have, in turn, been
shaped by the flowers that feed them. The long,
curved tubes of Western Australia's Red Kangaroo
Paw, for example, are peculiarly suited to the slender

beak of the honey-sipping Western Spinebill. When the
spinebill inserts its beak far enough to reach the nec-
tary at the base of the flower, the pollen-loaded
anthers that fringe the entrance to the tube are
precisely positioned to brush their genetic parcels onto
the bird's head, ready for transfer to the next flower.

■ ABOVE RIGHT : Lake Hillier, near Esperance
The colour of Lake Hillier, on Middle Island in the
Recherche Archipelago, off Western Australia's south
coast, remains something of a mystery. It varies little
throughout the year, is not known to be toxic, and is
not due to algae, diatoms or other pigmented organ-
isms, such as the minute crustaceans on which
Africa's pink flamingoes feed. The islands in the back-
ground are also part of the Recherche Archipelago,
granitic fragments of the tectonic glue that once
welded Australia to Antarctica.

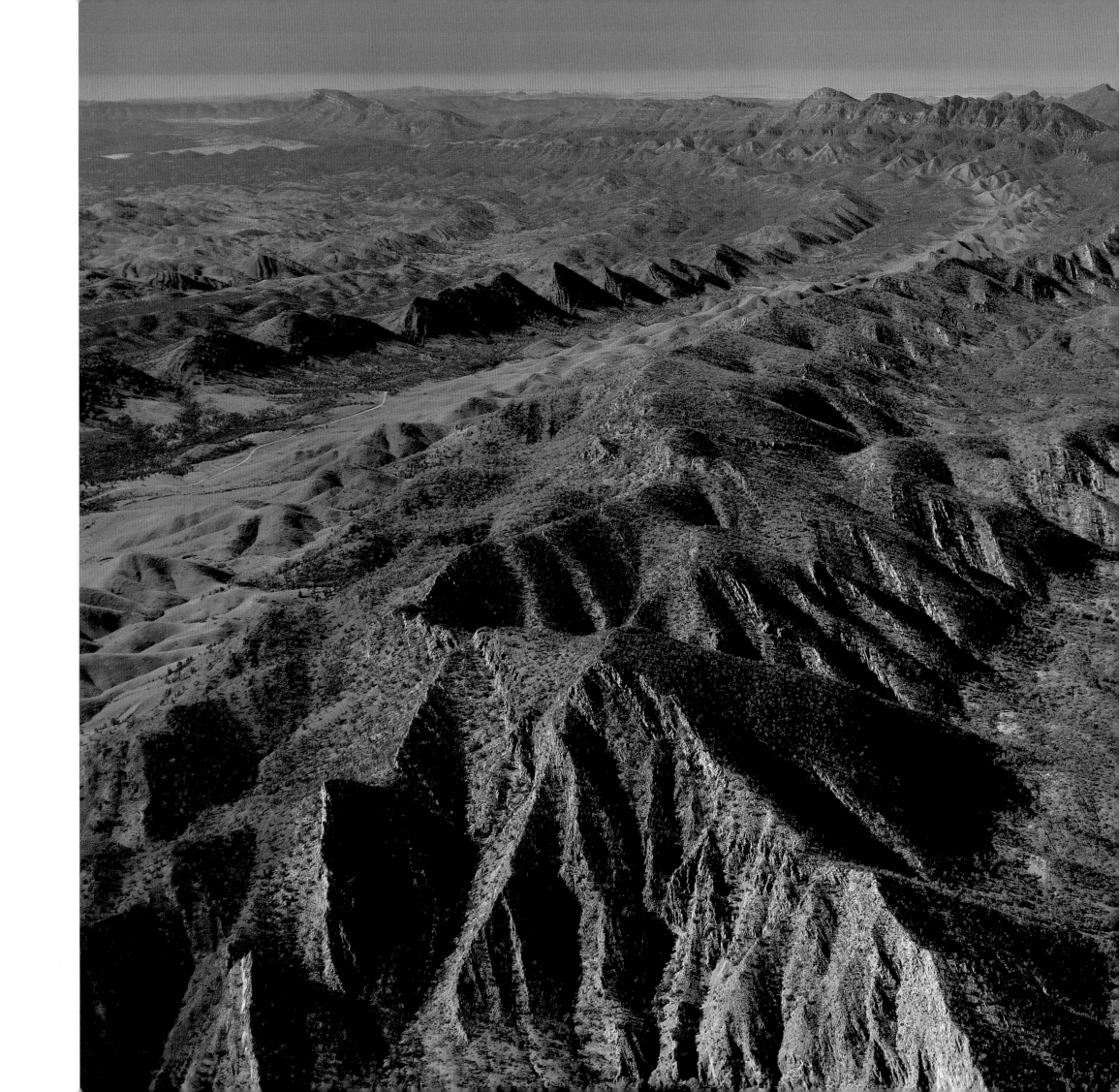

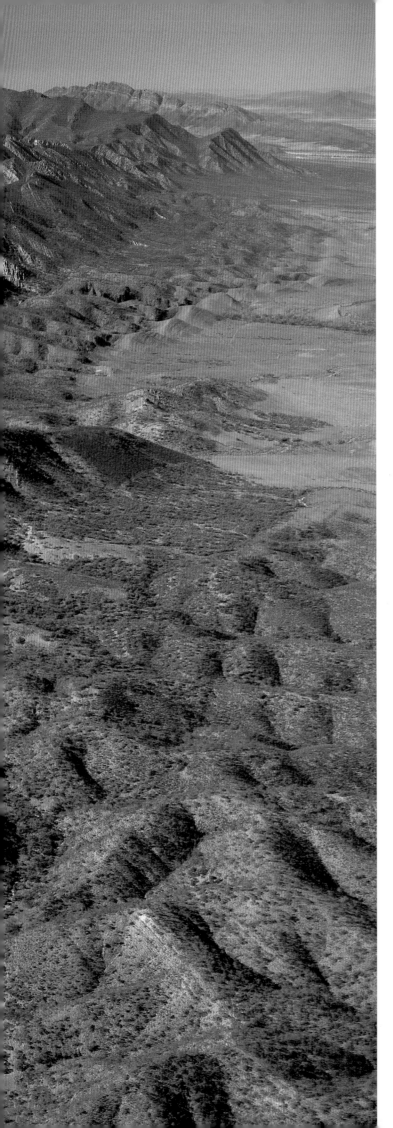

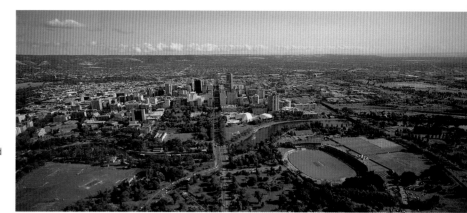

■ RIGHT : Adelaide
Elegant Adelaide, on the Torrens River,
where the Adelaide Oval (foreground) is
regarded the most beautiful cricket ground
in Australia. And no sport is more deeply
embedded in the national culture than
cricket.

■ LEFT : The Flinders Ranges
The massive Flinders Ranges curve northward
in the South Australian hinterland.

South Australia

South Australia rejoices in the distinction of the only Australian State untainted by a convict past. Moreover, it enjoyed the status of a province of Britain rather than a colony, albeit briefly. Yet is was the inhospitable environment that shaped the early history of the driest State in the continent as much as cultural precedent. The rich coastal plains apart, some 80 percent of its 984,377 square kilometres (395,000 square miles) of plains, desert and ancient eroded ranges, receive an average annual rainfall of less than 250mm (10 inches). The Aborigines prevailed in this arid inland with their unique bushcraft, but it took the settlers more than a century to accept that European agriculture could not.

The Dutch noted the region in 1627 and British navigator Matthew Flinders' observations in 1802 were inconclusive. A truly favourable report had to wait until redoubtable explorer Charles Sturt traced the Murray River to South Australia in 1829.

If colonisation was predicated on a belief that there was ample good land, it was inspired by the social theories of Edward Gibbon Wakefield, who became a passionate advocate for a free settlement in South Australia, unhindered by government, an establishment church, or convicts. Settlers should, he prescribed, be a young and balanced mixture of both sexes, to encourage families. Land should be sufficiently expensive to deny ownership to some, creating both a pool of willing labour missing in other colonies, and ultimately an orderly class structure. Immigrants should be chosen for a variety of skills, their passages financed by the sale of Crown Lands.

Wakefield's vision was not without irony, being formulated while he himself was serving time for eloping with an underage heiress. Nevertheless, his views on assisted passage for skilled immigrants were perceptive, because North America was much more tempting than Australia to prosperous adventurers, being cheaper to sail to and closer to home if they failed. His views

about the sexes were equally relevant. A chronic shortage of women in colonial Australia was ever desperate.

An investment company proposed the settlement, but the more pragmatic Colonial Office, chastened by the WA fiasco, engineered government control of the venture, fortuitously as it turned out.

The Adelaide Plains proved sufficiently fertile for small family holdings, but the flood of immigrants from Britain, and stock from New South Wales and Tasmania, soon clogged, then diverted, orderly progress. Eventually, however, agriculture flourished in the south, particularly wheat, supplemented by mining. Copper finds at Burra Burra and Kapunda in the 1840s triggered Australia's first mining boom. By the 1860s the Adelaide region was prosperous.

Settlers gamely pushed the frontier into the dry interior, trying to tame it with European ways. Rain, they reasoned, would follow the plough. But the mean soils and withering droughts eventually drove the vast majority back to the wetter coastal districts, south of the Flinders Ranges, and the fertile flats of the Murray River, the state's only substantial river. A bitter imprint of deserted towns and abandoned runs remains.

Northward expansion owed much to John McDouall Stuart who identified marginal grazing plains while exploring the two great salt pans of Lake Torrens and the more distant Lake Eyre. Lake Eyre, which was part of a seascape in the geological past, is normally a 5,000 square kilometre (2,000 square mile) carpet of hardened salt. It fills only once or twice a decade, when inland rivers that rise in Queensland flood sufficiently for their waters to reach it, a journey that takes the best part of six months!

Even in the coastal region, a relatively low rainfall and high evaporation rate obliges Adelaide and surrounding rural areas to depend on the Murray River for 50 percent of its water, creating a problem that is getting worse. The Murray-Darling river system, which delivers such plenty to Australian agriculture, is

now of national concern. Its rivers and tributaries have long been exploited by both townships and agriculture, the abundant irrigation basin drawing off most. As a result, the Murray's flow has grown so sluggish—and saline—that it barely flows by the time it reaches Lake Alexandrina in coastal South Australia.

South Australia prospered to the point of becoming the biggest wheat producer at the turn of the 20th century, its golden era. Its Overland Telegraph line made it the first State to communicate directly with the outside world. Close links with Broken Hill mines helped develop local industry, which included smelting, shipbuilding, automobile and white goods production. The capital, Adelaide, grew increasingly elegant, with wide streets, generous parklands, fine buildings and so many stately churches, of various denominations, that it inspired the "City of Churches" epithette.

SA liberalism attracted non-conformist religions from the outset. Among the earliest refugees were Old Lutherans fleeing religious oppression in Prussia and Silesia. Respected for their diligence, devotion, and decency, they pioneered Australia's wine industry in the Barossa Valley, which remains the premier region.

The State's auto industry has prevailed also, but SA's broader industrial base has suffered since Australia confronted the harsh realities of a more global economic outlook. Growth has slowed.

SA's tradition as a crucible of Australian liberalism —and a slightly patrician sense of public duty— remains undiminished, however. Historic resolutions abound, such as an 8-hour working day (1873); the second in the world to enfranchise women (1896, after New Zealand); the first British colony to dissolve all links between Church and State; and unflinching support for the Federation that defined Australian nationhood (1901). In 1976 the State chose the first Aboriginal to be appointed an Australian Governor, pastor Sir Douglas Nicholls. It appointed the first female Governor, Dame Roma Mitchell, in 1990. ■

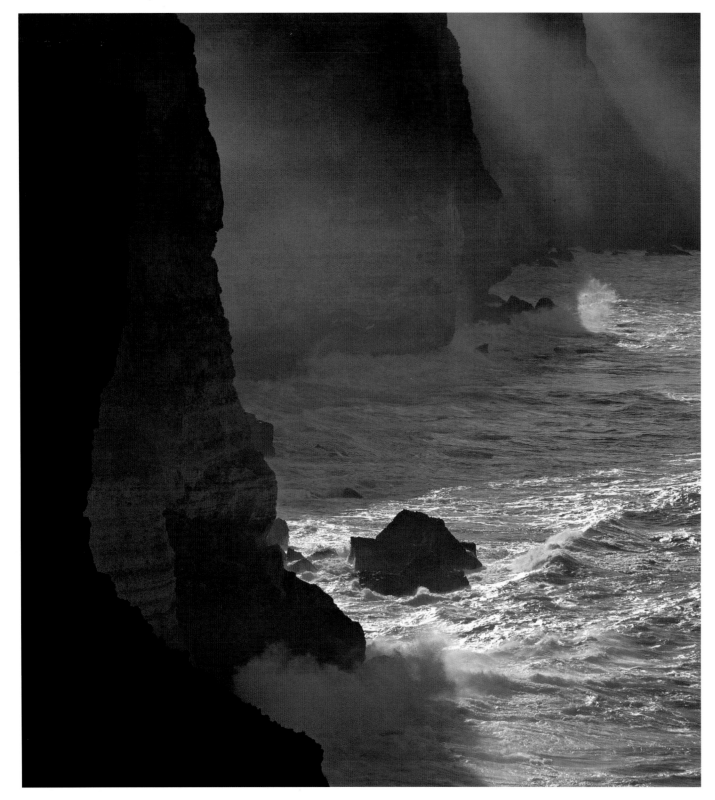

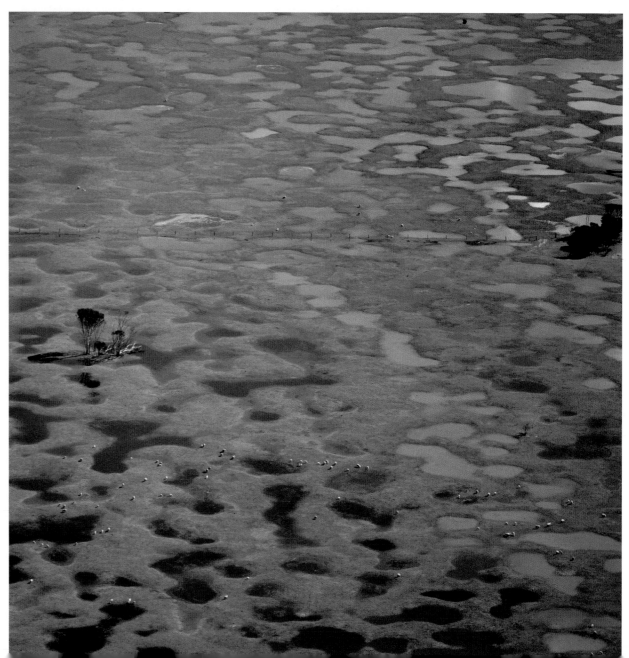

■ ABOVE : Bunda Cliffs, Nullarbor Plain

These massive limestone cliffs are a byproduct of the final separation of Australia from Antarctica, 40 to 50 million years ago. Unbroken for almost 200 kilometres (125 miles), they define the southeastern edge of a vast limestone slab, riddled with caves and sinkholes, that underpins the Nullarbor Plain. Some of its better known subterranean systems run for several miles, but many more are unexplored. In a delayed response to changes in the barometric pressure above the Nullarbor, this network of cavities "breathes" in and out, like a gigantic lung.

■ ABOVE RIGHT : A whisper in a koala's ear, on Kangaroo Island

A Brown-headed honeyeater, *Melithreptus brevirostris*, plucks fur for its nest from the ear of a koala. Australia's most adored native animal, the koala, has suffered a savage decline throughout their east coastal range during the past 200 years. Clearing of their habitat, disease, and the now outlawed harvesting for pelts, thinned numbers to the point where they are now hard to find in mainland woodlands. In protected habitats such as Kangaroo Island, however, their growing numbers and dietary preference for young gum leaves now threaten the eucalypt forests that nurture them!

■ RIGHT : Waterlogged pasture, Kangaroo Island

Thrusting into the cold wash of the Southern Ocean, Kangaroo Island, unlike mainland South Australia, usually enjoys mild summers and drenching winter rains—ideal for intensive agriculture and pasture.

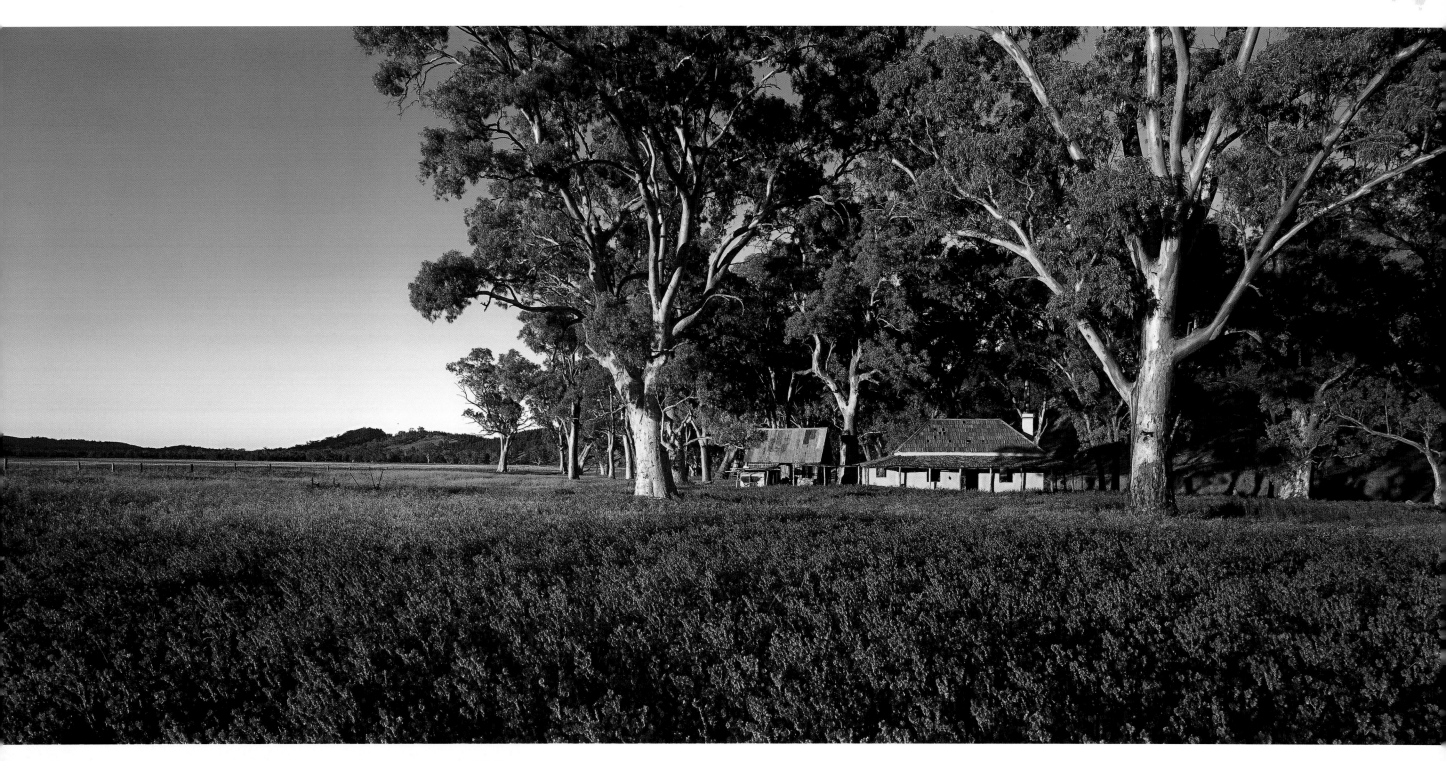

■ ABOVE : Homestead, Flinders Ranges
Classical Australian rural homestead near Wilpena Pound in the Flinders Ranges. This style of farmhouse—tin roof, weatherboard walls, wide verandahs and ubiquitous water tank, and often set among one of few stands of uncleared timber on the property—can be found throughout Australia.

■ LEFT : A great Australian sheep dog breed
The kelpie was bred for herding sheep in Australia. It can work all day with lightning speed over hard-baked surfaces in burning heat. But its finest qualities are its incredible skills at driving a mob of sheep with minimal signals from its master. A good kelpie is so deft and quick-witted that it has been known to herd a newborn chick into a used baked beans tin without harming it.

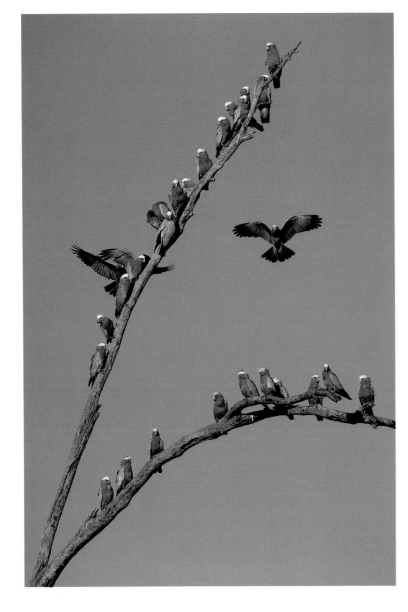

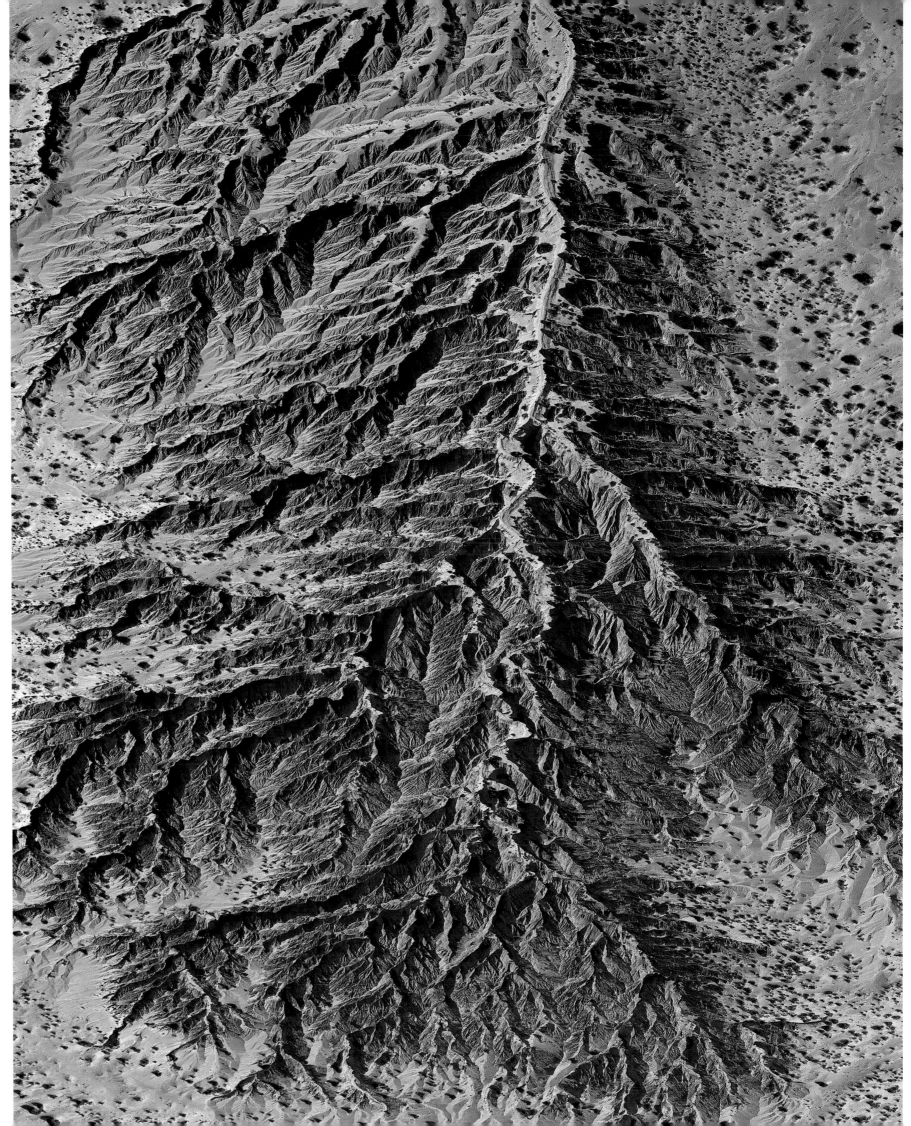

■ ABOVE : Galahs, *Cacatua roseicapilla*

The pink and grey galah, one of the prettiest and most commonplace of Australia's cockatoos, is spread throughout inland Australia in huge numbers, and a pest for grain farmers. Of the 360 species of parrots throughout the world, 60 live in Australia.

■ RIGHT : View of rill erosion, north of Lake Eyre

Though the Lake Eyre basin, with an average rainfall of 100 to 150mm (4-6 inches) a year is the driest region in Australia, the climatic backlash that usually follows a severe *El Niño* drought may produce flooding throughout central Australia. This has occurred more frequently in the past two decades due to global warming, generating erosion patterns such as this.

■ OPPOSITE : The Everard Ranges

Protruding through the sheet of sand that shrouds Australia's arid heart, the ground-down "mountains", such as the Everard Range (foreground) and the Musgrave Range beyond, represent the remains of Australia's ancient foundations. The continent's geological record suggests that some of these foundations were laid more than two billion years ago.

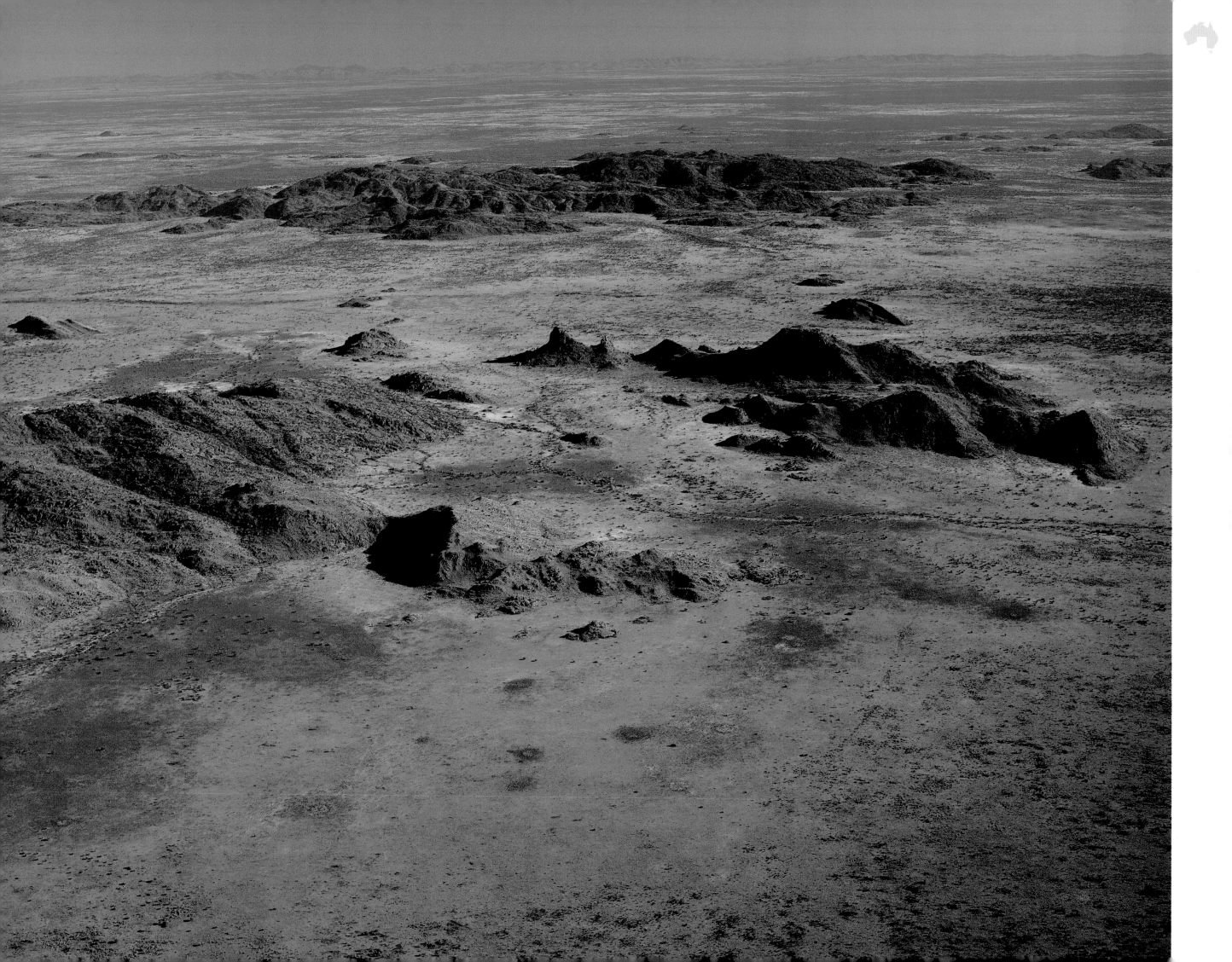

■ ABOVE : **Lake Eyre, August 1988**

■ ABOVE RIGHT : **Lake Eyre, June 1989**

The salt that now bedevils farmers and pastoralists throughout southeastern Australia was built into the fabric of the continent more than 100 million years ago, when much of it lay beneath a shallow inland sea. Cradled in a depression that dips below modern sea levels, Lake Eyre, normally a hard-baked, salt-encrusted playa, is one of the last muddy remnants of that sea. Although it provides the primary sump for eastern Australia's vast internal drainage system, the lake used to fill very rarely. In response perhaps to global warming, it now fills at least once or twice each decade.

■ RIGHT : **Krefft's turtle, Emydura krefftii, Coongie Lakes, Strzelecki Desert**

Despite extreme aridity and savage evaporation rates, a few waterholes in eastern Australia's desert river systems never entirely dry up. By providing a refuge for many species that would not otherwise survive, they represent reservoirs of biodiversity that enable an extraordinary array of waterlife, even turtles, to survive the savage droughts that are a feature of this inhospitable region.

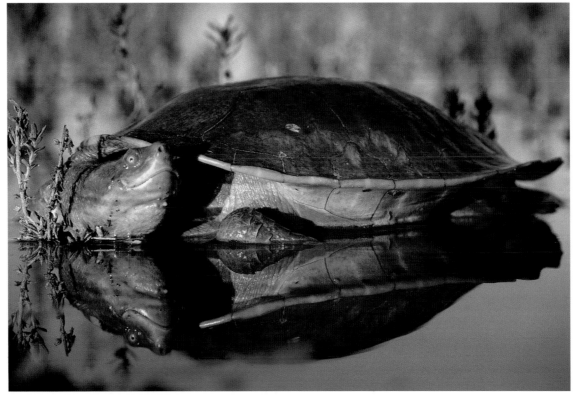

■ OPPOSITE : **Lake Gairdner**

This sprawling, salt-encrusted playa is cradled in part of a ring-shaped depression that defines the limits of a gigantic crustal "bruise" caused by a comet impact some 600 million years ago. The original ground zero is still visible and defined by a smaller playa, Lake Acraman, which forms the bull's eye in this circular deformity that is more than 140 kilometres (90 miles) in diameter. The original crater would have been more than 30 kilometres (20 miles) wide and 3 to 5 kilometres (2–3 miles) deep. Debris thrown up by this massive explosion was first identified in the Flinders Ranges, nearly 300 kilometres (180 miles) to the west and drill cores have revealed that it extends at least 480 kilometres (300 miles) in other directions.

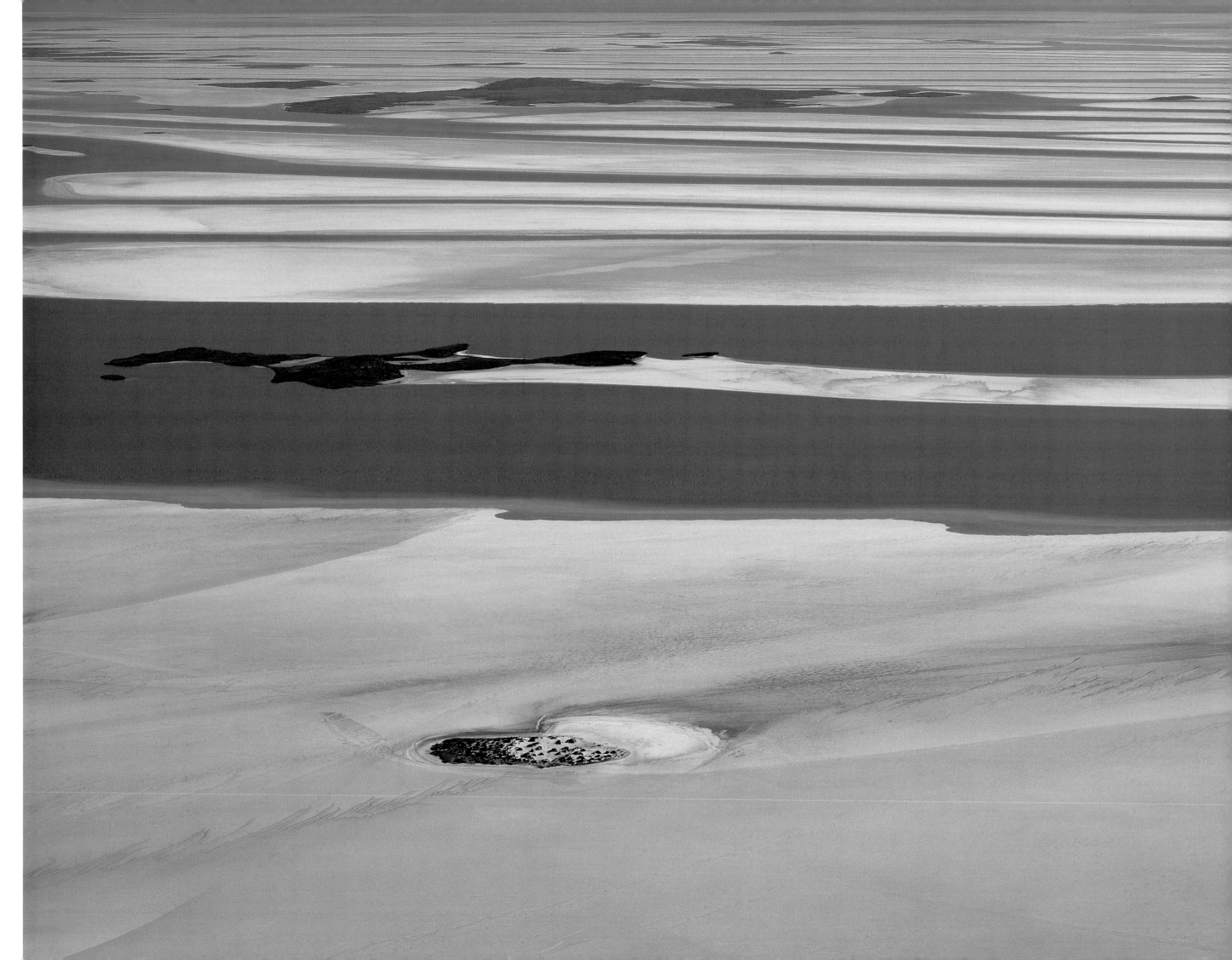

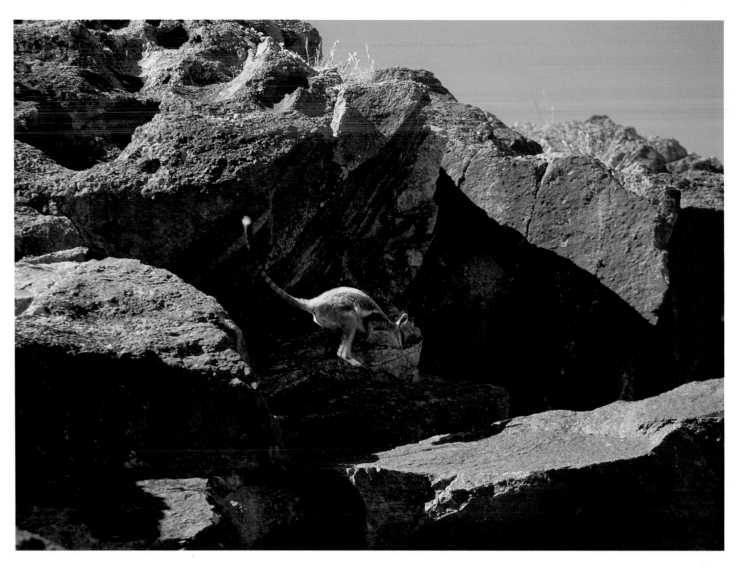

■ Above : **William Creek**
This lonely remnant of the original rail link between
Adelaide and the old outpost settlement of Alice
Springs in central Australia survives as a fuel and
refreshment stop for the growing stream of tourists
who prefer to explore the real "outback" by avoiding
the sealed highway that now links the two cities.

■ Above right : **Yellow-footed Rock wallaby,**
Petrogale xanthopus
Once common in rocky outcrops in the arid regions
of southeastern Australia, this splendid, sure-footed
wallaby survived predation by early colonial fur-
hunters but now it struggles to compete with feral
goats for food. Its last major stronghold is among the
rocky folds of the Flinders Ranges north of Adelaide.

■ Right : **Gibber (stones) plains, Simpson Desert**

■ Opposite : **Arkaringa Hills, Painted Desert**
The sterility and hardship implicit in landscapes such
as the gibber plains of the western Simpson Desert
and the barren buttes around Mount Arkaringa
deterred even the most determined of settlers during
Britain's early attempts to colonise Australia's interior.
Shimmering with heat haze and strewn with wind-bur-
nished stones, or "gibbers", landscapes such as this
fringe both the eastern and western edges of the
Simpson desert.

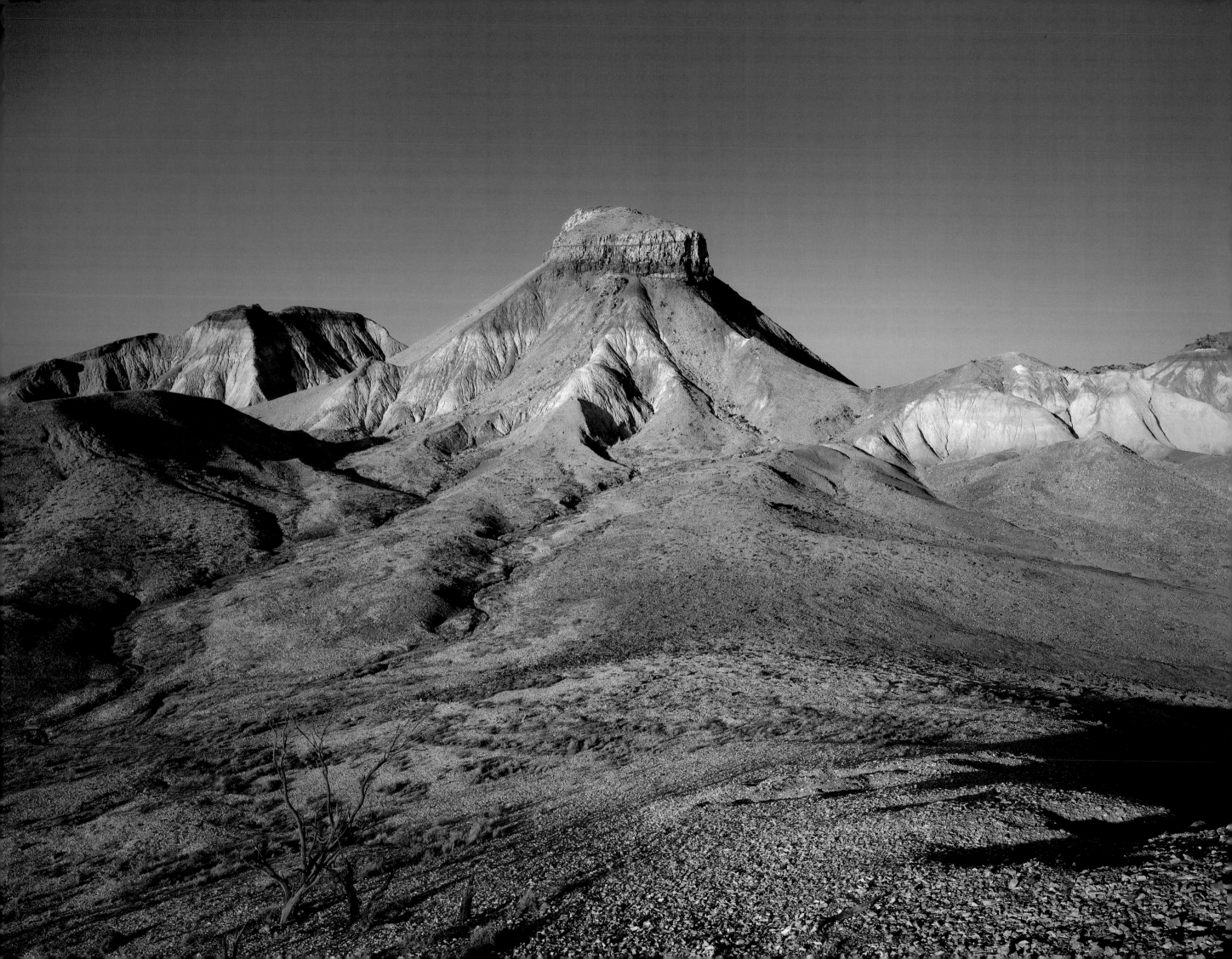

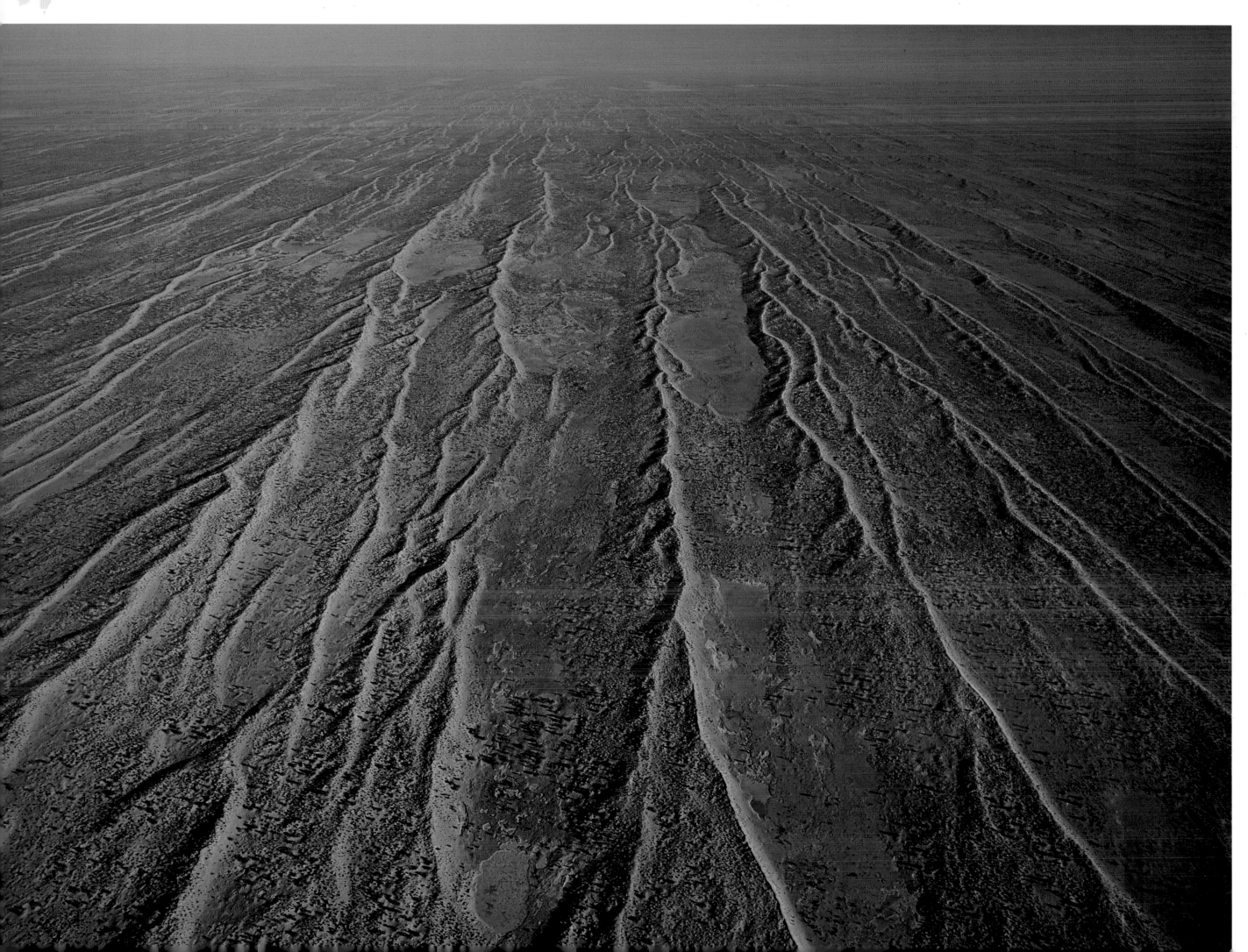

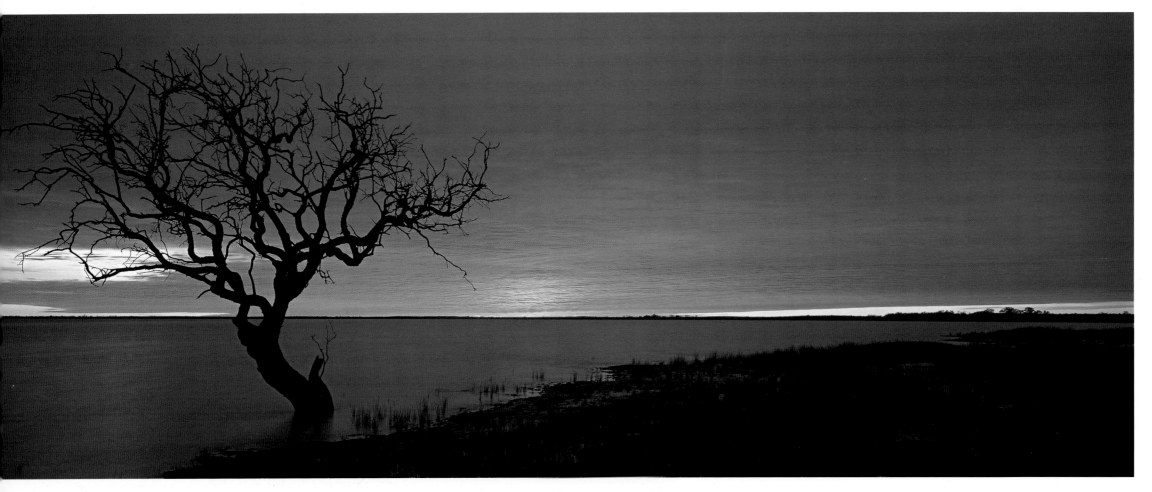

Many Australian landscapes have so much in common with the sea that the imagery becomes interchangable. It is a hot, flat, arid land, where the deserts' barren dunes roll eastward from horizon to horizon, like the endless swells of the Southern Ocean—only these are salmon seas, studded here and there with archipelagoes of salt-white claypans. This is a land where miraged horizons regularly turn to water, and flat-topped hills float by, yet when storm clouds draw their grey curtains over the parched sandplains, those mirage seas can turn to reality almost overnight.

■ LEFT : Sunrise, Lake Coongie
The Coongie Lakes in the Strzelecki Desert are part of eastern Australia's massive internal drainage system and never completely dry out. In flood years, however, the region becomes so totally inundated it is possible to go boating among the dunes.

■ BELOW, FAR LEFT : Younghusband Peninsula and The Coorong
The coastal lagoon system known as The Coorong runs parallel to South Australia's southeast coastline for more than 144 kilometres (90 miles). Much of it is separated from the sea by Younghusband Peninsula, a narrow sand spit that is rarely more than 2.5 kilometres (1.5 miles) wide. The Coorong's only access to the sea occurs at its junction with the mouth of Australia's largest river, the Murray.

■ LEFT : Sand dunes, Simpson Desert
Where early explorers dreamed of finding an inland sea, they found only endless waves of salmon-coloured sand.

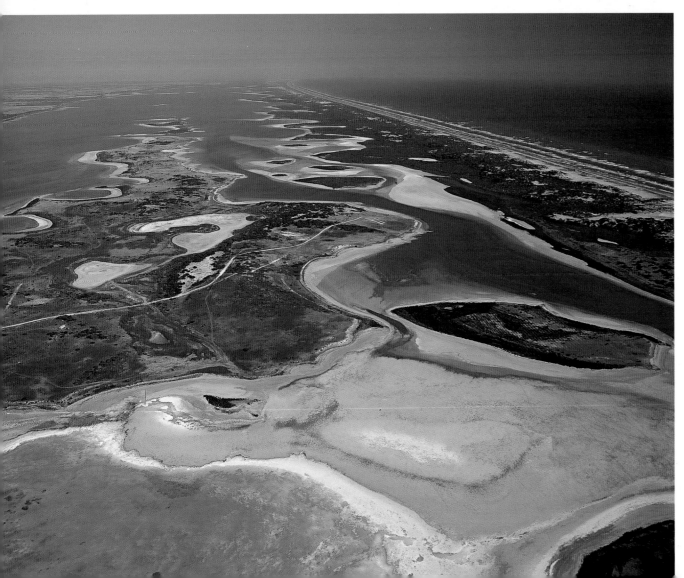

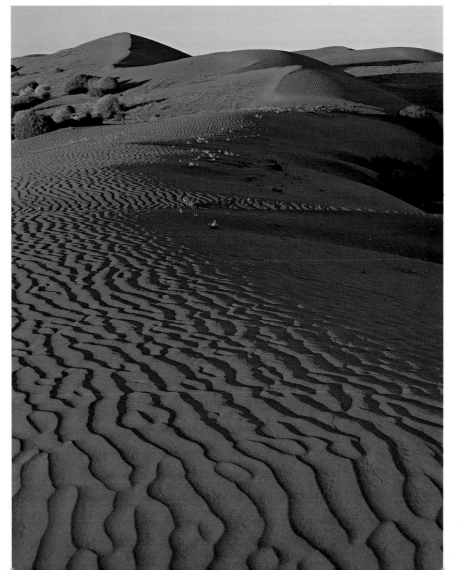

■ OPPOSITE : A parallel dune field in the southern Simpson Desert
Thousands of years of desiccating summer winds have piled the sands of the Simpson Desert into this vast parallel dune field. Many dune crests rise 40 metres (130 feet) above the intervening swales and some of the desert's 1,100 ridge lines run unbroken for more than 200 kilometres (125 miles). The region is generally treeless, waterless, and extremely hazardous to traverse in summer.

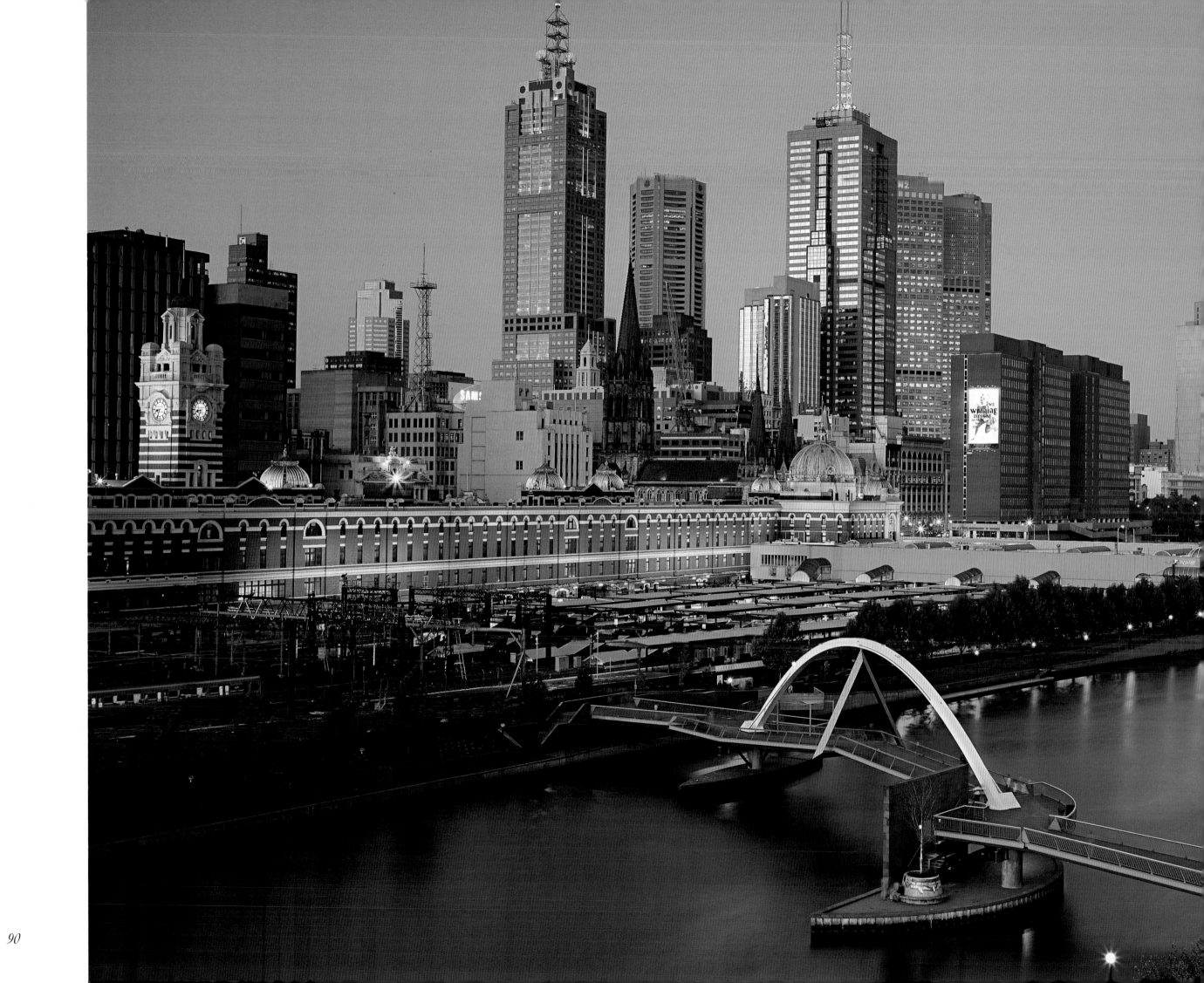

 # Victoria

In a land of such vast, empty wastes, size has less meaning. Water is the measure. Victoria, which occupies only three percent of the mainland, supports 26 percent of the population. It is awash by Australian standards. Even in the parched northwest, the Murray River has irrigated a vigorous fruits and vine industry at Mildura since 1880.

Victoria's 227,000 square kilometres (88,000 square miles) spread southward from the Murray to the Southern Ocean, its fertile plains spread around the crumpled tail of the Great Divide, which tends westward across the State, before dwindling to the Wimmera, beyond the Grampians. From these highlands spring waters that flow both north and south; rivers of the northern slopes water the rich plains of the Murray and Goulburn valleys, those that rise on the southern slopes serve the coastal Gippsland Plains.

The eastern highlands, soaked by 2,600mm (102 inches) of rainfall, are deeply dissected, with noble forests and high-country plains. The region is dominated by Mount Bogong (1,986 metres; 6,300 feet) and Mount Feathertop, part of Victoria's 2,330 square kilometres (900 square miles) of winter snowfields above the 1,000-metre (3,000 feet) mark, that include such resorts as Mount Buller, Mount Buffalo, Hotham and Falls Creek. At the western end of the State, the drier plains of the Wimmera, south of Victoria's relatively small desert region, produce wool and grain.

Forests cloak a third of the State, a generous cover of mainly eucalypts that can fuel furious bushfires: the "Black Friday" inferno of 1939 swept through 1.2 million hectares (3 million acres), killing 71 and destroying 1,000 homes. Australia's voluntary bushfire fighters earn their community status, sometimes with terrible loss.

Some 70 percent of Victoria is under use, mostly grazing land, sheep being the chief source of rural income. The balance is crops, mainly wheat, plus an ample basket of fruit, vegetables and wine.

More significantly, Victoria is highly industrialised, and the most closely settled State. The majority live in Melbourne, but Geelong, Ballarat and Bendigo are major centres. Melbourne lies on the Yarra River, at the head of Port Phillip Bay, a wide, almost landlocked inlet facing the Bass Strait. Broad avenues, public parks and gardens, introduced trees and shrubs, plus elements of 19th century Georgian and Victorian architecture attached the sobriquet of Australia's most English city, which contemporary skyscrapers and freeways have not quite submerged.

If the momentum has swung Sydney's way, rivalry between the two cities remains. The Sydney Olympics aside, sport was ever a national passion, and the keenest fans Victorian. Australia still slows to a halt for the Melbourne Cup horse race. Australian football, "Aussie Rules", the only uniquely Australian national game, began there in 1858. Victorians also enjoy reminding Sydneysiders that *they* staged an Olympics back in 1956. The Melbourne Cricket Ground houses Australia's most "hallowed" sporting turf; the newer Colonial Stadium and the National Tennis Centre, with their retractable roofs, attract gala events. The Australian Grand Prix (Formula One) is staged in Melbourne and the biggest motorcycle championships are at Phillip Island. Other States boast much more glittering beaches, yet the oldest professional surfboard championship on Earth is conducted off the bleak cliffs of Bells Beach, in western Victoria.

The absurdity of interstate rivalry reached its giddiest heights at the opening of the Sydney-Melbourne rail link in 1881. Different State rail gauges met with implacable obstinacy at the border, obliging passengers and goods to change trains there for the next 20 years!

In the 1830s, the Victorian region was still part of NSW, when John Batman and John Fawkner from Tasmania sought land there, despite government objections. Batman treated with local Aborigines for a large parcel on Port Phillip Bay for an annual tribute of

tools and such. The NSW governor dismissed the treaty as capricious, but realised he could not keep squatters out of the south indefinitely. So, he opted to control them with a government presence. In the process, he named Batman's raw village of tents and wattle-and-daub huts. He called it Melbourne.

Victoria's population barely exceeded 80,000 when it separated from NSW in 1851. Within months it was convulsed by the Gold Rush, discoveries at Ballarat and Bendigo so stupendous that the colony produced a third of the world's gold for the next decade. The population flooded to 540,000, stimulating the economy and a small manufacturing base. Miners also brought democratic ideas, and with it, civil defiance. Government mining licenses aroused such resentment that a band of armed miners made a stand at the Eureka Stockade at Ballarat in 1854. Thirty miners and five soldiers were killed when the government stepped in, but Melbourne juries refused to convict those charged. It led to fairer fees, and indirectly, to universal manhood suffrage. Secret ballots, possibly the first in the world, followed.

A less likely legend of the 1880s was Ned Kelly, a murderous bushranger (bandit) with a burning Irish hatred for authority. He was idealised by some as a bold spirit from impoverished stock, victimised by the police he killed and, more insidiously, by the powerful landholders, known as the "squattocracy".

Victoria was the leading colony by the 1890s. Highly politicised, more industrialised, and protectionist, Melbourne eclipsed Sydney in size and wealth before profligacy brought a crash in 1893. Recovery was painful, but with federation, aggressive export drives and a manufacturing base boosted by two world wars, it reclaimed the seat of influence it regarded as its right, a hub of the nation's industry, finance and politics. It remained so for 40 years, though NSW is now ascendant. The next challenge to Victoria's prestige, if a long way off, may come from Queensland. ■

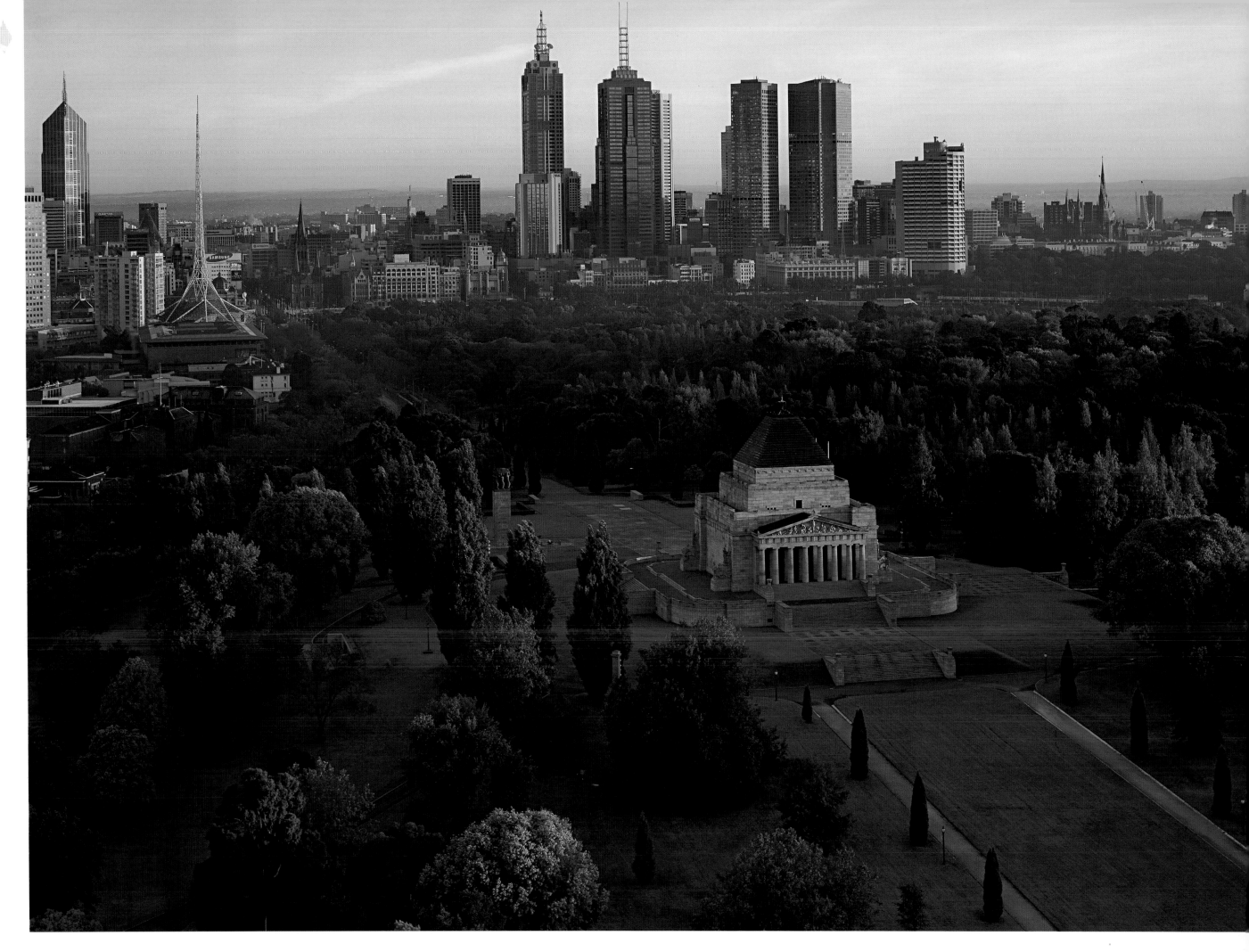

■ LEFT : Bell Tower, Saint Michael's Church, Collins Street, Melbourne

Like most Australian cities, Melbourne's earlier Victorian, and to a lesser extent Georgian, architecture, has been crowded out by modern concrete and glass highrise structures since the 1950s. But the mood has since swung. Now a National Trust, with government support, offers protection for buildings such as this that are regarded as worthy examples of Australia's heritage.

■ FAR LEFT : Captain Cook's cottage, Fitzroy Gardens, Melbourne

This traditional English cottage, built in Yorkshire in 1775 by the father of the renowned English navigator Captain James Cook, was dismantled in 1934 and shipped to Australia the following year. Re-erected in Melbourne's Fitzroy Gardens to mark the city's centenary, it has been fully restored as a memorial to the original builder's famous son who, as captain of the bark *Endeavour*, first explored Australia's east coast in 1770 and claimed the continent for Britain. Although James Cook did not live in the cottage himself, he is known to have visited his parents in their Yorkshire home at least once during his final sojourn in England.

■ FAR LEFT : Southeast Point, Wilsons Promontory

This lighthouse at the tip of Wilsons Promontory marks the southern extremity of the Australian mainland. The headland was once part of a broad land bridge that linked the Australian mainland with the island of Tasmania, a link that was severed by rising sea levels between 8,000 and 10,000 years ago at the end of the last episode of Ice Age glaciation. The entire peninsula is now a national park frequented largely by bushwalkers and birdwatchers.

■ OPPOSITE : Shrine of Remembrance war memorial, Botanic Gardens, and city skyline

Established in 1835, Melbourne is currently the nation's second largest city, with a population of more than three million people. Boasting spacious parks, broad thorough-fares, and many fine examples of Gothic, Victorian, and Georgian style architecture, the city is known for its richly endowed cathedrals and art galleries, its many fine restaurants, and its devotion to sport. Modern Melbourne's rich ethnic mixture, drawn largely from Europe and Asia, has lent a cosmopolitan flavor to this formerly staid business capital. It boasts a thriving Chinatown, and is often claimed to be "the largest Greek city outside Athens".

■ ABOVE : Snow detail, Tom Goggin Station,
Snowy Mountains

■ ABOVE RIGHT : Mount Feathertop,
Alpine National Park, Victorian Alps

The Victorian Alps are a recreational mecca for
Victorians seeking refuge from the daily grind of
urban life. Mount Hotham, one of the alp's most
popular snow fields, is unusual in that the ski village
has been built near the top of the mountain to take
full advantage of panoramic views such as this one
towards Mount Feathertop, and to allow many of the
best downhill ski runs to start from the village. Most
of Australia's snow fields cover highland plateaus
rather than soaring mountains, and are better suited
to cross-country skiing than to downhill racing.
Nevertheless, they cover an area that is, in total,
much larger than the snow fields of Switzerland.

■ RIGHT : Mount William Range,
Grampians, western Victoria

Rising steeply from Victoria's western plains, the
Grampians are the southwestern outpost of
Australia's 5,000 kilometre (3,000 mile) Great Dividing
Range. The three main ranges that comprise the
Grampians are deeply dissected and shelter several
pockets of rainforest, and abundant wildlife. More
than 1,000 species of native plants have been
catalogued there, including 100 species of orchid.
The highest point, Mount William, boasts a unique
species of miniature eucalypt.

■ OPPOSITE : The Cathedral,
Mount Buffalo National Park

This outcrop of weathered granite tors, known as
The Cathedral, presides over Victoria's oldest ski
resort, Mount Buffalo, near Myrtleford in northern
Victoria. One of six major ski fields in the State,
Mount Buffalo has become a favorite refuge for
Melbourne families who appreciate its gentler slopes,
and good cross-country skiing in winter, and its good
scenery and shady walking trails in summer.

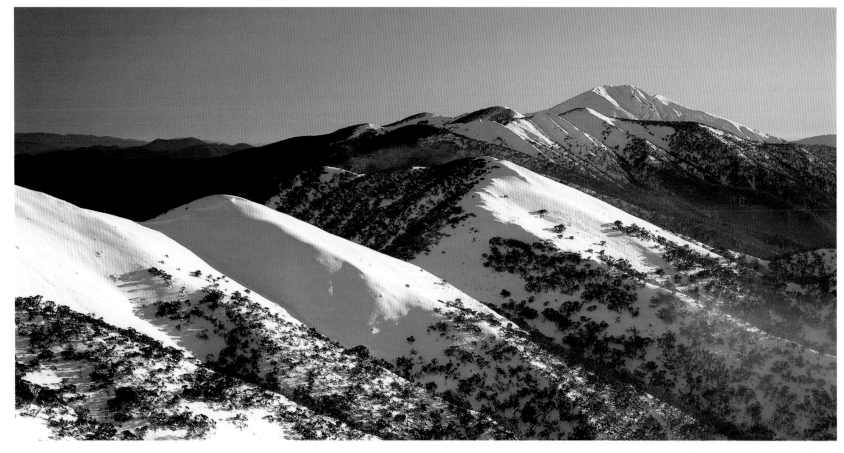

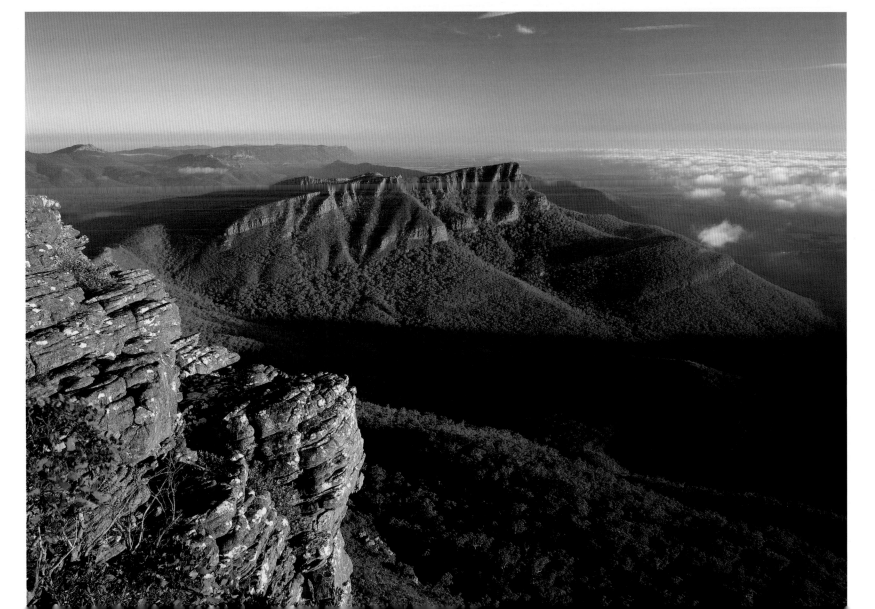

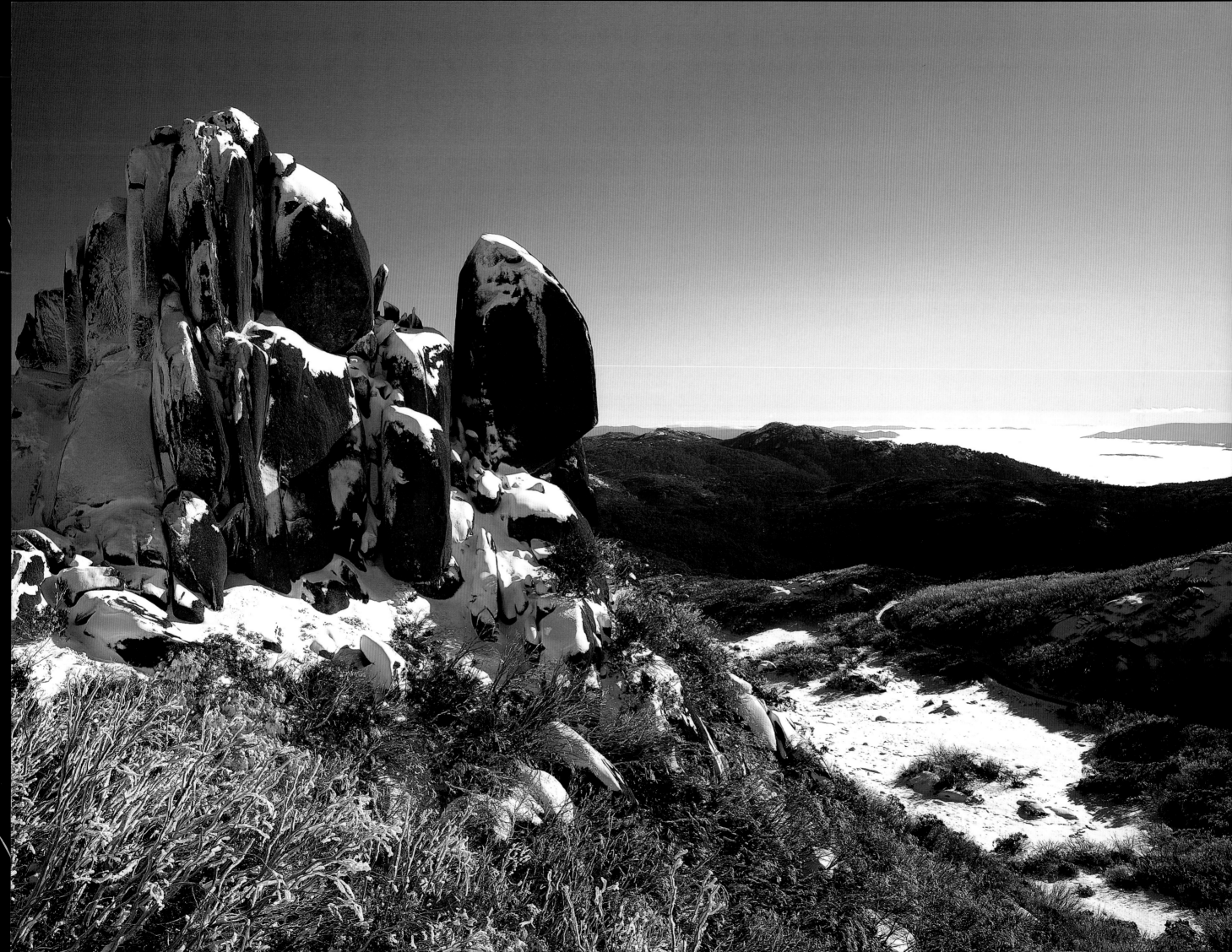

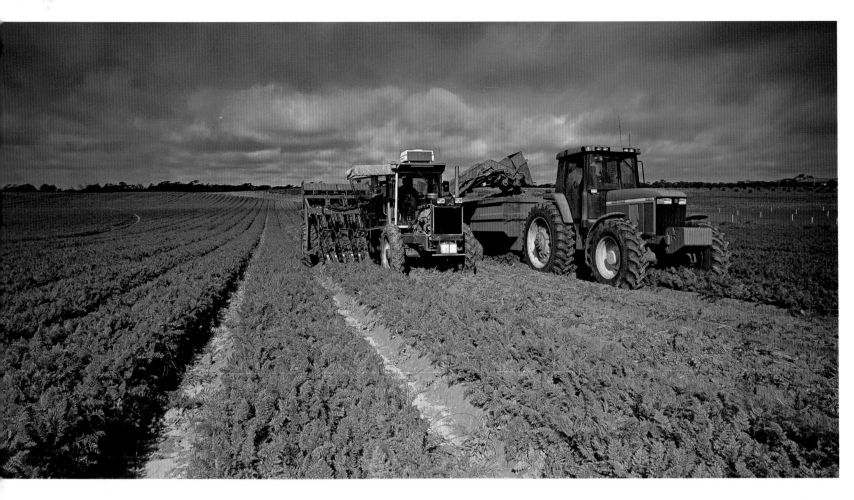

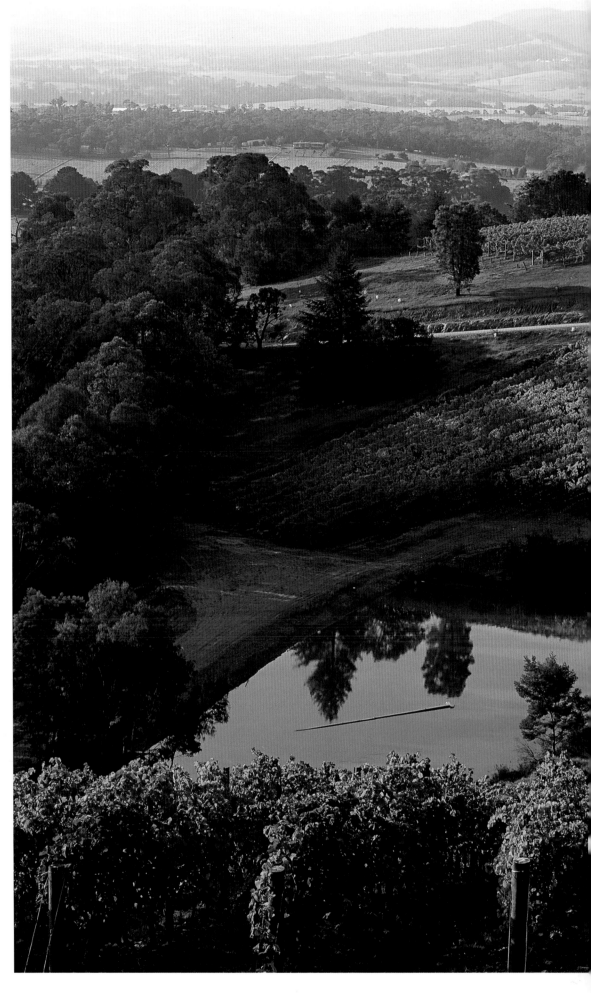

■ ABOVE : **Harvesting vegetables, Robinvale**
Carrot producers in Australia's fertile food bowl in northwest Victoria.

■ RIGHT : **The Murray River**
Rising in Australia's snowfields at the southern end of the Great Dividing Range, the 950 kilometre (1,600 miles) Murray River forms the boundary between Victoria and New South Wales for much of its length, before turning southwest to flow through South Australia to the sea. In conjunction with its tributaries, notably the equally-long Darling River, it drains most of eastern Australia. The fertility and flatness of the flood-plains that fill the Murray Valley, supplemented with extensive irrigation, make this by far the most productive agricultural region in Australia.

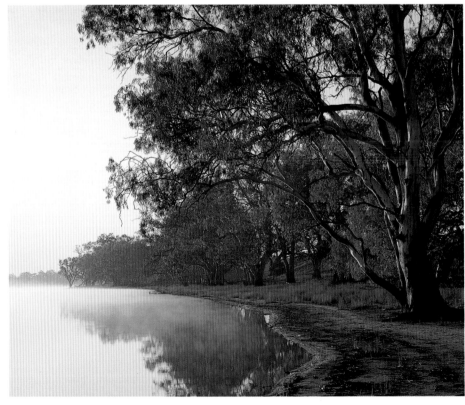

■ RIGHT : **Vinyards, Coldstream Winery, Yarra Valley**
The broad, fertile valley that delivers the Yarra River to Melbourne also supplies some of the wine that washes down the fine food served by many of the city's better restaurants.

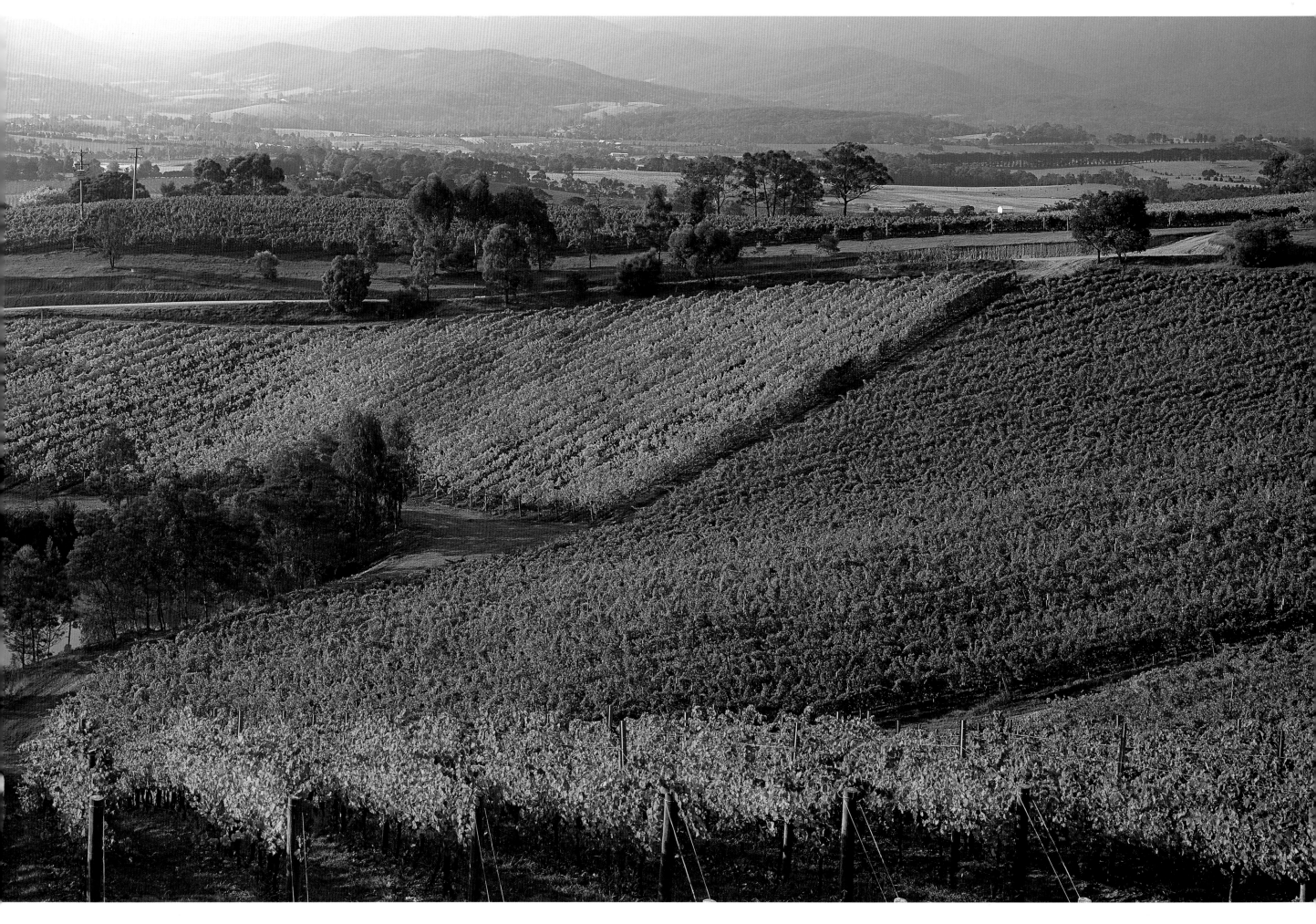

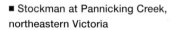

■ **Stockman at Pannicking Creek,
northeastern Victoria**

Among the most hallowed legends of colonial pio-
neers are those concerning the hardy stockmen
who once ranged the heavily-timbered valleys and
windswept plateaus scattered through the Victorian
Alps. It is a region where the horse still works the
mountain trails, and although the number of stock-
men has dwindled dramatically, they may still be
seen each spring and autumn, driving small herds
of cattle between the summer pastures on the high
plains and their lowland winter refuge. The modern
stockmen also maintain and use the crude
cottages and huts that were built throughout the
region to give their predecessors occasional refuge
from the biting winter snows.



66

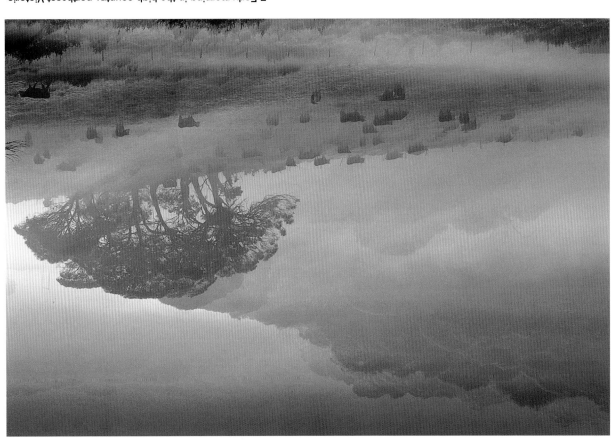

■ Early morning in the high country, northeast Victoria

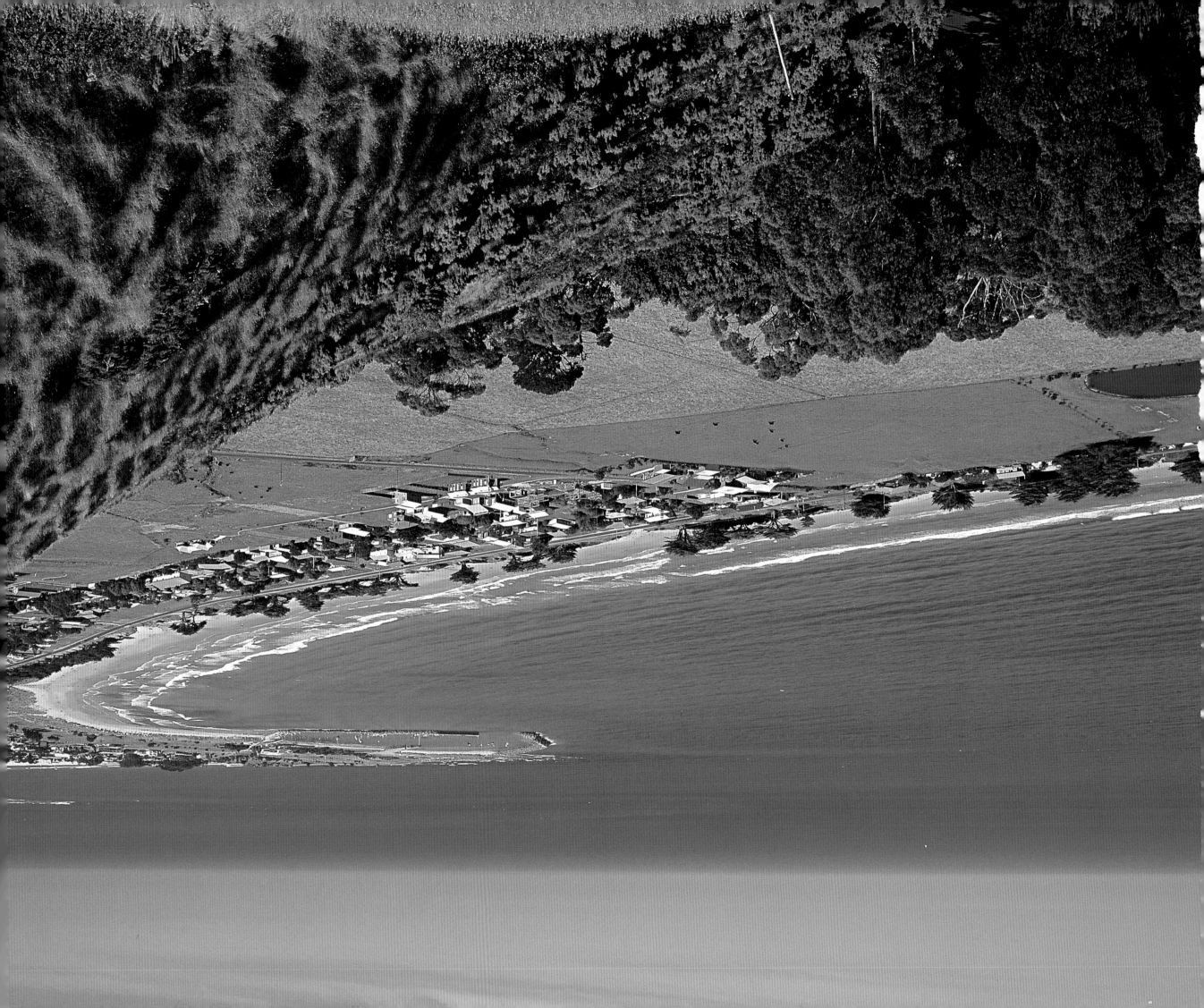

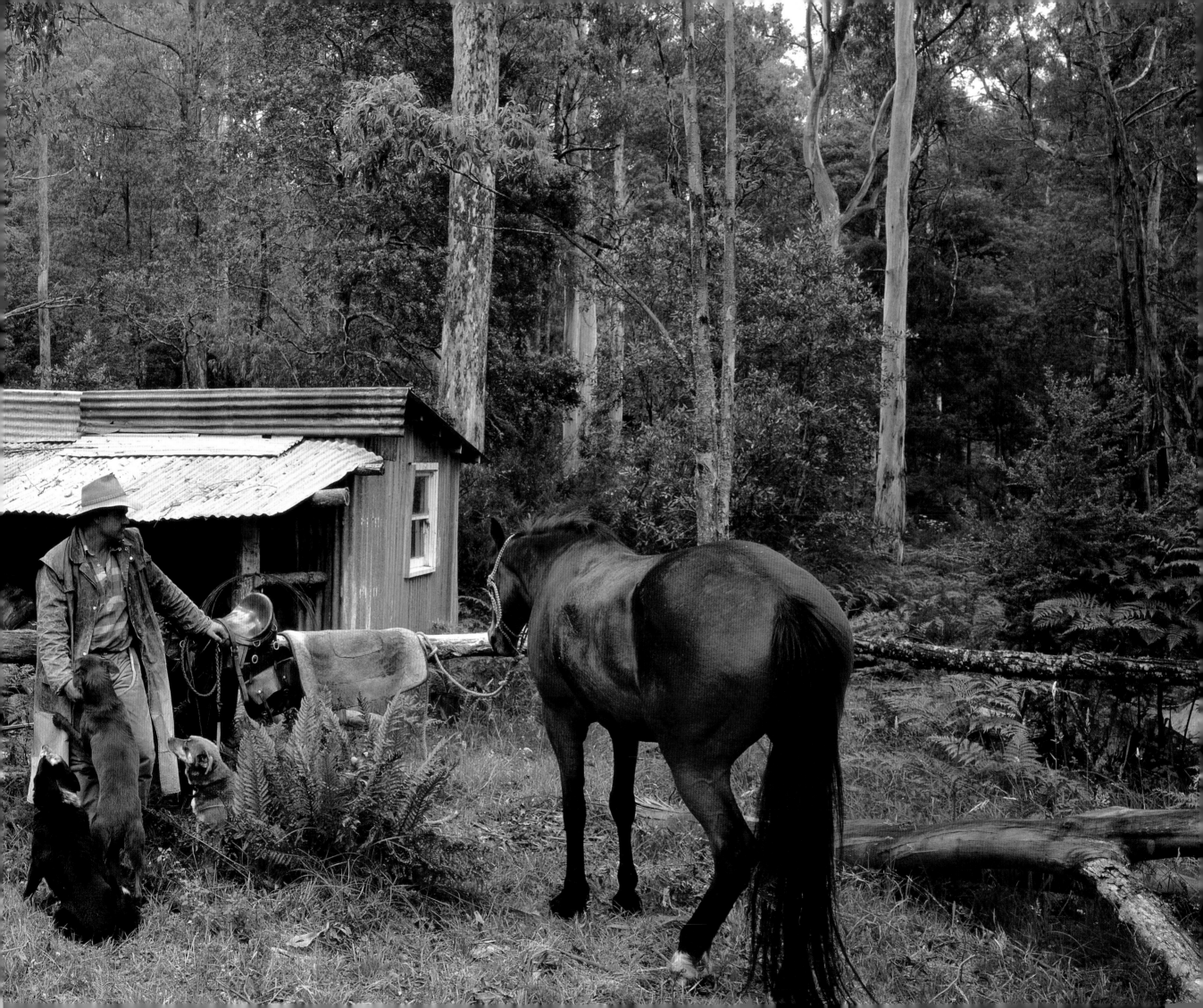

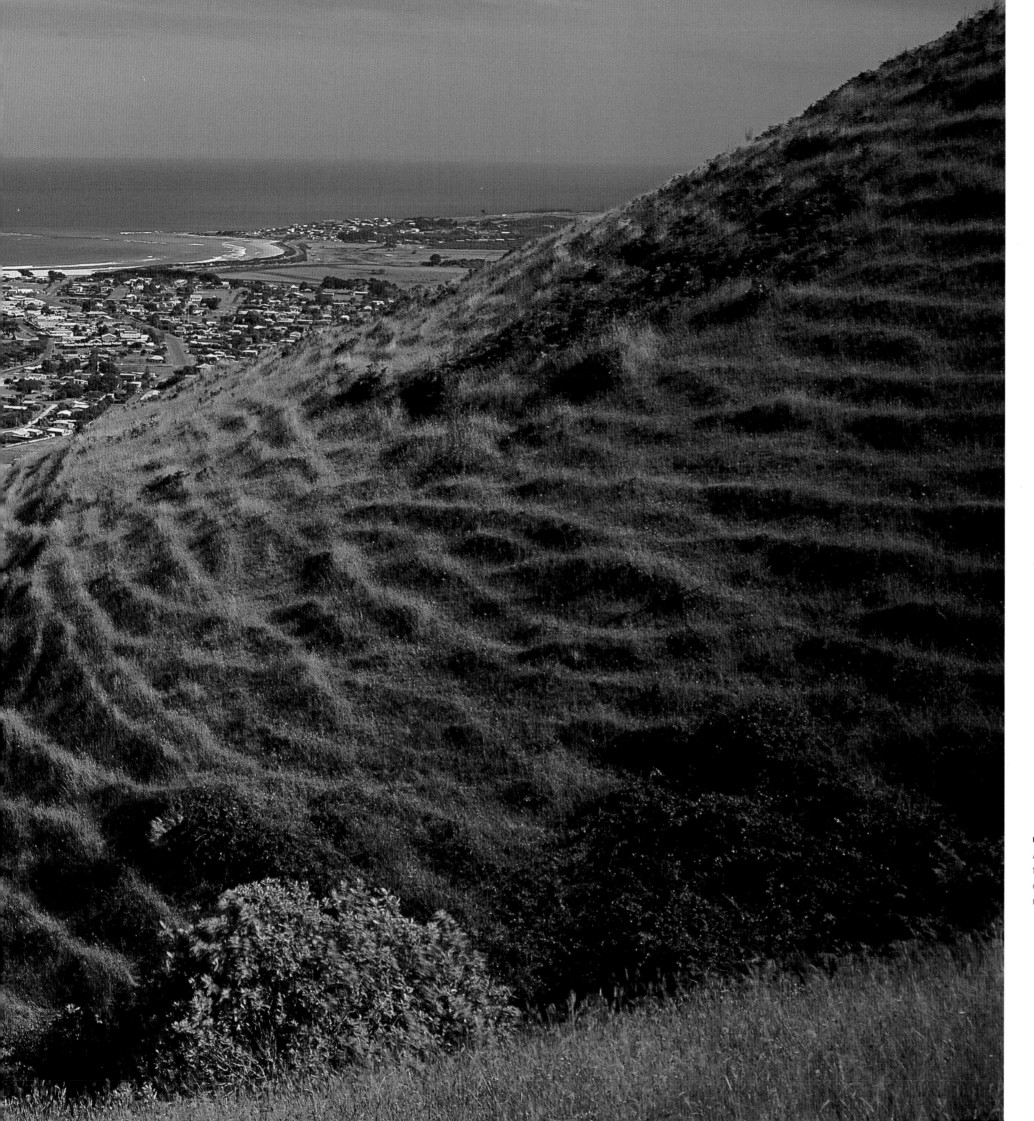

■ Apollo Bay
Apollo Bay is typical of the tiny but charming resorts of the southwestern coast of Victoria. Sleepy in winter, it comes alive with holidaymakers during the summer months.

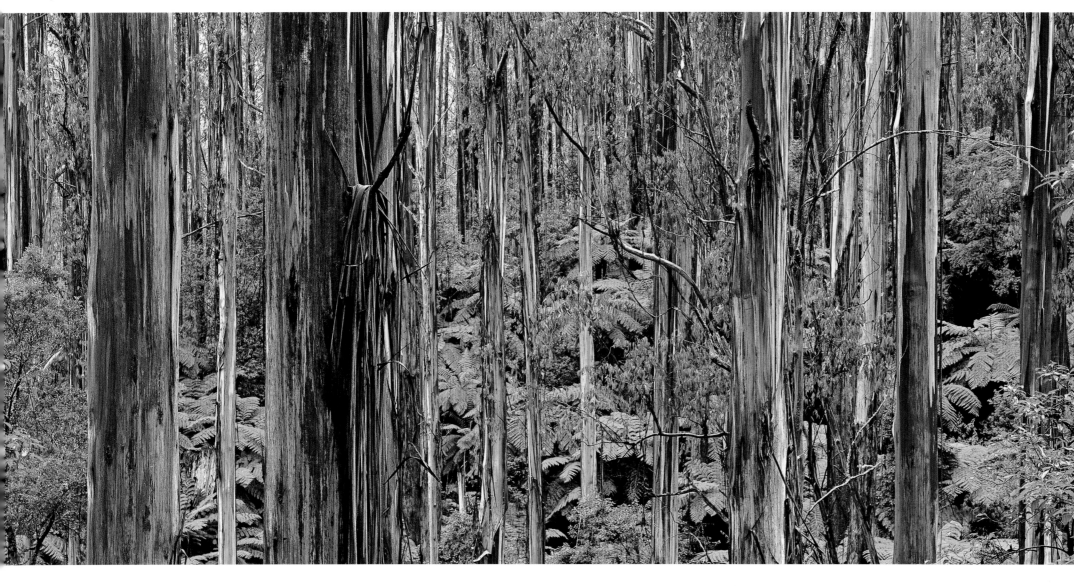

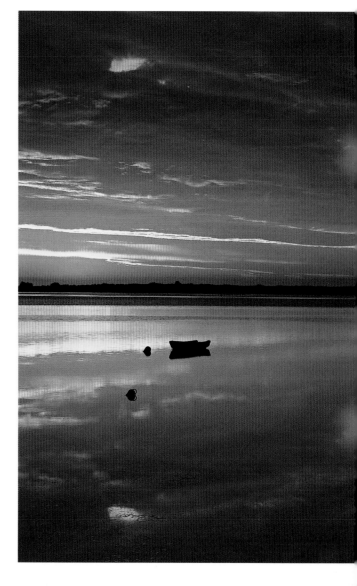

■ ABOVE RIGHT : Fern Forest, Tarra-Bulga
National Park, Strzelecki Ranges
Some of Australia's ancient rainforests have
remained largely unchanged since they
resounded to the tread of dinosaurs more than
65 million years ago. The fern forests preserved
in Tarra Bulga National Park are such a relic.
Ferns that grow there—10 metres (30 feet) tall
in some cases—are descendants of a flora that
evolved in the ancient southern supercontinent
of Gondwana, some 250 million years ago, long
before dinosaurs appeared on Earth. They have
altered little since. The major difference between
Australian forests, then and now, is the canopy.
The eucalypts that form the canopy in this
instance evolved relatively recently. They are the
Mountain Ash, the tallest flowering plants on
earth.

■ BELOW RIGHT : Feathertail Glider,
Acrobates pygmaeus, feeding on
a Heath Banksia *Banksia ericifolia*
Aided by a flattened, feather-like tail, and broad
flaps of skin linking its front and hind legs, the
diminuitive Feathertail Glider is able to commute
by air between its scattered food sources,
gliding from tree to tree with consummate

precision. The Feathertail's range includes most
of the eucalypt forests and woodlands of
eastern Australia, where they feed on nectar,
the sweet sap of certain trees and shrubs, and
any small insects they happen to find among
the foliage. Feathertails tend to be gregarious,
and large trees in full flower may occasionally
harbor up to 40 foraging gliders.

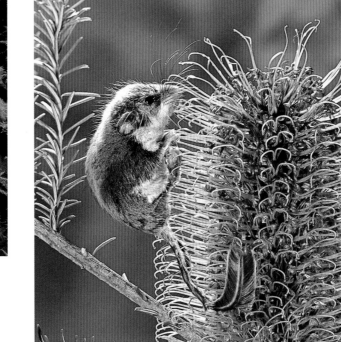

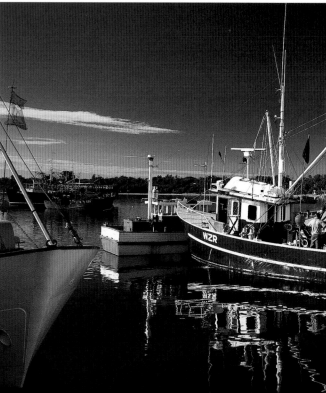

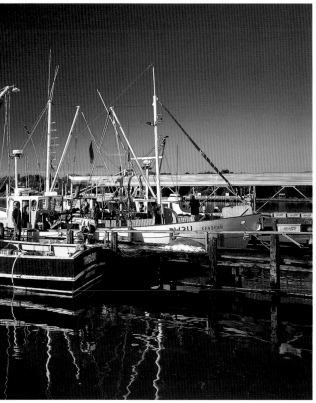

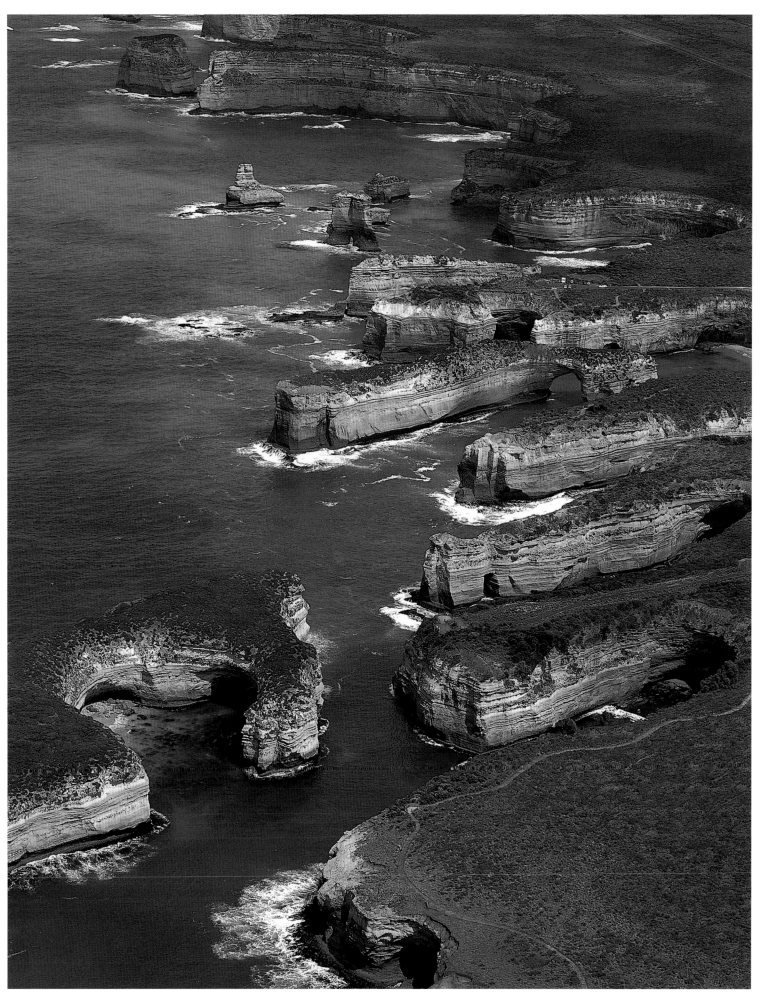

■ LEFT : **Port Campbell National Park, southwestern Victoria**

The constant battering of Southern Ocean storm waves have bitten deeply into the layercake sandstones of southwestern Victoria to create this dramatically dissected coastline, near Port Campbell. It is part of a 25 million-year-old seabed that was thrust more than 150 metres (400 feet.) into the air. It is being gradually torn to pieces by the ocean. Sea caves, natural archways, and rock-stack islands characterise a coastline incessantly changing from the onslaught of the waves. In the early days of colonisation, this rugged stretch of coast was the graveyard of many ships and their crews: there are few beaches here, the shallow waters are treacherous, and most of the cliffs are vertical, friable, and practically impossible to climb without ropes.

■ FAR LEFT : **Reeve Channel, Gippsland Lakes, southeastern Victoria**

Thc Gippsland Lakes region incorporates the second largest system of natural lakes and waterways in Australia. It not only represents a major habitat for wildlife, but offers Victorians an extensive recreation area, offering excellent fishing and boating.

■ BELOW LEFT : **Fishing boats at Lakes Entrance, East Gippsland**

The large fishing fleet based at Lakes Entrance in eastern Gippsland commutes to its fishing grounds in Bass Strait via a man-made channel that connects the Gippsland Lakes to the sea. Apart from supplying a large proportion of Melbourne's fresh fish, Lakes Entrance has also become one of Victoria's major aquatic recreation centres. The Gippsland Basin is also Australia's most important source of oil. Oil was first discovered on the continent at nearby Lake Bunga in 1924, though subsequent drilling proved that the main reserves lay in the offshore segment of the basin, in Bass Strait.

The first church service was held by Rev Richard Johnson of the First Fleet in 1788. The Church of England remained the predominant church in the nation until overhauled numerically by Roman Catholicism, which now claims some 25 percent of the population. However, many of Australia's churches are now nearly empty or abandoned as a result of growing secularism in Australia. Church attendance has been halved this century. On the other hand, a rich variety of religions now exist, including Greek Orthodox Christianity, Judaism, Islam, Buddhism, and Hinduism among many others. The major Christian churches, in particular—as may other religions—continue to exercise a moral, social and political influence in the community, but no church is recognised by Australia's secular consitution.

The Australian pub

The "pub" (public house, hotel), with its mandatory ice-cold beer on tap, is an Australian institution. A hub of community in much of country Australia, they are often the most substantial building in many small towns. In some they are the *only* building. But their heyday has passed. If city pubs have suffered from changing tastes, and competition, country pubs have felt the squeeze of shrinking townships. The first wave was driven from the land by better mechanisation; a recent wave was driven off by thin commodity prices and economic rationalisation; bigger, better farms meant less farms, fewer farming families, and smaller service communities.

Historically, the goldfields spawned the grandest pubs, serving townships bulging with thirsty miners from the 1850s. Some achieved legendary oppulence, catering for the instant wealth of lucky diggers. Most were, well, primitive. When the diggers left with the easier pickings, big companies with heavy machinery and a unionised workforce replaced them.

Now that too is dwinding. Many city pubs have long gone or reinvented themselves so often they're barely recognizable. Few country pubs go that far. Perhaps there is less need. Life in the bush is still rugged and isolated. The work, like the roads, is long—and parched. An ice-cold beer, a word with a mate, a hot meal, or a bed for the night, they're needed still.

■ RIGHT : The Botanical Hotel, Learmonth

■ OPPOSITE : Irrigated citrus and apricot orchards near Mildurah
The fertile flood plains of the Murray River are the food bowl of eastern Australia. Irrigated by the waters of the Murray, most of the valley is now under intensive cultivation, producing the bulk of Victoria's fruit, vegetables, cotton, rice, and other cereals. It is a wine region too. Such agricultural abundance, however, comes at a price. Although about 6,500 square kilometres (2,500 square miles) of Victoria are now under some form of irrigation, more than 30 percent of this land is showing signs of degradation due to rising water tables and salination.

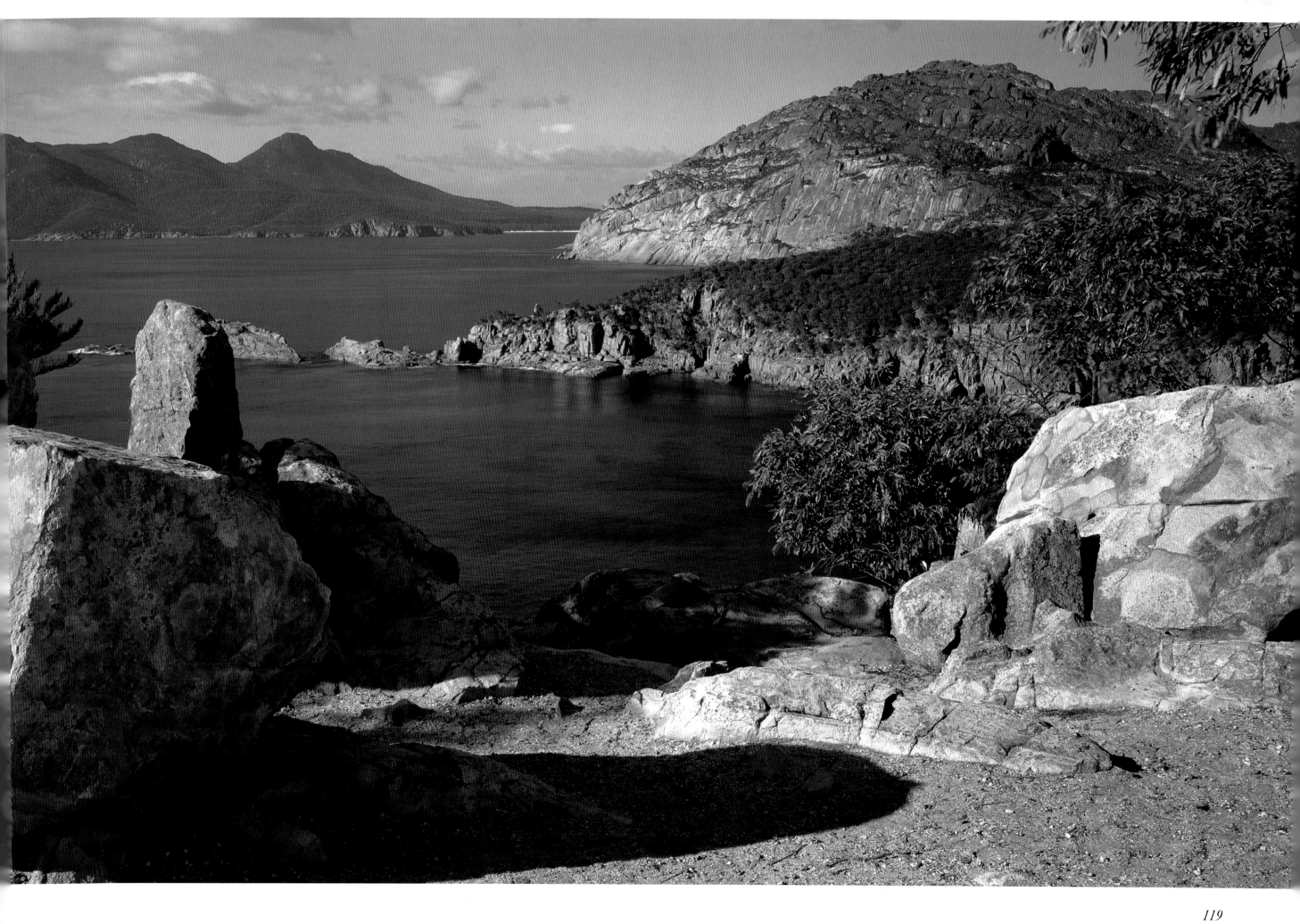

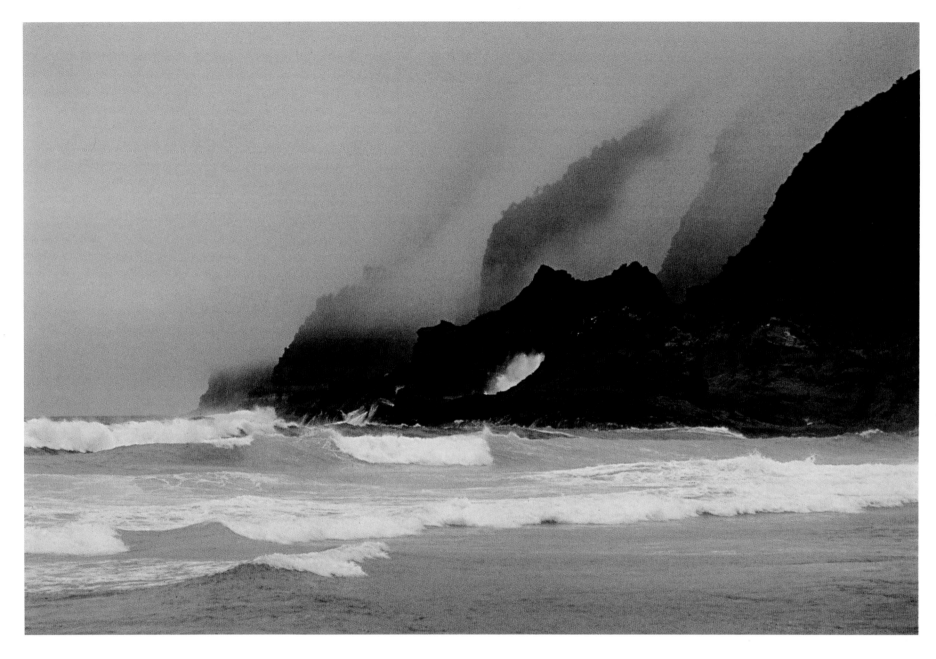

■ **The Fluted Cliffs, Southwest National Park**
Originating off Patagonia, the swells of the Southern Ocean
heave across some 10,000 nautical miles before launching
themselves in an endless procession at this southern tip of
the Australian continent. There the spume of storm waves,
and the rain-bearing westerlies of the Roaring Forties, veil
the Fluted Cliffs of Southwest National Park in continual
mist.

ARAFURA SEA

PACIFIC OCEAN

INDIAN OCEAN

SOUTHERN OCEAN

TASMAN SEA